"*the déjà vu* is a rousing, eclectic black feminist project. It blends elements of spoken word, critical writing, poetry, letters, journal writing, book review, photography, artwork, and performance, defying at once the limitations imposed by more conventional approaches to genre. Here, Gabrielle Civil has crafted a pedagogical model for *writing* performance art." —**Alexis De Veaux**

"What if we could offer our archives to each other like flowers? Hold them in glass, heavy but transparent? What if we could show each other the journey of unknowing and remembering ourselves now? Why would we wait? With this work, Gabrielle Civil continues to model generosity, bravery, and vulnerability as core principles of black feminist performance, creativity, and living. Read it for the beauty, the black feminist references. Read it for a particular herstory of this time. Look for what you might be unknowing right now and what you need urgently to remember." —**Alexis Pauline Gumbs**

"Civil soldiers for the possibility of black life to dream beyond the confines of colonialist rhetoric laden within modern world systems. Here, she asks the reader to think and experiment playfully with her as she skillfully complicates our time-dream-space continuum with new poetic knowledge. *the déjà vu* is a book project that performs as a conceptual artwork crafting its own genre of intertextual experience." —**Jaamil Olawale Kosoko**

"This is the book I wish I'd had as an artist as a young woman. And it's the book I'll relish in sharing now. Performance studies has a new one for the mantel in this generous, funny, tender journey through the thicket and politic of Becoming." —**Cauleen Smith**

"While the world insists that blackness exists only in the body, Gabrielle Civil shows us that black feminist consciousness extends well beyond any corporeal limitations. Affirming the power of black dreams and black time, *the déjà vu* notes metaphysical links between the ancestors and the stars. It is an astounding book." —**Wendy S. Walters**

"So often, in reading *the déjà vu*, I'm reminded of how breakable memory is, especially when that memory tries to hold trauma within it. The act of remembering itself haunts *the déjà vu* as Gabrielle Civil catalogues her experience through impetuous lists, vigorous anaphora, repetition, and the interpretation of dreams, both waking and asleep. Civil meets the multiplicity of memory with formal multiplicity. There are several categories of memory, after all: childhood nostalgia has a peculiar quality to it; history is never yet fully formed; and visioning, also, is related to dreams. Moving in and out of enjambment, Civil works from poetry to prose to arts criticism, to inexplicable junctures of poetic bravery, to sheer amplitude, to breaks into the conversational, to epistolary, to performance. In all this plurality, Civil manages to deliver a kind of replete self-accounting, or autotheory, in *the déjà vu*. She goes deeper than ekphrasis or arts criticism, toward an experience that's closer to that of intimately living with, and within, the text of our culture."

—**Anaïs Duplan**

"Gabrielle Civil's luminous *the déjà vu* emanates deeply within and around the speaker's memory, in which the politics of joy are palpable intimacies of language and performance, a 'sphericity' in which 'all the time / is seeping and oozing.' Civil brilliantly envelops the reader in black time, hers, ours, a way into the present moment by excavating a self, one taking great risks and following big dreams, where humility and compassion ignite a vivid tableau and conceptual stratagem, ever human, where 'blood clots form . . . a bright red arterial flash that leads . . . a few steps to find a snow globe.' This book is roundly wise and rich with surprise, where 'art-making and black feminist professing' reveal the heart of this incredibly moving work: Gabrielle Civil's 'own vibrating, undeniable power ~~~~~~~~~~~~~black future~~~~~~~~~.' Civil inspires a life of love for the self, for others, for the human condition, as we follow hers, engaged in 'practice and play as human beings,' out of which Civil urges and instructs: 'Imagine an iridescent bubble around your head / This is your dreams happening now.'" —**Ronaldo V. Wilson**

the déjà vu

the déjà vu

black dreams & black time

Gabrielle Civil

COFFEE HOUSE PRESS
Minneapolis
2022

Coffee House Press books are available to the trade through our primary distributor, Consortium Book Sales & Distribution, cbsd.com or (800) 283-3572. For personal orders, catalogs, or other information, write to info@coffeehousepress.org.

Coffee House Press is a nonprofit literary publishing house. Support from private foundations, corporate giving programs, government programs, and generous individuals helps make the publication of our books possible. We gratefully acknowledge their support in detail in the back of this book.

LIBRARY OF CONGRESS CATALOGING-IN-PUBLICATION DATA

The cataloging-in-publication data for *the déjà vu* (ISBN: 978-1-56689-622-1) is available from the Library of Congress.

PERMISSIONS

"Dreams" by Langston Hughes, © 1951 by the Langston Hughes Estate, is reprinted by permission of Harold Ober Associates.

"refractions" by aegor ray and bobbi vaughn is reprinted by permission.

PRINTED IN THE UNITED STATES OF AMERICA

29 28 27 26 25 24 23 22 1 2 3 4 5 6 7 8

Blacktime is time for chimeful
poemhood
but they decree a
jagged chiming now.

If there are flowers flowers
must come out to the road. Rowdy!—
 . . .
across the Changes

—*Gwendolyn Brooks*

the déjà vu

the déjà vu

Double Negatives

there's joy in repetition

there's joy in repetition

there's joy in repetition.

—*Prince*

The Déjà Vu

1. the déjà vu is not not a strip club in ypsilanti
2. this is to say when you tell your sister yolaine that the name of
 your next book is *the déjà vu* and she laughs and says, herman
 says, isn't the déjà vu a strip club in ypsilanti? herman is her
 husband, and we won't get into how he and his brothers might
 know about this club, you just laugh and say back
3. that maybe it is
4. revealing glistening bodies
5. like in *the magicians,* when alice asked the black man in jail
 with the salt-and-pepper beard if he was santa claus
 and he answered, well i have, i have got problems
 with that name, but i'm *not not* that
5. the déjà vu is like that, the you doubling back as me
6. merry christmas!
7. welcome to flashback season, or should i say welcome back
 to the feeling of been here or maybe been that before
4. embodying gestures repeating
8. double consciousness, double negatives
 double dreams, double time
9. *the black feminist performance artist in performance still*
10. mining experiential echoes

~~~~~~~~~~~~~~~~~~~~~~~~~~~

—10. you could say *the déjà vu* started as another response to a call. okay, it's true you're not a household name. you don't have a million books yet like naomi long madgett (rest in power, detroit poetry goddess) or a streaming television series adapted from *swallow the fish* that will make artsy nerds of all races, classes, and genders cry out with love and wonder at the screen (coming soon! hit me up if you want to finance this), but that doesn't mean you should second-guess your worthiness. even though it's california, so far away, so expensive, so full of health nuts, movie stars, skinny people, and traffic, plus there's your whole driving *thing,* so what??? who cares about all that? stop trying to talk yourself out of your own greatness. especially when there's a chance for joy.

remember your double take when you first saw the ad? it all seemed so lovely, teaching writing! and whatever else you wanted! literature! performance! black feminism! at an art school! no more "acting for leadership" or presentations on "the secret practicality of art-making"—the secret would be out. everyone would already know that art-making was completely impractical and urgent, and you wouldn't ever have to convince anyone of its value again.

to be fair, it wasn't that you didn't think you could actually do the job. you just doubted they would give it to *you.* wait a minute, aren't you supposed to be a badass? FAT BLACK PERFORMANCE AAAAARRRRRRT! wasn't that you? from windflower to wallflower in two seconds flat, a knee-jerk response. who knew you were so insecure? you had seen those articles, how women psych themselves out, but you never thought they were talking about you. the ghosts you thought you'd banished came floating back. so when you saw your dream job, instead of jumping at the chance, you figured you wouldn't get a second look. never mind that the playboys of this world will put themselves forward without a second thought. they jump up to run the art world, the university, the country, and everything else without a single qualification. then, with tedious

familiarity, yet again, they run it all into the ground. and here you are, balking at applying for what you've been doing for years: reading and writing, art-making and black feminist professing . . .

COME ON, BLACK DIVA! you're not just talking about a job, you're talking about another life: teaching juicy memoir and translated bodies . . . you could sit in on a directing class or feel the squish of clay in your hands or take morning dance or hang out with music profs in the sunshine! on the beach! you're talking about new performances, being black in a different place, where blackness is expansive, beyond black or white. you're talking about shifting your context again but still staying true to how astral you are. you're talking about your dreams. and, you say to yourself, if you want to follow your dreams, don't worry about what you're not: double down on who you are. talk about what you love, what you've seen without seeing. be playful. trace overlaps and hauntings. create an accounting of black feminist consciousness. call it *the déjà vu.*

~~~~~~~~~~~~~~~~~~~~~~~~

The Déjà Vu: An Accounting of Black Feminist Consciousness (after Ben Okri and John Berger, plus a shot of stardust)

1
The Déjà Vu comes from the phrase *déjà vu,* which in French means *already seen.* My name, Gabrielle Civil, also comes from the French by way of Haiti, Alabama, and the Kingdom of Detroit. This coincidence of common heritage is a hallmark of The Déjà Vu. This recalls previous apparitions.

2
Once, at an airport, some strangers were waiting for Gabrielle Civil. Is that her? That blonde lifting a logo bag from the claim? Is that her? That diminutive brunette from Quebec? That vixen whipping back

her shiny weave, dancing fierce in the club? Is this the Gabrielle Civil you've already seen? A specter lingers of what you have in mind. The Déjà Vu is what precedes and what follows.

3

Things can look like one thing and be something else at the same time. Just look at these prayer cards in my hand. You may see Joan of Arc with pale skin striding in silver armor and also see Ogoun Ferraille. You may spy the Black Madonna of Częstochowa with her scratched and gilded face and recognize Erzulie Dantor. Revel in this simultaneity on full display. The Déjà Vu dwells in syncretism and enjoys open secrets.

4

There is the surface of things and what we carry under our skin. In the flesh, a black woman foots the bill. Henrietta Lacks never knew her cells would become the heart of microbiology. From her body, we encounter immortal regeneration. The Déjà Vu becomes a helix of epigenetics.

5

The Déjà Vu is living someone else's memory before. Remember when they tried to kick M. NourbeSe Philip off the bus in Morocco? You heard about that, right? She had dreamed of the Sahara and seeing desert sand and stars, and even showed up early on the bus for the tour. But then things got hectic, as they do for black women in the world, and they tried to kick her off for some Happy Happy White Girls and . . .

5

"I hold my hands chest-high, palms facing outward as if my body, arms and hands were all of a piece in my resistance. *I was the second person on this bus,* I say, and *I'm telling you, I'm not getting off.*"

6

Rosa Parks was clearly on that bus first in spirit, if not in body. Later, Philip said she thought of Rosa and Nanny of the Maroons in Jamaica and Queen Yaa Asantewaa of the Ashanti guiding her hands and planting her feet. Reading Philip's words, I feel them all—Rosa, Nanny, Yaa, NourbeSe herself—guiding my own hands and planting my own feet. The Déjà Vu arrives as shared ritual performance.

7

The Déjà Vu combines personal and historical memory across a dazzling array of forms. In her rememory, *The Forgetting Tree*, Rae Paris revisits the Smithfield plantation in Blacksburg, Virginia. She rebukes the white tour guide's repeated whitewashed stories. She takes her own field notes and photographs the faceless, armless slave mannequin in the kitchen. She vows to remember what she may never have seen. Kara Walker follows a similar impulse in her monumental mammy sphinx sculpture *A Subtlety, or the Marvelous Sugar Baby, an Homage to the unpaid and overworked Artisans who have refined our Sweet tastes from the cane fields to the Kitchens of the New World on the Occasion of the demolition of the Domino Sugar Refining Plant.* Made completely of sugar, this temporary vision served as a bittersweet reminder of black ancestral pain. Nona Faustine brings this remembering back into her own body. In her photograph *From Her Body Sprang the Greatest Wealth*, she stands unapologetically nude, beautiful, fleshy, and brown in bright white pumps on a box in the middle of Wall Street. In this way, she incorporates all the black bodies who birthed the capital of the world. The Déjà Vu embodies art as reclamation. It skirts the fleeting and enduring, the mythic and uncanny.

4

"*boooooooo.* spooky ripplings of icy waves. this / umpteenth time she returns," Wanda Coleman writes as a black woman ghost in

"American Sonnet (35)." What arrives involuntary? Another gasp. A shiver in the spine. We know it's coming but still get shook. Our haunting blurs inside and outside, our cells and the surround. There is the surface of things and what we carry under our skin. There is also what exceeds us. What happens when the body is no longer mine? When it's no longer alive? The Déjà Vu is the blackness before and after.

8
The Déjà Vu is a living memory of someone else.

tumbling from dreams

*AFTER GEORGE FLOYD**

100,000,000,0000,000,000,000,000,000,000,0000,000,000,000,000, 000,000,0000,000,000,000,0000,000,000,000,000,000,000,0000,000, 000,000,000,000,000,0000,000,000,000,0000,000,000,000,000,000, 000,000,000,000,0000,000,000,000,000,000 (so many more names, beings, and years, enumeration beyond naming) 000,000,000,000 The Déjà Vu invokes and activates the power of memory.

9
 a noticing (in the body), a prickling intuition

 a mingling, an overlay

 keen recognition
 2
 second sight, blind spots

 6

repetition, reenactment, recurrence, reckoning

1

an inherited shield, an embodied call

1955

tumbling from dreams

recalling and channeling 4

black dreams and black time

in a pandemic

AFTER GEORGE FLOYD

what could I gather and make this mean?

instances unfurling as idea

3

memory and rememory

return of the repressed

1905 (after psychology)

a cracking open of space and time

8

an artifact panel

an electric slide

11

a visualization

voice-over tour

The Déjà Vu exists

within multiplicities

2020

epigraph or footnote 10 a thousand-year plan

superscript or splice

3033

7

exploding the text election season

the end of the world

5

archive

2022

commemoration

transcript

score

19
The Déjà Vu marks constellations of positive and negative time.
Even as it reckons with black feminist memory, it revels in time travel
and leaps.

20
The Déjà Vu is an expanding set of forms.

~~~~~~~~~~~~~~~~~~~~~~~

*the déjà vu* sprang directly from the twin moments of pandemic and uprising. It was a terrible time in these dis-United States. Suffering and injustice surged and seemed unstoppable. At the same time, I really couldn't complain. I had landed my dream job at an art school with a job talk called "Into the Déjà Vu: Mining Experiential Echoes in Black Feminist Consciousness." Proud and excited to move to California, I now felt isolated and lonely. Still, 2020 promised something different: a year of radiant vision. It started with wild beauty, my dancing with beautiful queer black dancers in New York City and Seattle. That was January. But then, as you know, calamity struck in March. Almost no one took the virus seriously until it seriously took over. The world stopped, or was it travel or art or your job or your money or possibilities of touch? Everything called off or gone online. What kind of radiant vision was that?

It's hard now to capture the early feeling. For weeks, time and space blurred. Only one story blared on the radio. If you were crowded, you were more crowded. If you were alone, more alone. As a single black woman living a fairly monastic art life, I felt deeply punished for my life choices. But then so did my friends with children under the age of twenty-one. (Let's not even get into home-schooling.) It took a while for the routineness of these ramifications to set in. I certainly didn't start with any lucidity. My days were spent in a state of something close to dreaming with a lot less delight, more tedium and paranoia, mustered perkiness for my students, private flashes of rage, panic, worry about loved ones, boredom, more loneliness than I had ever imagined, fragile moments of quiet, wonder at nature, endless handwashing, and unimaginable hours on Zoom.

Then, three blocks away from one of my Twin Cities heart homes came the murder of George Floyd.

It was painful but not surprising to hear the police had killed another black person. George Floyd, Breonna Taylor, Tamir Rice, John Crawford III, Michael Brown, Sandra Bland (yes, I count her), Jamar Clark, Philando Castile, Atatiana Jefferson (on my birthday), Tony McDade, Ronell Foster, Anthony McClain, and counting. The police have slain so many black people, men, women, and children that I was sad but not surprised. It was more like, *here we go again.* Never mind the acute, biomedical crisis in America; there's always room for more racist spectacle of black death.

But this time, the whole world started cracking open. My people in the Twin Cities rose up, and my people in New York City, Atlanta, Louisville, Durham, Detroit, L.A., London, Paris, everywhere. BLACK LIVES MATTER! *You wanna talk about a pandemic, bruh, let's talk about the pandemic of white supremacy!* In the face of a killer virus, tear gas, and armed white supremacists, people still left their shelters-in-place. Although it could have cost them their health, their lives, their liberty, people still rose up! (merry christmas!) It wasn't the first time. People have always been rising, even if they weren't in the spotlight; underneath the surface, things can look like one thing and be something else at the same time. I'm talking about guiding hands and planting feet. I'm talking about dreaming and resistance, carrying on for someone else's memory.

Something happened to me when all this went down. I wasn't less scared about contracting the coronavirus. I didn't set aside my plans to visit my older parents across the country. I maintained my vigilance around quarantine isolation even as many friends hit the streets. I wasn't sure what the results of the protests would be, if George Floyd or anyone would ultimately get justice, but I was deeply inspired and grateful. I still feel profound love for everyone who immediately protested. They marched with homemade posters and banners. They sang songs and did the electric slide. They reported from the streets and shifted the narrative. They stood up to power. They refused to let George Floyd die in vain.

And I understood something deeply about the moment: I could help network and exchange information, contribute donations and mutual aid. I could offer emotional support for protesters in my circle. I could prepare myself to tap in when the time was right, because it was sure to be a long haul. But more than that, I knew the time to second-guess myself or my purpose was over. Organizers, marchers, first responders, caretakers, nurses, lawyers, trouble-makers, peacemakers, bodyworkers, dancers, farmers, scientists, pastors, sailors, journalists, and, yes, black feminist performance artists and writers all have deep work to do. On a cellular level, it was time to show up to my deepest calling.

And so I entered the field of imagination and was consumed. I would wake up with words pouring out of me, reaching for my notebook ~~~~~~~~~~~~~~~~~~~it tumbled from dreams ~~~~~~~~~~~~~ I started writing about dreaming, writing about time, what was happening, what had happened, what could happen in my lifetime. It might not have looked like what people expected ~~~~~~at the end of the world~~~~~~~~~~~~ I wrote about movies and dances that nourished my soul ~~~~~~~~~~ I wrote about poetry and paintings and books ~~~~~~~~afterimages ~~~~~~~~~~ and the painful truth of my own body. I wrote about love and failure and trying again. It wasn't all new ~~~~~~~~~~~time is not align~~~~~~~~~~~~~~~~~~~~~~~~ I reached back to earlier speeches and performances reflecting my dreams, my teaching and reading, my students and comrades. I forged new words about love and failure and trying again. I invited my own vibrating, undeni-able power ~~~~~~~~~~~~~~black future~~~~~~~~~ I wrote to honor those resting and radiating in power ~~~~~~~~ I write to honor those resting and radiating in power. I remember the experi-ential echoes of the déjà vu because the moment is always now.

September 11, 2006
September 11, 2021 / May 25, 2020 / September 11,
1922 / October 12, 1974 // 2 . 22 . 22 //
September 11, 2001 / April 21, 2016 / July 24,
1701 / October 14, 1939 / October 12, 1492

## On Commemoration
### *We Will Always Forget*

It is September 11, 2006, and I am walking in Montreal. It's the fifth
anniversary of 9/11, a day of commemorations. I've looked at the *New
York Times*, the *International Herald Tribune*, *La Presse de Montréal*. Here
in Canada, I hear snatches of radio, in French and in English, about the
Canadians killed and the Canadian presence in Afghanistan. I watch
flashbacks to the terrorist attacks, planes flying into the World Trade
Center in New York City, on television programs. I remember the mes-
sage I see from the L on the way to the airport in Chicago. On the side
of a storage facility, emblazoned in bold letters: "December 7, 1941–
September 11, 2001. God Bless America. We Will Never Forget." What
does it mean to forget or remember? What does it mean in public space?

public space? Does this now only
exist in dreams?

It is September 11, 2006, and I am walking in Montreal. It is January 18, 2021, and I am writing this in L.A. It's a gorgeous Martin Luther King, Jr. Day and I'm wallowing in black time—or reveling or loafing or spellcasting or burrowing under covers while still in quarantine, supposedly trying to finish this book, in actuality taking my time. Maybe secretly I don't want this dreaming to end? Or maybe I am just very tired. I'm looking back at this text written a while ago called "On Commemoration." Is all writing a time capsule? I wrote it in real time on a wild solo trip to Montreal trying to find an elder Haitian woman poet. Recovering this text, I cringe and smile. How earnest I was, I am, how much a product of my time. I have to decide what to update, shift, or preserve, exactly how to remember.

flashbacks *Beep.* My godmother Jean's voice on my answering machine in Minneapolis that morning: *"Gabby, your mother said you were in New York City. I just saw what's going on. I hope you're back."* I get out of bed, turn on the TV to see the Twin Towers engulfed in flames. When I think back to that day, it always starts with that voice. Rest in Power, Myrtle Jean Jones (1939–2012).

television programs The algorithm must have known. At the end of something else (which I no longer remember), it decided it was time for *Sleeper Cell.* Michael Ealy showed up with his black man blue eyes circa 2005, 2006, infiltrating an underground terrorist enclave to stop the next attack. He was Muslim on the show; and key topics included Islamophobia, radicalization, U.S. hypocrisy in foreign affairs, and, of course, the fundamental decency of federal employees. Oh, and because it was pay cable, there were plenty of strippers, bare-breasted women, and people having sex. (I guess they call it *Showtime* for a reason.) While the plot was vaguely familiar—had I caught some of this in Casa Tarami in Mexico City or on a plane?—I was more interested in the surround. Flip phones. Phone booths. Mail Boxes Etc. The Patriot Act. Bush & Cheney. Homeland Security. The search for Osama bin Laden. I had lived through it all but forgotten so many details. How suffused we all were in all these things, what it was like to live inside them.

<u>remember?</u> Every day my father watches reruns of *Perry Mason, Leave It to Beaver, The Andy Griffith Show.* He clearly enjoys the acting and the storylines. But I think he also likes their reminder of a different time, how they remind him of himself back then. The other day, *ER* came on. (Autoplay on Hulu is what TV used to be: somebody else deciding what you should watch next.) And I found myself sucked back into all the drama of that inner-city Chicago emergency room. People prepping for Y2K! A toy gorilla playing the Macarena. I marveled at the amount of anxiety about HIV, how sexual harassment was routine, how morality was dictated by white lady do-gooders, and how much I craved better stories for the people of color on the sidelines. (Good news: *Grey's Anatomy* basically took the nurses of *ER* and let them run the whole damn hospital. Thank you, Shonda!) What bothered me now for the most part bothered me back then. Still, when you grow up with something, it grows on you. That must be why, though I don't consider myself a fan, I have seen every episode of *ER* (and that show aired for fifteen years, so that's really saying something).

> You can love something or not even like it very much
> and still see yourself deeply in it
> because you recognize the times
> because those were the times
> you became the person you are

Maybe this is why I flipped on *ER* after the blood clots traveled up into my lungs and I ended up first in the ICU and then by myself in a hospital room. When the nurse walked in and saw me watching *ER,* she said "I'm not sure that would have been my choice." But to me, freaked out in my hospital bed, it just felt familiar and kind of comforting. Besides, Doug Ross and Carol Hathaway were living in a completely different world, much like I'm sure *Andy Griffith* does not reflect my father's understanding of policing.

<u>Oliver Stone's *World Trade Center*</u>  Wow, when was the last time you heard anyone mention that? If you're looking for a truly moving movie memorial, skip ahead to Tourmaline's *Happy Birthday, Marsha!* and Sophia Nahli Allison's *A Love Song for Latasha*. Rest in Power, Marsha P. Johnson (1945–1992). Rest in Power, Latasha Harlins (1975–1991). We miss your beautiful black girl woman dreaming.

It's been cold and rainy off and on and so I duck into the multiplex to see <u>Oliver Stone's *World Trade Center*</u>. The American flag waves, brave firefighters almost die, and strong white men cry while their kind white wives hold them firm in faith. <u>This arrives as a monument</u> to collective tragedy. It is often moving. Still, it feels official and endorsed throughout. I leave and keep walking.

The city is a little warmer now, more dry. I compare this memorial on the silver screen to other monuments here in Montreal. Not the usual statues of men on horses, or Grand Army Plazas, or Arcs de Triomphe. Instead, I see graffiti everywhere in the city, signed performances, monuments of self.

<u>This arrives as a monument</u>  The Fall/Winter 2020 issue of *Art Papers* arrived yesterday. I love this magazine so much! In a burst of synchronicity, the theme is "Monumental Interventions." It features black monuments by Wangechi Mutu, Simone Leigh, and Hank Willis Thomas, plus Beverly Buchanan's *Marsh Ruins*. Right now, I'm poring over a collaboration between danilo machado and Re'al Christian responding to the work of Félix González-Torres, one of my earliest artist loves. Christian writes: "A rupture, an ideological rift exists between memory and history. How we remember the past, and by extension how we choose to commemorate it, can be at once synchronous and contentious. . . . With each monument that has been erected, we must ask whose history the structure embodies, and which histories are buried."

Walking down Boulevard Saint-Laurent, I see this wall of tags right next to a store of gravestones. At first, the juxtaposition is funny. It seems like <u>life and death</u> or <u>youth and age</u>, new jack and old school. But both the graffiti and gravestones are markers of time and ephemeral body, people both present and gone. Would I have noticed this intersection if it weren't for the other commemorations of the day? <u>Monuments and memorials</u>.

<u>Monuments and memorials</u> My first summer teaching in the Bard Language & Thinking program was the summer after 9/11. Each student received a paper map of the New York City subway. We were asked to remember where we were when we first heard the Twin Towers had fallen. "Why are they making us talk about this?" I overheard one student mutter. The theme was memory, monuments, and memorials. We made memory theaters, proposed monuments, and assembled mnemonic devices. We read Italo Calvino's *Invisible Cities* and some of Daniel Schacter's *Searching for Memory*. Sometimes we would take a reading and intersperse it with our own language. We would palimpsest it with new annotations. This was called exploding the text.

<u>life and death</u>  My first semester of college, on December 1, I observed Day Without Art at the University of Michigan. I had been seventeen for less than two months but already identified as an artist, so figuring out art and commemoration especially felt like life and death. This thing called AIDS was also so scary, it made sense to try to wrap my head around it. *Silence = Death* was chalked on the quad. Public artworks and fountains were swathed in black cloth. Could not seeing art be a galvanizing act? But on some level, weren't these artworks too? A kind of double negative? The dancer/choreographer Alexandra Beller was just a year ahead of me, but she was speaking at the program. We've never met, but her presence that day has always stuck with me: her voice strong and sharp. I can't recall her exact words at the mic, but they were something like: *I'm tired of my friends getting sick and dying. I'm tired of there not being a cure. I'm tired of nobody caring.*

<u>youth and age</u>  Despite what some might call the facts, I still think of myself as young. Not because young is better than old, it's not, but because I think of myself as still learning, wide-eyed, too often clueless, a secret ingénue. This flips when I'm actually around younger people, or more like when I'm grappling with their culture. TikTok. Snapchat. Social media. Memes. Trigger warnings. Emotional labor. Calling out, calling in, cancelled. In the face of all that, I feel O-L-D, world-weary, wounded, and quietly aggrieved. *O poor curséd Generation X!* Caught between Baby Boomers and Millennials, both of whom took up all the language, take up all the space. Boohoo! What's more middle-aged than whining about kids today? Still, it's been painful seeing the world I knew slip away, the one we tried to make, our resolutions and approaches to race, gender, friendship, affinity, or power mocked, ignored, or barely traced.

homeless people
*(Excusez-moi, madame, s'il-vous plaît—)*
people experiencing homelessness, houseless people

A few blocks down on Saint-Laurent, something takes my breath away. A mural sits next to what looks almost like a construction lot. Orange plastic net marks the perimeter of the space. The ground is gravel mixed with tar. In the mural, we see a city skyline and figures of five people of color, smiling, together holding a sign that says: "We honor the more than 60 sex workers, most of them indigenous, who were killed or kidnapped in Vancouver BC." This message is repeated in French and English and two other languages that I don't recognize.

This is the first thing in Montreal that really makes me stop, that makes me feel as if I'm encountering something real in the city, something specific. Along with graffiti, I've walked past cafés and yoga studios, museums and theaters, crowded malls and homeless people in the streets, all the things you find in every city. But this is something I haven't seen anywhere else. Of course, I've seen murals before but not this one. A chocolate-brown-skinned woman with a tattoo that says "Freak 69" on her arm. A caramel-colored man with an earring. A tan woman with brown hair and a feather hanging from her neck. All painted in bright, vivid colors.

"We honor the more than 60 sex workers,
most of them indigenous, who were killed
or kidnapped in Vancouver BC."
>>>>>>>>>>>>>>>>>>>>>>>>>>> Do we? <<<<<<<<<<<<<<<<<<<<<<<<<<<<<
<<<<<<<<<<<<<<< What would it mean to really do this? >>>>>>>>>>>>>>

A chocolate-brown skinned woman
with a tattoo that says "Freak 69" on her arm.
A caramel-colored man
"Do you find it offensive when people use food words to describe skin
tone?" I ask Rosa. "Less offensive than unimaginative," she replies. "Plus,
chocolate, caramel, brown sugar all come in different colors, so it's silly
or imprecise." When my awesome editor Anitra flags my chocolate and
caramel description, it makes me realize a few things. One, I don't usually
write this kind of description. So, it's funny to see this on the page from
back then. But also, I don't automatically find food descriptions like this
offensive. Of course, anything can be offensive depending on the con-
text, and describing black people can especially be a minefield. For me
though, using *chocolate, coffee,* or *cocoa* for skin tone is oral, *inside* lan-
guage. It's a throwback to how I would chat up my black friends growing
up in Detroit, what we called a chocolate city—*girl, she all light-skinned
buttery*—but not to my white friends at the white Catholic school. (Yes,
I was a champion code-switcher and maybe still am.) For me, this kind
of black talk was direct, delicious, playful, and yes, sometimes silly and
stereotypical. Yet, it connected to everyday life. Anitra shared with me
a text advocating the wholesale rejection of this kind of language for its
reinforcement of racist fetish, its use of products prominent in the slave
trade, and the colonialist consumption of people of color, not to mention
being cliché. I definitely hear this critique, particularly in formal writing.
Still, by default, when we think of offensive language, who do we imagine
is speaking, listening, writing, or reading? Who is overhearing?

men and women and those who are neither men nor women, and those who are both, and those who completely reject binary categories of gender, and those who are assigned one category at birth but exceed or live beyond that category, and I wish the people in this mural were alive so we could all hang out and they could tell us who they are, how they see themselves, how they move through the world, and what they would say or want us to say.

Even though the mural refers to the plight of people in another part of the country, it still feels local, connected. Right there in the public space of Montreal, it commemorates these sex workers, mostly indigenous people of color, men and women, presumably straight and gay. This is marvelous to me. I have learned something. I know about these people now, even if just a little bit, and I can be a part of remembering them. This commemoration makes me feel some presence, some solidarity here.

But wait—I'm only seeing what I want to see.
I'm not defacing, but I'm not facing it either.
I'm trying to see through it; I'm splitting it apart.
The whole bottom of the mural was covered in tags.

solidarity *Solidarity* is an old-fashioned word, like *compassion, empathy, unity, witness, allyship, optimism, excellence,* and *hope,* all words that have recently been radically questioned. These old-fashioned words have been cornerstones for me, touchstones for who I am. Yes, these words sometimes co-opt me into collusion with harm, oppression, and the status quo; they sometimes bring some bullshit. Nevertheless, I still believe in them, along with *creativity, intuition, black feminism,* and *joy.*

24

presumably straight and gay and presumably queer and trans and asexual and demisexual and how when I first wrote this, the language wasn't there yet for all these possibilities, or maybe it was and I just didn't have it. But I did know a range of desires existed, even within these words, because I felt and still feel that range myself. And even as language encompassed, consolidated, and elided different identities, even as it does that now, I knew then and know now that people exist on a rich and wide spectrum, and maybe here's the part that seems naïve today: I believed that all these people could be my people and that I could love them all.

This is marvelous to me. I have learned something.
I know about these people now, even if just a little bit,
and I can be a part of remembering them.
This part of the original text felt hardest to reveal. What I actually wrote was: *This is marvelous to me. I have learned something. I know these people now, even if just a little bit, and I can be a part of remembering them. They have become a part of my consciousness.* In 2021, I wouldn't write such sentences. I wouldn't feel allowed to write them. What nerve, what presumption to claim to have learned something, to claim to know these people, to grasp their experiences just from looking at a mural. This wasn't my country, my city, my main racialized identity, or my work experience. Even if I felt grateful to see the mural, even if I felt grief at the loss of these more than sixty human beings, even if I felt some affinity through my own sense of marginalization and sexual pain, what right would I have to tie them to my consciousness? In 2021, that kind of empathy has been called out as self-centered, entitled, and suspect. Even if you felt it, who would be naïve enough to say it? I almost took the whole thing out, but that didn't seem right either. This was who I was, how I felt. This is what I believed art could do and I wanted to remember.

But wait, I'm only seeing what I want to see. How earnest and naïve, how grandiose and romantic. Trying to make my own monuments, trying to give myself space to make bold claims while still always reining myself in, trying to imagine otherwise but still checking myself for overstepping, even now waiting to be knocked off a pedestal.

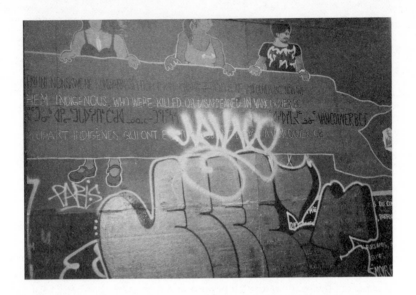

From afar, I thought that the tags were a part of the design. That the figures were walking on another part of urban space. Maybe that's what I wanted to think to avoid the truth: the taggers of Montreal, so active, so ambitious, had desecrated this memorial to the dead and disappeared.

It feels especially apt that I have come across this today, on a day assigned for grief. I've already seen stock images of loss replayed. I've already faced the hollows of national tragedy. Here now another national tragedy, so outside those conversations, the public memories discussed on this day. I am witnessing different scales of memory's operation, local awareness and global silence. <u>I am considering ignorance and knowledge.</u>

<u>I am considering ignorance and knowledge.</u> In osmosis, water moves through a living cell into a solution of higher concentration until the solution on two sides of the membrane ends up equalized. In people, osmosis is a gradual process of assimilation, unconscious absorption, and diffusion. How we learn things, when and how we come to know, how that forms and transforms our remembering.

26

<u>Still, what day of commemoration stands for this tragedy?</u>
March 3: International Sex Worker Rights Day
March 31: International Transgender Day of Visibility
June 21: National Indigenous Peoples Day /
*Journée nationale des peuples autochtones* in Canada
October 12: Indigenous People's Day in the U.S.
  (also Columbus Day and my birthday)
November 20: Transgender Day of Remembrance

I did not know the specific people in this mural. I did know that indigenous people and other people of color had been killed and discriminated against in Canada, as in the United States (although liberal Americans always claim Canada as their paradise). <u>Still, what day of commemoration stands for this tragedy?</u> Five years later, after the death or disappearance of the last one, where were the headlines, articles, movies, television programs? What does it mean to walk into someone else's collective memory? What does it mean for a collective memory to be yours? <u>What does it mean to come across someone's memorial and see that it's been defaced?</u> What does it say about this city? Or this world?

<u>What does it mean to come across</u> something unexpected in the world? It's hard now to convey that feeling of being in a city before it all got fucked up. A chance encounter then was a chance for magic, not online but in real time in the world. Flashback to my art comrades, Madhu and Rosa, and me never leaving home without our No. 1 Gold Emergency Kits. These held markers, postcards, poems, glitter, scissors, string, a stencil, and other urgent supplies. (As Björk said, "Who knows what's going to happen, lottery or car crash / or you'll join a cult.") This feeling of wandering and roaming. Writing this in quarantine, I yearn for that kind of freedom, so glorious and pedestrian. Even before the pandemic I yearned for it too. This kind of spatial openness hasn't seemed possible for some time, at least not in L.A. At least not for me.

<u>What does it mean to come across someone's memorial and see that it's been defaced?</u> "I know what it means," Madhu said when I showed this to her back in 2006. "It's *awful*." And I remember thinking, *Wow, I just spent all this time going through this blow by blow when that really said it all.*

27

The tags on the mural don't look new. The layers of writing, tags on top of tags, show one person's monument to self layered over another and rising. One white tag actively defacing the writing under one brown woman's hands. And I look at those brown hands, the faces of those mostly indigenous sex workers. How would they feel to know that their bodies were again being disintegrated in the city—usurped, absorbed, disappeared?

I'm sad because I usually think of graffiti as urban flowering, a present-day hieroglyphic. Yet here it is: the vandalism authorities often accuse it of being. Blatant disregard. And I wonder, if this mural had been a monument to those fallen in the Twin Towers, who would have dared? If so, would the city have allowed this desecration to stand?

To look at it all, the commemoration and the defacement.
To see how monuments of self are thrown up, overlapped
over anything, over everything, all the time, any time.

My performance art is never about erasing or defacement.
But what if this isn't true? <<<<<<<<<<<<<<<<<<<<< Or maybe
sometimes it should be.

This is not my aim in my performance art practice. When I smear my body with honey and ash in "art training letter (love)" or layer Rumi and Lucille Clifton over my own words in "infestation of gnats," I'm attempting texture, palimpsest. My performance art is never about erasing or defacement. My memorials, the monuments I'm making, are about archeology, layers, where what's at the bottom is more important than what's on top. I am trying to take memory, material-ize it, lay it over my body. I am trying to say something, embody some-thing about the thing remembered, about myself, and about memory itself.

I'm sad because I usually think of graffiti as urban flowering
My mom would talk about how the little kids at the school where she was principal were afraid of the gang tags in the neighbor-hood. Still, I revered graffiti as a key pillar of hip-hop. I loved
*Wild Style* and Lady Pink and will always love Basquiat. And I drank the Kool-Aid about graffiti as a subversive reclaiming of urban space. Now I don't really feel it anymore. Too much baggage and experiences like this one, I guess. (For the record, I should say that graffiti writers in southwest Detroit never touched the neighborhood mural of La Virgen de Guadalupe.)

These people who scrawled their names on top of names, and put fly-ers for shows on top of those scrawled names, did they think that the mural was already invisible? Had it already become a toilet in a chic, trashed club? Or once one person defaces a monument, does it just become fair game? Or is this <u>the city absorbing everything the way that a city does, the way it will? Pigeon shit on park statues. Scribbles on cornerstones.</u>

<u>the city absorbing everything the way that a city does, the way it will? Pigeon shit on park statues. Scribbles on cornerstones.</u>
Is this also what the writer does?
Desecration and inscription.

In five years, will anything be left, even a palimpsest?
Almost fifteen years later, does this mural still stand?
Back then, the mural was on the side of a radical bookstore.
Is the whole building now luxury condos?

Right now, the figures still stand above the devouring city. There's no way to take it as an homage, but at least they've left the faces alone. So far. They are layering mainly over each other's lines. A month from now will the graffiti have crept even higher? In five years, will anything be left, even a palimpsest? I imagine someone else now shamed and appalled by what's happening here. But what could she do? You can't unpaint a painted-over sign. Should they redo the whole thing? What would that mean for the original energy, the original laborers of the first memorial? And if they did manage to redo it, recover what was desecrated, would it just be defaced again?

You can't unpaint a painted-over sign
but actually maybe you can, maybe we should try
to perform a cracking, scratching, scraping, dissolving
of all the shit that gets overlaid, all the extra scripts
we don't need them and can recover something
more than mere erasure or more disappearance

Metallic paint covers some writing at the bottom of the mural. I can't decipher it at all. <u>Still, when I come closer, I can make out more.</u> I read how these human beings were valiant and loving and how they were missed and loved and how their friends and loved ones remember them and will never forget. The writing thanks everyone who contributed to the project and names a connection between Vancouver and Montreal. It explains how the images of the boats in the sky above their heads will carry the souls of these murdered and disappeared people on to another place.

<u>Still when I come closer, I can make out more.</u> Thirst & Glitter, the queer poetry workshop, has been over for more than six months, but Blue and David and I are still meeting. When it's my turn to offer a prompt, I decide to use the full photo of this mural with the transparent boats and stars. I drop the JPEG into the Zoom chat and they both download it. Blue sets the timer for nine minutes and we write, more writing on layered writing. This is their first time coming across this image, and I have no idea what they'll say. I realize I've had the photos from this day for a long time but rarely look at them. Now I'm surprised to see something I've never noticed before: a trash can in the bottom left corner. It's black and blurs easily into the foreground. In the future, will even more come to light? Writing in early 2021 arrives as an admission of blind spots, a girding for the blow, still a chance to recover something else.

The tags at the bottom of the mural are balanced visually if not politically by these boats painted above in the blue night sky with its white stars of spirits. The original artists of the monument made these boats transparent to carry <u>these sixty souls or more</u>.

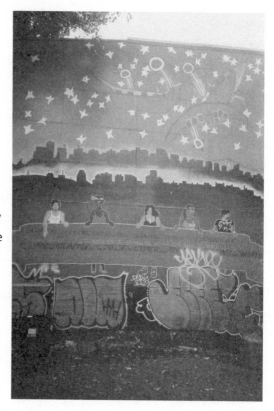

<u>these sixty souls or more</u> I wish I knew their names. I wish they were still in this world today. I rebuke the people and systems that robbed the world and took their lives. I pray their loved ones found balm. I hope their spirit journeys were smooth and that the stars gleamed as bright as they looked on the wall.

33

The rain clears and I go to the public space in front of the Montreal Contemporary Museum of Art. All of a sudden it is bright and sunny and I actually pull out my computer and start to write all this down. I look at a man take off his socks and use them as a pillow, lay back and dangle his feet in the fountain. I see young people fooling around. I am determined to remember all of it. As much as I can. _Never forget._ I still feel outrage and sadness, but I feel happy too, happy that I got to see that mural and think about all this and that there is something for me to do.

I would buy a cheap camera and go back there and take pictures. I would come to perform my own commemorations and aim against defacing. I would look at things, spend time really looking at them and think about them, and try to remember them in multiple ways so that when they become faded and forgotten, overwritten or conscripted, something still will have penetrated to my bones.

_Never forget._ We will always forget. It will always slip our minds how the world really was, even the times we lived through, maybe especially those times, because how could we hold the enormity of everything that happened on any given day, the names we used for things, the names we didn't know, the tugging on our heartstrings, the funny tattoos, the silences, the mistakes, the things we let slide, our projections, our aspirations, what we'll come to regret, what actually crossed our paths or our minds? At Bard, that summer studying memory in Language & Thinking, we learned that you actually have to forget in order to remember. Similarly, we will always have to be reminded of the dreams we had then, and what we imagine we're doing now.

*Afterimages*

When I mention the ravages of now, I mean to say, then.
I mean to say the rough-hewn edges of time and space,
a continuum that folds back on itself in furtive attempts
to witness what was, what is, and what will be . . .

—*Airea D. Matthews*

# these bodies don't touch

the way those glass
vessels hang in space
out of reach
in the art museum
in portland

it's raining outside
the day after
valentine's day
and as usual
i'm alone

yesterday
i went to the spa
a splurge!
to pay for
ninety minutes
of touch

now i'm here
for du bois in paris
in 1905 his images and
infographics show

black people in a past
we can't touch
but feel every day
in our bones

on the way
these glass
talismans
catch my eye
artifact panel
by william morris

i'd never heard of it
before but still
it makes me
linger

how something
can stay safe
without touch
how breath
hardens into bubble

i should have
known then
this world would end
the signs were
everywhere

i was living
in a bubble
so what's new
now in a
magnetic field

if a body shimmers
with no one
there to touch
is it really a body
at all?

half-life gleam
these bodies don't touch
but arrive
in other ways
enclosed and exuding

this tumbled from dreams
washing and washing
my hands
with my mother
right there

we don't touch—
but then, I'm in jail—
with transparent bars
still made of steel

*in this dream*
*i have Xs*
*where my breasts*
*should be*

i exist in an
isolation chamber
cooped up stir-crazy
cabin fever
house arrest
lockdown

stop using
carceral metaphors
when you don't know
what the fuck
you're talking about

in solitary
confinement
the one white student
in my prison class

practiced
transcendental
meditation
for hours

this
earmarked
him as
college
material

when he says
don't get it twisted
a lot of fags are strong
i say hey! in this space
we don't use that kind
of language

which language
bubbles up inside
or lives in a bubble
trapped in a closet
which words
can't we touch?

in the secret
garden (closet)
i never touched
the audience
sitting on my bed

i only
remember
disguising and
shedding skin
my language
of desire

who
actually
chooses to live
in a bubble
self-isolation or
self-quarantine

jayy dodd
tells our class
this isn't the first long
stretch she hasn't
been touched
me either

a black woman thing
donna summer
turning into a machine
doing the robot
and i feel
love

in her talk
kara keeling shows
us this footage and that
part of arthur jafa's film
love is the message

the message is death
where the stripper
explains her body
is her work
place another
black woman thing

now
we don't work
from home
if we're lucky enough
to have one instead
we live at work
stuck inside
a body

in fuck painting #1
we see the balls
and cock inside
the cunt but no gloves
or fingertips

i saw this
at the pompidou
in paris years ago
but wasn't allowed
to touch it
the painter

betty tompkins
used a spray gun
to make this flesh
so she didn't
touch it either

this tumbled from dreams
my skin erupting
into flowers
like ana mendieta
on a postcard
on my fridge

pandemic
social distance
flatten the curve
these words like bodies
were once new

and wearing gloves
to hold an apple
in the grocery store
and keeping the world
at arm's length

and tiger king
which made me
feel so dirty
and freaked out
and never-ending
streaming

moe! moe!
there's a pain
in my chest
and i can't tell is it
a lump in my breast?
what should i do?

we face time
can you look at it
right here zoom
in closer right here
squeeze
and pinch
the swelling

42

the weight
of my breast
in my hand
send a picture
he says without
touching it

is this the curve
to be flattened
not the virus but THIS
will this be
how i DIE?

RAGE
at the talk
of a new epidemic
what about the epidemic
of rape the epidemic
of opioids the epidemic
of hunger of black people
being killed by the cops

and the birds now so
loud like buzz saws
a cross between
church bells and alarms
full-throated singing
of what was drowned
out before

release
nonviolent
offenders
reduce carbon
emissions
de facto
enact
the new
green deal
everything

impossible
now
happening
instantly

SO THIS IS WHAT
you motherfuckers can do
when you decide
something actually
MATTERS

ghoul me mask me
take away my breath
take away my art spaces
take away my walks
take away my bougie
black privilege
double down on my exile
take away my yoga class
my only chance for touch
remove any gentle
correction

dennie says
gabrielle
you're not taking
this seriously
thousands of
people are going
to DIE

and i feel like
an asshole
caring about
my art body
my schedule
my mental health
and i feel ashamed
and punished
for my lonesome life

then she says
I'm so proud of
mike dewine
for what he's done
here in ohio—

and i know
something must be
wrong with my ears
because my dennie
ardent protestor

with her
BLACK LIVES MATTER
sign held high
would NEVER say
such a thing and i say

I WILL
NEVER BE PROUD
OF MIKE FUCKING
DEWINE FOR WHAT
HE HAS DONE IN OHIO

in this bubble
of time after
relentless siege
before uprising
i will never forget

tamir rice
shot dead
at twelve years old
in a cleveland park
john crawford iii
shot dead
in a beavercreek
walmart
the cops who did this
were never touched

and neither was
ronald ritchie
who called 9-1-1
on john crawford iii
who was just

a black man
in walmart on the phone
with a toy gun for his son
in his hand

when our protest
letters arrived on his steps
attorney general
mike dewine
refused to touch them

and the week before
cops shot john crawford iii
my student leo
went to that walmart
to make a public
performance
for my class

in an aisle
of that walmart
leo got down
on his knees
and prayed

when
the walmart worker
came to see
if leo was okay
when
the walmart manager
came to take him away
they never touched
him either

what does it take
to be untouchable
or to be touched?
what could it mean
to burst the bubble?

tehching hsieh
and linda montano
lived for a whole year
tied together by a rope
and the whole time
they never touched

did they love each other
were they even friends
without touch
what other kinds
of proximity
can emerge?

this tumbled from dreams
memories of fucking
over and over
to janet jackson's
i get so lonely

living single
independent
grown ass
woman
untethered
shut in
shut out
shut up

you may not
see the tether
loose or taut
but believe me
it's still there

in her talk
lisa nakamura
discusses
a virtual reality
game for people
to know what it's like
to be a black woman

wow
how touching
the game designers
market this as a way
to gain empathy
contact free

clearly this game
is not for me
because
i already embody
the sensation

on the sorority
prayer call each week
we're supposed
to stay silent
but our voices overlap
in a din

every time we arrive
when we get on the line
we still say our names
and i think this is
the prayer

keeping in touch
vibrating shimmering
resolute radiation
black aliveness
ready
to feel

# Tourist Art

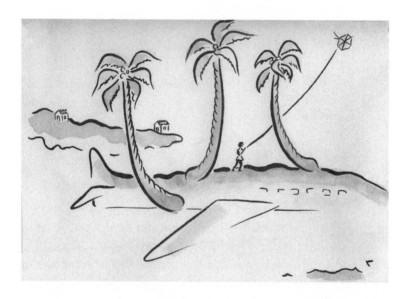

You are welcomed as if straight off the plane. Two black women, one light, one dark, in deliberately folkloric garb—bright colors, long skirts, and beads—beckon you with nostalgic Caribbean strains. One stands still. The other moves slowly, almost imperceptibly, and then gains momentum. Harry Belafonte croons, "Haïti Chérie says Haiti is my beloved land . . ." Very slowly, projected

writing, darker gray on gray, scrolls up a screen. Quotes by Veerle Poupeye and Frantz Fanon compose themselves. Fanon marks the turn: "and these outer garments are merely the reflection of a hidden life, teeming and perpetually in motion." The tableau vivant breaks with the sound of Haitian cha-chas and sticks. Vladimir Cybil Charlier's images shift as slides. My words ring in the air. *This is not the usual presentation of knowledge.* This is performance. This is how it always begins.

take the art tour
to jacmel air stream to boston
donkey hoof to port-au-prince
shark raft to montreal
cracked foot to cap-haïtien
tap tap to brooklyn dark
limousine aux cayes
visa to miami shot
to croix-des-bouquets
return
tracery of tourist art
itinerary en route

One summer, I traveled to Santo Domingo to show a section of my performance art work *Anacaona*. I was thinking a lot about embodiments of history, aestheticization, and what I was calling *figures of self*. How does a self get constituted in a body? How can we recognize and activate our own representations? It was my first time in the Dominican Republic, and Haitian art was everywhere. Canvases were stacked in markets like fruit, hung in stalls with T-shirts and magnets. The same impossible forests. The same replicated images of market women. Who was painting them? What selves did these figures represent?

When I got back home to the U.S., those Haitian images kept floating in my head. What does it mean to buy a souvenir of a place outside of that place? What does it mean for Haitian art to have more value and mobility than Haitian people? I started writing a long poem called "Tourist Art" to figure out these questions.

in the market
effusion, emulsion, florescence of art
dead wood sculptures with death grip smiles
big-dicked warriors with casket-like shields
flip-flops melting in the sun and these
landscapes of higglers, angular gourd men

in the market
in santo domingo,

a voice-over in english,
*welcome to the colonial zone*
the tourist kills two birds with one stone
gets taino dominicans and voodoo haitians at once
gets white sand and black magic, an all-inclusive resort

A few months later, *BOMB* magazine dropped a special issue on Haiti. In it, my grad school friend Jerry Philogene had penned a feature on Vladimir Cybil Charlier. Born and raised in Haiti and based in Harlem, Cybil plays with iconography in her art. For *Ogoun X,* a large painting in her Panteón series, she transformed the African American hero Malcolm X into the Haitian vodoun spirit Ogoun. She often mixes high and low visual references and explores the romantic imagery found both in Haitian masterpieces and tourist souvenirs. In her Time Life Jungle series, Cybil drained stock scenes of their color, rendered them in wavy lines of black ink, and then inserted a bright cartoon in the frame. In an impossible Haitian jungle scene, you now find Garfield, Snoopy, or Dumbo. This was true dyaspora art, synthesizing Haitian culture, pop culture, and commercial symbols of globalization. Her work was super bold and shot with wit. I loved it! Like me, she was reconsidering *figures of self.* Through Jerry, I approached Cybil about a collaboration. To my delight, she agreed. *Tourist Art* was born. We combined my poetry with her drawings and watercolors. We deliberately produced a fine art book in cheap, mass-market form.

hands down

the haitian crap beats the dominican crap

hands out    hand outs

the expatriate art dealer says the higher grade

stuff takes a trip over the border

her man wants more money

hardly worth the trip. it's more than a gift to sell

tourist art is always selling

\*

If you haven't seen much Haitian art, you have something wonderful in store. Look up the work of Vladimir Cybil Charlier, Edouard Duval-Carrié, Rejin Leys, Jean-Michel Basquiat (he counts too), Tracy Guiteau, and Franketienne (read his books while you're at it). These artists are more new school. The old-school masters set the style. Their work became the blueprint for Haitian tourist art later circulated worldwide. At this point, Haitian painters from the 1940s and '50s like Hector Hippolyte, Castera Bazile, Rigaud Benoit, and Préfète Duffaut, and Haitian sculptors like Jasmin Joseph and Georges Liautaud receive worldwide recognition. Their art fetches high prices on the global art market and lives abroad in museum collections. The average U.S. tourist on a cruise to the Bahamas will likely not know the names of any of these artists but will encounter multiple rip-offs of their work at local markets. If only it were as easy to bring a Haitian person back to the U.S. as to bring a knock-off Haitian painting. Go ahead. Buy it. Bring it back. Take it home and hang it up in your kitchen.

along with rum and poverty, tourist art
is a mainstay of the haitian economy
elsewhere, in museums, hector hyppolite,
wilson bigaud, pétion savain, préfète duffaut,
castera bazile, luce turnier, rigaud benoît
serve counterpoint to anonymity
tourist art as flattery
exile, the highest form

<center>*</center>

Three standard scenes exist, Cybil explains to me: the market, the forest, and the vodoun ritual. I've seen them all many times in and out of Haiti. The market painting usually features a grid of kerchiefed women and baskets, sometimes with donkeys, often with vegetables and fruit. The forest painting shows impossibly lush and verdant foliage. Incongruous with actual, extreme Haitian deforestation, this scene teems with oversized flowers and endangered jaguars and leopards. The vodoun ritual painting swirls with motion and sacrifice. People are dancing, mouths open as if chanting. Bottles, rattles, vèvès appear. Sometimes lightning strikes or Boukman holds up a knife to slay the pig and start the Haitian Revolution.

As an art student in the United States, Cybil learned a Western visual vocabulary. She confronted and studied the Haitian visual vocabulary on her own. Early on, she decided to isolate and replicate a system of forms in Haitian folk art. Images in Haitian masterworks by Hippolyte, Liautaud, Duffaut and the rest have distinct lines, curves, and strokes, she says. These form the Haitian women with baskets, the donkeys and trees, the initiates dancing in ceremony. Cybil's eight-foot-square painting *Bubblegum Haitiana* becomes a primer for the Haitian system of forms. She deconstructs masterful lines of tourist art into distinct, delicate strokes.

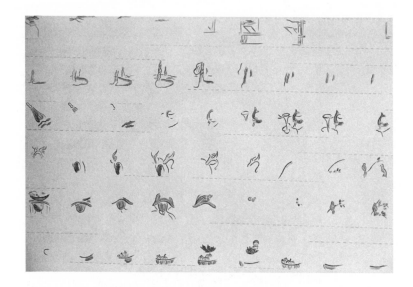

tourist art is anachronistic. tourist art is historical.
tourist art is nostalgic. tourist art is timeless.
tourist art is mnemonic. tourist art is native xerox.
tourist art is anachronistic. tourist art is historical.
tourist art is nostalgic. tourist art is timeless.
tourist art is mnemonic. tourist art is native xerox.
tourist art is etcetera ad infinitum repetition
past present and future. amen.

In *Tourist Art,* Cybil also incorporates deliberate homages to Haitian masterworks. She inserts my face into Hippolyte's painting of the vodoun spirit *La Sirène.* In her version, my mermaid's tail becomes an unfinished paint-by-numbers. She inscribes her own face into Castera Bazile's famous portrait of Henri Christophe, the Haitian revolutionary who became the only king of Haiti. These gestures resemble the playful insertion of cartoon characters in her Time Life Jungle series and the synthesis of dyaspora iconography in *Ogoun X.*

*

every year
my father
brought back
more and more
decorative survival.
different color schemes
endless proliferation
unredeemable dreams
tourist art
as presence of absence
in my childhood
more art than we could hang

Haitian art was everywhere in my house growing up. We had wood carvings, metalwork, tablecloths, knickknacks, and especially paintings. The paintings fell into two categories: souvenirs from my father's summer trips back home and relics from the early days of my parents' marriage. "These paintings are the real thing," my mother proclaimed. "We purchased them from galleries." So the paintings became airport paintings and gallery paintings in my mind. That could have represented low and high art for me growing up, but that didn't really stick. Real and fake, valuable and cheap. As a dyaspora, that kind of thinking was dangerous. What made something precious or authentic? What made a Haitian painting or a Haitian person real?

Airport paintings were bright, cheerful, and decorative. I didn't think of them as tourist art because my father wasn't a tourist. He was an emigrant, an expatriate, or maybe an exile. The flat surfaces of those paintings exuded orange, yellow, and green. They imbued a room with Haitian identity. For me, this was comforting, but also a little challenging. They reminded me of my pride and my ignorance, my belonging to something that I might never really know or understand.

Gallery paintings weren't cheerful. They sported a more somber palette: brown, blue, gray, and white. Their surfaces were textured, thick with oil. Because my parents are people who decorate a room once and then maybe change one aspect thirty years later, the three gallery paintings from the 1970s still hang on the living room wall. One painting especially captivates me. It shows a house in a clearing surrounded by trees, a couple figures on either side, and a woman with a kerchief wrapped around her head walking away from water, or maybe walking toward me. I have spent hours, probably days, staring at this painting over the years. So how come I can't remember if she's walking forward or backward? Something about this painting is unknowable. You have to keep looking at it even to catch a glimpse. I used to believe it was from Narnia. You know, like how they travel through the painting to get back to

Narnia in *The Voyage of the Dawn Treader*? Haiti as Narnia. Except now, I would say Haiti as Wakanda.

*

sublimated.

deferred

delayed

desire.

My knowledge of Haitian art started with my father, but my introduction to Haitian art history started with Selden Rodman. He was a prolific white U.S. American writer who came to Haiti in the 1940s and fell in love with Haitian art. For some people, his 1948

book *Renaissance in Haiti* put Haitian art on the map. (By some people, I mean non-Haitian white people.) His 1988 book *Where Art Is Joy*, an account of "Haitian Art: The First Forty Years," was the one I knew.

My mother gave me this book as a gift for my seventeenth birthday. We found out about it after spending a special Saturday afternoon together at the Detroit Institute of Arts. Rodman himself was there to lecture on the Haitian art works in the collection. It was a wonderful afternoon. Rodman was old, a little shrunken, but still animated with passion about these paintings. He seemed down-to-earth and funny. At first sight, I thought maybe he was Haitian because I didn't know who he was when we showed up and many upper-class Haitian people are bright (even my own African American godmother Liz was very pale with freckles and could probably have passed for white if she had wanted). Quick enough though, Rodman's identity as a white American came through. But here's the thing, and something I love about the Kingdom of Detroit: that afternoon was not suffused with whiteness.

The museum crowd at the DIA was notably black. The event was likely sponsored by the friends of African American art club at the museum. There had to have been some white folks there. It was a museum after all. But what I remember was an African American crowd admiring Haitian art. I strolled through the exhibit with my African American mother, swelled with pride and hyped on Haitian heritage outside of our home.

My mother must have seen my eyes light up when Rodman mentioned *Where Art Is Joy*. Receiving the book for my birthday was a wonderful surprise—it was one of the first art books I ever owned! I loved poring over the rich colorplates, learning about Hippolyte, Bazile, and my favorites: Turnier and Duffaut. It made my chest swell to know that their work was seen and respected (and validated) by international critics, circulated and collected by international patrons and museums. I keep the book now in my bedroom

with other precious possessions. You can trace my desire to make *Tourist Art* back to this first gift.

> tourist art is always selling time
> those dream manufacturers they are not naïve
> they allow you what you long for: paradise
> servile and slow, what you know must be
> and has never existed, a souvenir
> of *haïti chérie* where art is joy

<p style="text-align:center">*</p>

*Where Art Is Joy* accomplished some other remarkable things for me as a young dyaspora. Haitian art became something serious and important, not just at home—something present for my family, a present from my family, a presence of my family so far away and close—but something with established outside value, something valued by outsiders, people living outside Haiti, insiders of the international art scene. I had never seen Haitian art *written about.* Or anything about Haiti outside of my family being associated with something rich, valuable, and happy: *joy!* This shifted the discourse radically from what I heard on the news or in other parts of my life. It was always voodoo dolls, Papa Doc, Baby Doc, boat people, body odor, and especially "Haiti's last name" or what Haitian journalist Joel Dreyfuss calls "The Phrase."

> the poorest country in the Western hemisphere
> the poorest country in the Western hemisphere
> the poorest country in the Western hemisphere
> the poorest country in the Western hemisphere
> the poorest country in the Western hemisphere
> the poorest country in the Western hemisphere
> the poorest country in the Western hemisphere
> the poorest country in the Western hemisphere

the poorest country in the Western hemisphere
the poorest country in the Western hemisphere
the poorest country in the Western hemisphere
the poorest country in the Western hemisphere
the poorest country in the Western hemisphere
the poorest country in the Western hemisphere

# ALL RIGHT WE GET IT

\*

tourist art is always selling timelessness
the story of the travel the tourist wants to tell
not the stinging cloudburst but the cobalt sea
not the stench but the deep burnished kiss
of the sun, not the hawkers, but the barefoot
children dancing for coins. at once, the place
disseminates itself as a story you want to tell
your story displaced, a beautiful lie
evacuated, remote from customs threat
no clairin no flies no beggars no misery no bones

\*

Haitian art history started for me with Rodman. Where did it start
for him? The answer is DeWitt Peters, a white U.S. American con-
scientious objector to World War II who arrived in Haiti in 1943.
With the donation of a building by the Haitian government in 1944,
Peters founded the Centre d'Art d'Haïti and inaugurated what some
consider to be the golden age of Haitian art. (I think we're living
now in a golden age of Haitian art, but nobody asked me.) In 1947,
Rodman joined Peters as codirector of the Centre d'Art. Moreover,
in his books, Rodman has contributed to the notion of Peters as the
"father of Haitian art."

In *Where Art Is Joy,* Rodman recounts a familiar origin story: "DeWitt Peters, an American watercolorist teaching English on a wartime assignment who had wanted to start an academy where Haitians might learn to be artists, was about to receive the surprise of his life." Peters dreamed of teaching Haitians to be artists. The "surprise of his life" was that Haitian artists already existed.

# DUH

I APPRECIATE YOU
SELDEN RODMAN
CAUSE I MET YOU WHEN
I WAS 17
AND YOU WERE NICE BUT
HAITIAN ART
WAS NOT DISCOVERED
BY A WHITE MAN
FROM THE
UNITED STATES

Michel-Rolph Trouillot says: "The story that Haitians had to wait for Mr. Peters to discover their hidden talent is just one more story of arrogance."

Veerle Poupeye says: "Philomé Obin had been painting for some thirty years before he joined the Centre d'Art."

Daniel Simidor says: "[A] number of Haitian artists initially involved with the Centre d'Art have stated emphatically that they knew quite well what they were doing, and that they did not join the Center to learn how to paint but mostly to get a 'good price' for their works."

Nevertheless, a quick internet search on Haitian art today will turn up multiple sources repeating the story of Peters "discovering" Haitian art. No Haitian intellectuals or broader Caribbean or black diasporic intellectual, social, or cultural movements turn up with the same frequency as Peters' founding of the Centre d'Art. The story of the white male U.S. citizen discovering primitive Haitian artists has been simply too appealing to resist. The counternarrative of Haitian artists and intellectuals mobilizing their own vision, talent, and cultural nationalism is far less marketable. Shortly after Peters died in 1966, the U.S. ambassador to Haiti, Benson E. L. Timmons, remarkably declared, "If DeWitt Peters had not existed, it would have been necessary to invent him."

in 1943,
dewitt peters too sailed the ocean blue
not long after, selden rodman came too
they founded the *centre d'art d'haïti*
and saw primitive beauty as far as they could see
a new world for you, new markets for me
tourist art fabricates this discovery endlessly

\*

## *duty free consumption*

\*

tourist art is always selling time.
wood carvings, figurines, postcards
of sans souci. in santo domingo,
viejo san juan, nassau, brooklyn,
miami, detroit, in holes in the wall,
tourist art by haitians doesn't need haitians at all.

Developing *Tourist Art* with Cybil as a fine arts book into per-formance lecture into essay, I learned a lot about the production and circulation of Haitian art. Erin B. Taylor's work in economic anthropology shed new light. In her essay "Markets as Cultural Intersections I: Reflections of Nationality in Haitian and Dominican Paintings," Taylor clarifies the current conditions of production for most Haitian tourist artists:

> Most paintings sold on the street are close copies of each other . . . painters are wage labourers who are paid a fixed amount to produce art on a mass scale. They do not own the means of production—paint-brushes, can-vases, wooden frames, or a workspace—and their work-flows more closely resemble an assembly line than an artists' studio.

This mention of an assembly line makes me think again of my hometown, Detroit. My Uncle David would talk about the qual-ity of Chrysler cars with a sense of pride and ownership because he worked in the plant. Could the value of Haitian tourist art paint-ings be something like this for the artists who actually made them? What does it mean to be an artist in this way? How do these cul-tural representations intersect with personal artistic tastes or ten-dencies? Do the tourist artists like these paintings? Do they connect them to their own sense of *figures of self*?

*

tourist art as labor, market flood space
i want to imagine her spreading color
as more than a chore, that sweatshop artist
prettying up the line. the market arrays her,

displays her, frames her, invisible, displaced
could she smuggle home paint, add flour-
ishes, sign her name in some trace, unresigned
tourist art as self-portrait unsigned
basket women about face

*

Flashback: the past creates the present. Taylor links contemporary Haitian tourist art to the Centre d'Art: "During Haiti's 'golden age of tourism' after World War Two. . . . Peters commissioned wage labourers to reproduce the most popular styles en masse, and thus an art movement was born." Or maybe an art factory sweatshop.

Jamaican art historian Poupeye adds:

> The relationship between Caribbean tourism and art has always been uneasy. Haiti, in particular, has had art tourism since the late forties when its "primitive" school came to international attention . . . [C]heap mass-produced Haitian paintings can now be bought as souvenirs throughout the Caribbean. While this extreme commercialization is culturally deplorable, the demand for such Haitian art has provided employment for thousands of people, something that cannot easily be dismissed since Haiti is the poorest country in the Western hemisphere.

Yet again, the phrase even from Veerle! But I guess you could say that even Cybil and I use the phrase because this quotation, along with one from Fanon, graces the cover of our book *Tourist Art*. While she decries "extreme commercialization," Poupeye explicitly links this art-making to the survival of Haitian people themselves. Haitians make a living from this work; they make this work in order to live. In other words, in order to eat, Haitians have to

be eaten, consumed in the art market as cheap, mass-produced souvenirs.

> tourist art opens to the space of the grid
> not just the dense and rootless squads
> of women vendors with overripe fruit
> in weightless baskets, walking or standing
> one after another, again and again, peasant
> men and donkeys, haitians walking in place
> waiting to travel to the money embrace
> standing still, omnipresent, erased. tourist
> art as static market performance infiltration
> dissolution, consumable, inhabited space

*

# *a tour de force*

*

A photograph in Taylor's essay sends a shiver down my spine. At a market in Santo Domingo, a young black woman examines a wall of Haitian tourist paintings. This becomes a surprising *figure of self.* Was she a tourist? Was she dyaspora? Was she me?

> in santo domingo,
> the haitian works win the war. not just
> because i am mad at the roads and the lights
> and the toilets and the power. but everywhere
> looks reveal this: my haitian eyes undisguised
> imagination unrealized, *dyaspora* identity
> in crates. unstoppable reproduction
> tourist art for freight

*

To paraphrase Jayne Cortez:

You want the art but you don't want the people. You want the art but you don't want the people. You want the art but you don't want the people. You want the art but you don't want the people. You want the art but you don't want the people. In *Tourist Art,* Haitian market women sell baskets of paintings whose canvases are notably blank. This reverses the actual dynamic. Haitian market women are omnipresent in paintings, but have restricted circulation in the flesh. In *Tourist Art,* Haitian market women operate in a system of visual forms, poetic language, economics, and global relations. They are caught in the system but have agency too. Souvenirs move from the baskets on their heads to the ground to find their way into suitcases, onto jet planes, inside limousines, on kitchen and living room walls, moving from Jacmel, Port-au-Prince and Cap-Haïtien to Nassau, Miami, Brooklyn, Detroit . . .

> in the market
> the basket women are walking away
> endless kerchiefs and multiplied skirts, proliferated hands
> on hips, brown napes and legs

        they are walking past
eroded paths, across regenerated land
sun and streams, with impossible jaguars and leopards
resplendent population
they make an indomitable grid
        they are retelling, reminding at the register
you want us as background souvenir
we slip in as tracery, alluring, unsettling
you cannot keep us out

# The Spring Tour

*(how to retrace what was never preserved)*

(The stage)
I'm so sorry I'm late—oh dear, I can tell you've been waiting.
I'm new. I'm new. So gather round.
Yes, now, don't be shy.
We are on a schedule. Yes, Yes.
The work is fragile—so no cameras allowed.
But you'll need your valuables.
YOUR EYES YOUR EARS YOUR NOSE
YOUR TONGUE YOUR FINGERTIPS
Wait, does everyone have them? Or as many of them as you can?
YOUR EYES YOUR EARS YOUR NOSE
YOUR TONGUE YOUR FINGERTIPS
Okay—let's go now. Please follow me.

\*

(The gallery)
Welcome to the Spring Tour!
As I mentioned, you are my first group with this work.
The work changes, of course, so every group is the first group.
And I am always new.

\*

[*She consults her notes. She clears her throat.*]

*

What a great pleasure it is for me to take you
on this expansive exhibit of the great artist.
Before we begin, here are some things you should know:
1) She was born as a surprise to herself and everyone else.
2) Despite an allergy to snow, she lived in Minnesota
for a large part of her early adulthood.
3) There, her addiction to audience participation
got her into a number of serious scrapes.
4) As you can tell by the work, in winter,
she often felt like giving up.
5) Major Influences were Yoko Ono, Ruby Dee,
her mother, and the theme song to *Fame*.
    [*She bursts into song.*]
*Fame! I'm gonna live forever . . . I'm gonna learn how to fly. Hiiiiigh!*
    [*She recovers. She clears her throat.*]
6) Recently, we've learned that almost all of her planets were lined
up in the sixth and seventh houses—you know, work, community,
and relationships.
7) She owed money on her income taxes every year until she
declared she was a poet and a performance artist, and then the
government considered that money contaminated, counterfeit.
    [*She spits.*]
The feeling was mutual.
8) At the end of winter, she found creative ways to combat
disembodiment.
9) She went for long periods without being touched.
    [*She pauses. She holds, unholds her breath.*]
10) The bathrooms are out that door in the hallway on the left.
If you get lost, follow the circle back to the beginning.

*

Any Questions?
Let's move on.

*

(The front foyer)
Now hold out your hands.
This was one of her first patented holographic machines.
Here she combined her interest in fancy handbags from Amsterdam
with science and the work of Cuban American artist Félix
González-Torres.

*

[*She consults her notes again.*]

*

According to my notes, here's how it works.
⇨ LEMON DROPS
[*She passes around a drawstring bag.*]
Take the holographic spark and put it in your mouth.
Close your eyes. Let the machine work.
Isn't that a beauty?

*

(The hall of wonders)
[*She turns off the lights in the hall.*]
⇨ FLASHLIGHT
Here's a piece of video. Let's watch it for a minute.
It's called the future.
[*A video plays of her romping in the snow.*
*She finds a yellow sled. She walks toward the river.*
*She takes off her coat to reveal bright yellow garments.*
*She picks up a bouquet of flowers covered in plastic.*
*She removes the plastic.*
*She throws the yellow flowers into the river.*
*The video ends.*
*She turns off the flashlight and turns back on the lights.*]

*

Next is a classically inspired work.
Its shape is drawn from a CARYATID.
[*She stands on a folding chair,*
*holds a plastic jug of water on her head.*

*She stands still there for a while.*
*She speaks out while standing still.*]
The great artist never went to Greece—but
she did look through a book of photos by Lorna Simpson.
("they asked her to tell what happened,
only to discount her memory")
Ah! If only she could take snapshots of the world
as it was instead of how she wanted it to be.

*

[*She pulls the jug down, places it to her mouth, tilts back her head,
and drinks it in fierce gulps. She steps down, places the jug on the chair,
and looks at it with the group.*]

*

This piece is called *Admiration*.

*

[*She walks a few steps to find a* SNOW GLOBE.]

*

This piece is called *Memory*.

*

[*She shakes and turns the machine.*
*A tinny version of "The Locomotion" plays.*
*Many are with her. Many with her are still.*]

*

Does anyone here have an environmental illness?
CAN YOU ALL STILL STAND TO BE HERE?

*

According to my notes, this has been a very controversial piece.
This piece is called, *I wandered lonely as a cloud.*

*

[*She sprays* PERFUME.]

*

We see the influence of Yoko Ono and the ladies
at the cosmetic counter consulted in time of winter blues.
Some say it's about consumerism and mass production . . .

But I think it's about skin and reconciliation with loneliness.
Others have commented on the appropriated title
from William Wordsworth—A DEAD WHITE MAN.
Could it be irony? Or simple statement of fact?
I wandered lonely as a cloud.

Shhh. Let me tell you a secret. In a conversation—
over G&Ts and a mirror one night, the artist told me
instead it was about a warm towel on a lawn in Detroit,
seeing wisps in the shape of gold chains and catfish tails,
an isolation of green. Fresh a r o m a s of the season!

　　　*

[She has become excited and has to calm herself down.]

　　　*

(threshold back to the stage)
[She is very serious.]
This last piece has been called many names.
Stop and Seek.
TOUCH PIECE TWO (after Yoko).
I like to call it Hold.
Although some have deemed it indulgent—
a breach of personal and artistic space—
the great artist swears her intent is no less
than to welcome the possibility of spring.
The work has been known to treat
the ache of social alienation.
To experience it, an open secret,
come now, each of you, into my arms.

　　　*

[She takes them, each and every one, into her arms.]

　　　*

Thank you for visiting the Museum.

*Black Dreams*

Climb
into a jar
and live
for a while.
. . .
Your spine is
a flower.

—*Rita Dove*

I've stayed in the front yard all my life.
I want a peek at the back
Where it's rough and untended and hungry weed grows.
A girl gets sick of a rose.

—*Gwendolyn Brooks*

# ( Banana Traces )

In January 2008, I delivered a speech about dreams at the College of Saint Catherine in Saint Paul, Minnesota. I had been a professor there for eight years, landing the year before 9/11 and the start of the war in Afghanistan (still waging). I already identified as a black woman poet and was just starting to dream into performance. I arrived with many dreams.

> I dreamed of
> connecting the dots between art and life
>     and poetry and performance
> having many kinds of lovers
> being an ethical slut
> traveling the world
> going back to Africa (for the first time)
> improving my Kreyòl to be less embarrassing.
> speaking at least as many languages as my father
> publishing my translation of Jacqueline Beaugé-Rosier
> being well-dressed, well-groomed, well-paid, and well-loved
> being in love and having someone love me back
> maybe having babies

paying off my credit card debt
becoming a DJ
having my first book of poetry by 28!
taking the world by storm
writing plays
writing many books
finding my people
following Josephine Baker's banana traces in Paris

Being a professor was never my dream. I figured by working at St. Kate's for a year or two, I could get my financial ducks in a row and then follow Josephine to Paris. It didn't quite work out that way.

*(I could tell you how it started / How did it start?)* Education is big in my family. Both my parents are teachers. My father has taught French and Spanish for decades at a Catholic high school. My mother taught elementary science for twenty years before moving into administration. She ended up principal (or as she explained once to me: the *principal* teacher) of a Detroit public elementary school for another twenty years. (The motto of her school was "Where Dreams Become Reality." Was this a blessing or a curse?) She then served as an educational consultant before finally retiring. My mother's aunt Harriet in Athens, Alabama (called Sis by everybody), was also a teacher and ran a school. On the Haitian side, both my aunt and uncle became teachers. My aunt Ginette has run a well-regarded primary school in Pétion-Ville for decades, at times running her into political trouble. Furthermore, while I never call myself an academic—identifying far more strongly as an artist, performer, poet, and writer—I have to admit that I've been a college professor for twenty years!

This blows my mind, although I guess it shouldn't. I grew up playing teacher with a real live chalkboard in my bedroom. My stuffed animals would play my students. I'd read them "The Sugar-Plum Tree" by Eugene Field from the *Childcraft Encyclopedia: Volume 1 Poems and Rhymes*. Then we'd discuss the delicious images. At the

dinner table, my parents would talk shop sometimes, lesson plans, grading, funny things that happened at school. Every Christmas, students gave them mugs full of candy and packets of Swiss Miss instant cocoa and other tokens of appreciation.

I was no slouch as a student either, if I do say so myself. After reading 105 library books to win the kindergarten reading contest (I still have the certificate), I skipped the first grade. Add to that my late birthday (October 12), and I was always the youngest one in my class. I went to high school at twelve, graduated at sixteen, graduated from college at twenty, and earned my PhD at twenty-five. From the fourth grade through high school, I went to predominantly white Catholic schools and learned about code-switching, connecting, being overlooked, hiding in plain sight, and shining. Pretty much in that order.

While fast-tracking as a student, I also unfurled as a teacher. This included: tutoring younger kids in high school and college; after college, becoming a summer tutor at Phillips Academy Andover (a prestigious and lonely experience); in grad school, serving as a teaching assistant for COPE, a college prep program for women on public assistance; and running a TA section for an Intro to Women's Studies class at NYU. Then, the real fun began. I designed and delivered my very own college classes: Introduction to African American Literature at Rutgers University - Newark and Comparative Approaches to Black Poetry at Ohio University. This was just as awesome as expected. There's nothing like the collective mind click when everyone grasps an idea together. Breath hangs in the air. Or people all start talking at once. You can literally feel the electrons buzz.

I have always loved to teach! Outside of traditional school, I have found ways to run a workshop, create a poetry circle, visit a class, give a talk. This work often happened in community spaces. Through Witness Tree, our literary arts education organization, my intrepid pals Rosa, Madhu, and I conducted poetry workshops at the Revolution bookstore and in Washington Square Park. But being a college professor was something else. Was the job cursed?

Despite having the perfect setup, nice salaries, summers off, and sometimes even subsidized housing, professors were always complaining. They whined about their students, the administration, and even each other. They often seemed miserable, beleaguered, and out of touch. Who wanted to end up like that?

I wanted to be artsy, glamorous, a free spirit. I wanted to be free. I'd been a good little black girl for so long. I'd been in school my entire life. As Gwendolyn Brooks says in "a song in the front yard":

> And I'd like to be a bad woman, too,
> And wear the brave stockings of night-black lace
> And strut down the streets with paint on my face.

Forget the academy! I'm following traces of Josephine Baker in her banana skirt to find my own Folies Bergère. I was beautiful then, although I didn't know it. (No one ever said so). My braids were long and russet, woven through with some scarlet. Plump and brown, bookish and eager to take the world by storm. Paris would be an adventure, a chance to grow up. Josephine Baker had gone there and become a black performance legend. I needed some help to get there. When the Fulbright declined to fund my application (you mean you don't want to send me to Paris for a year with zero performance experience or connections—shame on you!), I had to figure out my next move.

I was living in Ohio on a dissertation fellowship at Ohio University. (After four years as a graduate student in New York City, this place was a salvation. O to be in one piece—still broke but with a little money coming in.) In the fall, the English department had posted a job call for a professor of African American literature. Being a professor was never my dream. But in a moment of weakness, I applied for it anyway. If I really didn't want to be a professor, why did I apply for this job? Habit and training? Path of least resistance? I didn't know what else to do? It was all academic, until they offered it to me. It wasn't that I doubted that I could do the job,

more like I was afraid that I would end up doing that job over and over, that the academy would take over my life, that I'd never have a life, that I'd always be a brain and never a body.

Still, it seemed like a no-brainer. I was already teaching there, liked the students, and relished the cheap rent of my mother-in-law shack. It wasn't in the woods exactly (although a *snake* once snuck in my house). It was just remote and kind of country. On the one hand, Athens, Ohio, has no airport, train, or bus station. To me, after New York City, it felt like falling off the map. On the other hand, it would be my first real job with a real paycheck. Even with a fellowship and outside jobs, my grad school debt was hefty. News flash: New York City ain't cheap (books and groceries and subway tokens cost a pretty penny, plus an occasional Vamp lipstick or a ticket to *How I Learned How to Drive* . . .). Taking the job would help me pay down my debt, and save up to follow Josephine's banana traces in Paris.

Hold up a minute! What happened to artsy and glamorous? What about breaking away and being free? I've had so many moments like this. When the practical thing is right there in my hand, but inside me, in my heart or throat or mouth or ears, there's resistance. It feels like something else is waiting. Like if I could just let myself go, another dream might crystallize and come true.

Should I take a professor job in rural Ohio? (This question would haunt my life . . .) First, I said no. Then, I said yes. Then I said, I'm not sure. (Yes, I'm a Libra.) I'm not usually a flip-flopper. Maybe because it was my first real adult life decision. Maybe it was because I craved change but didn't know how to do it. Maybe it was because I was alone, didn't have a partner to help me think through. I just couldn't get a grip.

I went to confess my acute indecision to the chair of the English department, a nice, red-headed white man named Art Wooley who wore snazzy checked and herringbone suits. Maybe they even had leather elbow patches? (In his office, a bill from Barneys New York lay on his desk. Art Wooley believed in fashion.)

I said: "I'm sorry that I keep changing my mind about the job."

I said: "It's really wild. I'm usually not like this at all."

I said: "Kinda yes, kinda no, thank you for the offer, you all have been so kind, yes, no, I don't have other plans, yes, this was the only place where I applied for an academic job, but I feel like I need a breather after so many years of school, maybe maybe maybe maybe maybe."

Art Wooley was understanding.

He said, "Gabrielle, take a little more time. Just let us know as soon as you can."

Cue more hand-wringing and teeth-gnashing.

More stalemate and me spinning my wheels.

Finally, my friend Michael spoke up.

Michael is a gay Lebanese man from a small town in Michigan who also loved French and had a serious thing for Wilson Phillips when we met in college.

He said, "Gabby, it's been amusing watching you spin around in circles like a wild chicken. You've been so random, it's crazy. I've never seen you like this before, going back and forth, going to talk to Art Wooley. It's just a job. *You're Gabrielle Civil. Now start acting like it.* It seems like you actually don't want to take this job, so tell them no. You'll figure something else out. And if it helps, you can come live with me in the Twin Cities while you get it together. Don't worry about the rent."

(Writing this, I'm having the most intense feeling of déjà vu. Have I written this all out before? Or have I just told this story many times because it's a touchstone in my life? I've certainly rehearsed it often enough: *I'm Gabrielle Civil. Now start acting like it.* Switch out my name for yours, then repeat it. *I'm _____. Now start acting like it.* See what happens. A speech act and a spell.)

Michael's words changed the course of my life. Such a generous gift. He believed in me and saw me when I couldn't see myself. He reminded me of my dreams, who I dreamed of becoming. He reminded me who I was. More than just affirmation, he offered

me shelter and material support. He didn't just say, take the leap: he offered me a safety net. That cinched it. I turned down the job. (Art Wooley was gracious. My friends and family were supportive.) My plan was to move to the Twin Cities after graduation, work for a community arts consultant we knew, and save money to follow Josephine's banana traces in Paris. While this was falling into place, the universe had other ideas.

(remember your double take when you first saw the ad?
it all seemed so lovely! teaching black women's literature!
composition and creative writing! feminism and social justice!)

While I was scheming about getting my stuff to Mike's place for the summer, our friend Eric Leigh sent me a job posting from the College of St. Catherine, a mid-sized, Catholic women's college in Saint Paul. I'd never heard of it. It wasn't my dream to be a professor. I had just turned down a pretty good job. So why did I apply? (Sigh: overachieving black girls can't stop applying for things. Something about how we understand our value. It's a thing.) If I advanced far enough in the process, there would be a campus visit to the Twin Cities. Michael and I could scheme summer plans. We could make a run to the Mall of America or Ruminator Books (what used to be Hungry Mind and now is a Patagonia on Grand Street) and then grab a beer and beet salad, and bowl at the Bryant-Lake Bowl. It was the land of Prince, what could go wrong? (Rest in power Jamar Clark, Philando Castile, George Floyd, Daunte Wright, and too many more . . .)

You already know what happened. For all my talk about just trying to get a free trip, I took the application seriously (habit and training) and landed a campus visit. The night before the interview, Mike and I had a great time at the Bryant-Lake Bowl. The next morning, bright and early, I was ready. The campus shimmered with huge green trees and magnificent pink and purple flowers. During the interview, we talked about black women's literature and theory in the U.S. and around the world; writing across the curriculum, social justice, feminism, and the works. In the teaching

demo, I had a ball with students diving deep into Rita Dove poems. (I was very into *Mother Love* at the time.) On the tour, they showed me the successful job candidate's office. It wasn't huge but looked cozy with a window overlooking an English garden and floor-to-ceiling wooden bookshelves. "How many professors share this space?" I asked. "What do you mean? This would all be for you," they answered. Suddenly, I could see myself sitting there, clear as day, looking out the window. My last campus conversation that day was with Patrick Troup, who worked in the diversity office, one of the few black St. Kate's employees at the time. Five minutes into it, he said, "You know they're going to offer you this job."

He was right. They did. I took it.

What made this time different? It helped that Michael lived there (and Prince), and there was an airport, a bus station, and a train station. The trees and flowers, the beauty and bookshelves helped, although it all turned deathly cold in the winter, as I would soon learn. The fact that it was small, but not too small, and only five minutes away from Ruminator Books helped. The fact that I could teach literature and creative writing and composition, that they were open to creative action as research. The fact that the place seemed values-driven and those values aligned with mine. The fact that the president of the college had been the president of Marygrove College, a small Catholic women's college in Detroit that now no longer exists. This president had founded the kiddie college there, where I had taken piano lessons as a kid. That seemed like a sign. The fact that even though it was my first time there, it felt like I'd been there before.

The College of St. Catherine was a predominantly white Catholic women's college, and I had attended a predominantly white Catholic all-girl's high school. (My father taught for decades at the Catholic all-boy's high school next door, a huge reason why my sister and I went there. He could drive us to school. Notably, he was the only black teacher at either school and, I suspect for some boys, the only black teacher they ever had . . .) I had already ached in

white girls' spaces, been hidden and unseen at the exact same time, had already excelled there, been successful and celebrated. Talent and wounds emerge from the same site and I was going back for more. Why not? My coping mechanisms were already well honed. (French fries, anyone?) I knew how to make friends and protect my heart. Wouldn't it be easier to depend on that hard-won knowledge for just a little longer rather than try to grow a new skill set from scratch? I may have been dreaming of breaking free, but the familiar has a strong allure. Besides, it would only be for a year or two while I paid down debt and saved up money to follow Josephine's banana traces in Paris.

I worked at St. Kate's for thirteen years.

I never dreamed of staying in Minnesota so long. It takes a minute to get the hang of a new job and a new place. It takes time to pay off debt. Also, the more you do a thing, the easier it is to keep doing it. So those minutes turn into years.

Do I regret taking the job? Or staying so long? Some of the most resplendent moments of my life happened in a classroom in Whitby Hall. Tackling Hortense Spillers and Audre Lorde. Poring over Bhanu Kapil's *Humanimal* together. Watching light bulbs spark. Feeling light bulbs myself. Was this another kind of dreaming? I'll never forget, after spending two intense sessions discussing interracial politics in Alice Walker's *Meridian*, I walked into class and the students looked at me and said, "We're not done. We have to talk about this book more." We channeled and shared so much life force! *(I was living in a bubble / maybe a magnetic field.)*

The gender politics of women's colleges are complex. Not everyone there is a woman. Even those admitted as women twenty years ago, or a hundred years ago, were not necessarily women or might not identify that way now. Catholic identity adds another layer. I loved the Jesus statue at the top of the horseshoe driveway pulling out his own heart. The anxiety about sexuality, queerness, and reproductive rights, not so much. With that said, working in a space that centered women was deeply healing for me. Talent and wounds

emerge from the same site. So do success and sorrow. I'd come to the College of St. Catherine with big dreams and a fair number of heart pangs too. At twenty-five, I was trying to figure out how to be in my body. Radically minimizing the male gaze helped that project tremendously. Even though it was a predominantly white space, being there soothed and strengthened some denied and marginalized parts of myself as a black woman.

Some of that came from my decision to model strong female presence. My women students of all races and classes used self-deprecating language, talked negatively about their bodies, their weight, their capabilities. I decreed early on never to do that in front of them. *I'm Gabrielle Civil. So start acting like it.* If someone complimented me, I said thank you. If we had treats in class, I ate mine with relish. When a student said, "Dr. Civil, I'm not smart enough to understand poetry," I would respond, "Nonsense. Of course you are." And then we worked it out. Ostensibly for them, this modeling of strong female presence and power helped me. Along with making performance art, being in the classroom this way helped solidify my self-confidence, courage, and body love. Come to think of it, working as a professor feels like another form of performance art, a durational, embodied social practice project now spanning decades.

It wasn't all dreamy. Meetings and bureaucratic drudgery, budget crises, infighting, tempests in a teapot. Later, when the recession hit, things got more corporate and neoliberal across the board in so-called higher education. Consumer mentality started to set in. Nevertheless, it felt good to help women take themselves seriously as thinkers. I enjoyed fostering connections across multiple differences of age, race, class, religion, and sexuality. I really loved supporting black and brown women students, first-generation, working-class, and multilingual students, queer and trans students as they became more visible in the space. As bell hooks would say, this was moving margin to center, teaching to transgress. This felt like a temporary way to take the world by storm.

I say temporary because I still yearned to try something new. (I wanted to be artsy, glamorous, a free spirit. I wanted to be free.) I didn't want to be always on my best behavior. I didn't want to live in Minnesota anymore. Then, coming home on a plane from co-teaching a winter session class in Paris (!), I had a harrowing health episode. Blood clots formed in my legs and traveled up to my lungs. I ended up in intensive care. Any plans to jump ship were put on hold. I needed health insurance and care. This happened in my third year on the job, so it didn't make sense to leave. I needed to take a year to recuperate. That would be year four. If I stayed until year six, went up for tenure, and got it, sabbatical would be my reward.

So I dug in and stayed. I kept connecting the dots between art and life and poetry and performance. I tackled other dreams on my list too. My steady paycheck helped me pay off my debt. I bankrolled my weird shows (after *Hieroglyphics, heart on a sleeve*). I worked overtime and taught summers at Bard College in their Language & Thinking program and saved money to travel around the world. In my sixth year at St. Kate's, in 2006, I earned tenure, becoming one of the school's first black tenured professors at the age of thirty-two. When does a dream become another dream? That summer, I gave up my car and my apartment, sold all my furniture, and set off on a yearlong adventure. I didn't follow Josephine's banana traces to Paris. I went to Montreal, then off to Mexico, Spain, Morocco, the Gambia, Senegal, and back to New York City, and Chicago.

Away from school, my job, I felt different—more sensual, and sexy, more alive in my body. Outside of Minnesota, my black woman's body took shape, felt touch and appreciation. That year showed me wryly what my life could have been, or maybe what it could be. Then, after all that globe-trotting, I came back to St. Kate's for another academic year. It was hard. The fall was cold and drab. I could feel my body receding again to invisibility. Would this just be the same old thing? When some St. Kate's colleagues invited me to deliver the keynote address at the annual teaching and learning

conference, all of this was on my mind. It's a time capsule of a very specific time. Many of the committees are defunct and the conversations are moot. I haven't seen many of the people mentioned in years. Later that year, financial collapse would kick off the Great Recession. The next year, the College of St. Catherine would no longer have this name. In due time, I would accept another job offer in rural Ohio. (Once again, much hand-wringing ensued, but this time it led to joy.) For all the things that are obsolete, my speech still vibrates with currency. I arrived with big dreams, and still arrive with big dreams.

Time away helped me see things more clearly. Sometimes I confused my own life with the life of the institution. I poured myself into my classes, my students, academic deadlines and responsibilities. I wanted to be good, do a good job, and so didn't prioritize all parts of myself. Poetry, art, and performance were in the mix, in the classroom, but what happened to my body dreams? (What happens to a dream deferred?) I dreamed about the institution, I dreamed for the institution? Being a professor was never my dream, but I'd stumbled into a dream job, had dreamed into it, materialized some dreams through it, and wondered about the fate of others.

Had I wasted my youth by spending it as a professor?

at a predominantly white women's college?

in the Upper Midwest?

Could I keep following traces and shake my own banana skirt?

What would it mean to hold fast and break free?

# Hold Fast to Dreams: Excellence, Creativity and Community at the College of St. Catherine & Beyond

*Anne Joachim Moore Lecture*
*January 22, 2008*
*Gabrielle Civil*

----------> Threshold (pretalk soundtrack)
      "Dream"—West Indian Girl
      "Monk's Dream"—Thelonious Monk
      "Dream"—The Game

### HOLD    FAST    TO    DREAMS
### DREAM INVOCATION

1. <u>Dream Overture</u>
----------> Mini performance w/ small bubbles, bubble sword,
      and playfulness
      Soundtrack: "Dream"—Ella Fitzgerald
      playing behind these projections:

## hold fast
## to dreams

Pat Nanoff can tell you,

when she extended the invitation
for me to deliver this year's esteemed
Anne Joachim Moore lecture,

       you could have knocked me over
       with a feather.

So many others have inspired us all with their
dedication to education and social justice, their
commitment to the College of St. Catherine:
Nancy Heitzeg, Mary Wagner, Cecilia Konchar Farr,
Maggie Dexheimer Pharris, to name just a few.

Wouldn't they be better choices?

       Pat responded: "Gabrielle,

if you will forgive the religious metaphor,

you have been <u>called</u> to speak  on this occasion,
and the question

       is whether or not you will answer the call."

Well, undaunted by the religious

       and positively seduced by metaphors,

I am proud

and humbled to accept this call.

                    Still,

                         I wondered what people
                                        would think

               about what I have to say about
**dreams**
**art**

and all the rest.

               Often, I think I live in a bubble.

I open my mouth

                    and what wonders . . .

what strangeness . . .

                    a new poem:

          for one morning                    soapy
     floating

fragile iridescence

          for as many as dreaming
                              you

## 1. Introduction + Thanks

Good morning! Say it back to me, friends! *Good morning!* It is a tremendous honor for me to come before you today for the 2008 Anne Joachim Moore lecture. Let me begin first with a note of thanks. To Pat Nanoff, the AJM and TLN Steering Committees, and the many people who contributed to this talk: Anne Joachim Moore herself, for her shining legacy of commitment to education and social change; prior lecturers Toné Blechert, Sharon Doherty, Mark Nowak, and Bill McDonough for sharing with me their words; Rollye Winnig in Minneapolis; my technical experts Kendra Graper, John Lange, and Gina Dabrowski; Sarah Berger for her hospitality and friendship; and a special thanks to Robert Grunst for his kind introduction. Along with him, I salute Kathy Daniels, Francine Conley-Scott, Hui Wilcox, and all of the other artists here at St. Kate's working in both traditional and nontraditional departments, who particularly inspired my remarks today. And of course, thanks to all of *you* for being here with me this morning. As you can see, I've brought you a little gift to amuse you while I speak. Feel free to keep moving and blowing the bubbles as I speak—to help maintain the spirit of imagination and play.

At this time, I'd also like to acknowledge two very special people who have traveled here today, and I would ask them to stand: my sister, Dr. Yolaine Civil, a pediatrician in Ann Arbor, and my mother, Kate Frances Civil, a veteran educator from the Detroit Public School System. Could you all please give them a round of applause?

## 2. Dream Invocation

It's especially fitting that my mother is here, as she is the one who first introduced me to the theme of my remarks.

HOLD     FAST     TO     DREAMS

Sometimes in the kitchen, in the style of Ruby Dee, or in her bedroom getting ready for bed, my mother would recite this poem, "Dreams," by Langston Hughes.

Hold fast to dreams
For if dreams die
Life is a broken-winged bird
That cannot fly.

Hold fast to dreams
For when dreams go
Life is a barren field
Frozen with snow.

This morning, I want to talk to you about dreams—my own and those of some other people. In doing so, I hope to meet a number of purposes. First, to share some of my own history, concerns, and priorities as a dreamer and black woman artist in the academy; second, to offer some ideas about excellence, academic and otherwise; and third, in the spirit of Anne Joachim Moore, to address our institutional vision and current climate.

I aim to inspire and catalyze, and as you may have guessed, my approach will be less linear than aesthetic, associative, and playful. I'm going to ask you some questions, show you some art, tell you a bunch of some stories, ply you with poetry, and finally offer some propositions. Treat my remarks as you would a dream: garner what you can, and hopefully by the end something new will have unfurled in your mind. The aim of all my work is to open up space.

So HOLD    FAST    TO    DREAMS
Say it with me:  [HOLD    FAST    TO    DREAMS]

What wondrous words. And what on earth can we do with them? In the midst of winter cold, in the midst of war and injustice and racism and sexism and homophobia and poverty and greed, in the context of this country, trying to stay cheerful, in the context of the College of St. Catherine, trying to stay warm and fed, productive and useful, prepared for class, compassionate with students,

responsive to colleagues, ready for service, current in our field, viable in a fast-paced, demanding, practical word—what does it mean for us to hold fast to dreams? What does it mean to *dream* at all?

3. Dream Definition

> *dream* (noun)
> 1. a succession of images, ideas, thoughts, emotions, or sensations, passing through the mind during sleep.
> 2. a vision occurring or indulged in while awake; a daydream; a reverie.
> 3. a condition or achievement that is longed for; an aspiration; a goal; an aim.
> 4. a wild or vain fancy; a hope.
> 5. one that is exceptionally gratifying; something of an unreal beauty, charm, or excellence.

In "dream," we have a mixture of the rational and irrational, the conscious and subconscious, the real and the wholly imagined. These definitions help us approach what happens as we sleep and what we do when we're awake. What is the relationship between an "aspiration, a goal, an aim" and a "wild and vain fancy?" How can we tell the value of our dreams? Or why should we valorize an experience, a practice that could be nothing more than "wild or vain," or even beautiful and charming?

The answer comes in the last definition—a dream is something "exceptionally gratifying . . . excellence." If we are in pursuit of excellence, academic or otherwise, it would do us well to pay attention to dreams. For dreams are precious, persistent, some might say pernicious analyses and projections of our lives. Our dreams inform and embarrass us. They are cryptic, symbolic, metaphorical. They are the poems of our souls. Singular, mysterious, and irreducible, they can build a new symbolic language. Sometimes they're so raw and clear, they can take your breath away. Dreams are our

own individualized performance art pieces. They offer alternative or interior logic. They sample and remix our daily lives. Although they occur in the mind, we feel them in our bodies. We awake consoled, exhausted, motivated, or refreshed. In the best-case scenario, we enact the good ones and materialize their visions.

4. "I Have a Dream" (Happy MLK Day!)

Just yesterday we celebrated the life of Dr. Martin Luther King, Jr., a brave and powerful dreamer. I hope you each did something specific and appropriate to celebrate. Lest you think that a dream is only something personal or individual—a flimsy, impractical, New Age thing—I want to invoke Dr. King, and his dream of racial justice and equality.

> [Audio clip from "I Have A Dream" speech by Dr. Martin Luther King, Jr.]

> *I have a dream that one day on the red hills of Georgia, the sons of former slaves and the sons of former slave owners will be able to sit down together at the table of brotherhood . . .*

> *I have a dream that my four little children will one day live in a nation where they will not be judged by the color of their skin but by the content of their character . . .*

> *I have a dream today . . .*

Amazing, isn't it? I am especially moved by the strength of the *I*. Dr. King's speech is not called: "We Have a Dream"—because not everyone dreamed what he did. Or even "The Dream of My People." He said "*I* have a dream." *I* have an aspiration that may seem like "a wild and vain fancy," but my dream takes me beyond the dogs and sticks and the hoses into charm and unreal beauty. *I* see it within

myself, and *I* can show this to you, and you can see it and share it with me and share with me what you see, and together we can make this dream a reality. In this way, Dr. King dreamed his way into excellence. He had a dream. He was and is the dream.

5. We Ourselves Are Dreamers

Here, at the College of St. Catherine, faculty, staff, and students all have dreams. Notice that I did not just say students have dreams. They do, and the dreams of our students are extremely important. But each and every one of us here also has dreams—and today I want to recognize and encourage and feed those. We are not just facilitators of the dreams of others—we ourselves are dreamers. I have a dream. You have a dream. *Hold fast to dreams / For if dreams die / Life is a broken-winged bird / That cannot fly.* If we are out of touch with our own capacity to dream, we are limited in our capacity to act. If we don't value our own dreams, how can we value ourselves? How can we achieve something new, something exceptionally gratifying, something excellent?

## MY DREAMS, MY WORKS

## 6. Childhood Dreams

As a child, I dreamed of being an astronomer—having a telescope and looking at the stars. I dreamed of being a chemist, mixing strange chemicals and colors and smells together. I dreamed of being a teddy bear entrepreneur, writing letters to bear manufacturers for tips. I dreamed of being a teacher like both of my parents, and I gave lessons to my stuffed animals in front of the chalkboard in my room. I dreamed of being a writer, scribbling stories on white paper and stapling them together with pictures drawn with red Chinese pencils—the kind you would unravel with string instead of sharpening. I dreamed many marvelous things.

Take a minute and close your eyes. Think back. *When you were a kid, what did you dream of doing in this world?* Now turn to your neighbor and share some of those dreams.

My invocation of childhood is not to invite Hallmark-brand nostalgia or sentimentality. For many of us, childhood was not perfect or simple or easy. But it was developmentally a time of more extravagant imagination, a time of beginning, a time when dreams were formed.

This makes me think of the wonderful gesture of our first faculty meeting, when the Faculty Council gave us each a crayon and Paul Buttenhoff reminded us of the wonder and excitement of the first day of school. Lime was under my seat, but I swapped it for magenta. And holding that magenta crayon, I got to hold fast to dreams, so I want to thank Faculty Council for that gesture. (Let's give the folks in Faculty Council a hand for the crayon and for everything else that they do.)

Overall, when I think about the possibility and power of my childhood dreams, I'm inspired and amazed and slightly chastened. I thought I could do anything then.

What exactly am I doing now?

Close your eyes again. *What do you dream now? What is the relationship between your first dreams and your current ones? How does the College of St. Catherine foster your dreams?*

These are the questions I want you to consider for the rest of this presentation, the rest of the conference, the rest of the semester, the rest of your time here. If we are lucky and all is well, some aspect of our early dreams is still present in our lives. Somehow we are living some part of our dreams, and this place, the College of St. Catherine, has something to do with it. Which doesn't make it easy.

7. My Dreams, My Work

As I grew out of childhood, I let some dreams go (notably the science and business) and held fast to others (the teaching, the writing). By the time I got to college, I had a strong but fuzzy dream of being an artist—although I didn't know to call it that then. I couldn't draw or paint or sing—I didn't act or dance (outside of clubs)—I was writing, and that was important—but somehow my dream was about beauty and creativity and living a particular kind of life. I had a dream of living and working in a community of creative people, cultivating personal vision, exercising creativity, and having joy and making things and making some kind of impact in the world. Even then, *excellence* and *justice* were integral to my dream. Excellence—because "to whom much is given, much is expected," and it seemed pivotal to me then and now to excel so as to afford this great gift, the life of an artist. *Justice* because for me, a young black girl from Detroit, to realize this dream, the world would need to be a certain way, a way that it was not entirely already. My ability to be an artist in the world would both contribute to and be a measurable outcome of a more just world and society.

Today, this is still my dream: to live and work as an artist—i.e., to live and work in a community of creative people, cultivating personal vision, exercising creativity, and having joy and making things and making some kind of impact in the world. In my eight years here, the College of St. Catherine has done much to foster this dream. It has offered me a chance to think with my students, teach and learn, explore ideas, and rehearse my values.

I have been extremely lucky. My poems and performances have been respected as intellectual endeavors; grants and awards have helped me develop performances, run community poetry circles, show work at national and international conferences. My colleagues in my home and affiliated departments—English, Women's Studies, and Critical Studies of Race and Ethnicity—have been amazing and supportive of my crazy, dream-fueled ideas. I have been blessed and give thanks, and even with all this, it has not been easy for me to *hold fast to dreams.*

8. Yawo's Dream

Let me show you a short performance work that speaks to this and also continues our theme of dreams. It is a video collaboration with my dear friend Ellen Marie Hinchcliffe, a local video and performance artist. It was shot a little more than two years ago in January 2006, and premiered at "RSVP: work / play / process," a two-day performance art event that I curated at the Center for Independent Artists in Minneapolis. The title is "Yawo's Dream." Let's watch and then I'll say a few words.

When University of Minnesota professor Omise'eke Natasha Tinsley was in the "yawo" or "bride" stage of her spiritual training to be a Yoruba priestess, she said to me: "I don't mean to get all priestess-y on you, but Oshún, the goddess of beauty of love,

wants you to offer yellow flowers to the river." My performance was a manifestation of that dream. It was not a spectacle but a ritual act. It was art, but it was also my life . . . how I often feel as a relatively young black woman here in Minnesota. Moving through the white landscape, aiming for revelation and color and blossoming. Assigned there by a dream. Hughes warns in his poem, "if dreams die . . . Life is a barren field / Frozen with snow." How can we keep dreams alive in the snowy field?

## MORE THAN A DREAM

9. Dreams Entwined Everywhere Among Us
Freud and Jung. *Somnium, sueño,* and *rêve.* A dream of world. The American Dream. A dream of diversity, resistance, and inclusion. A dream of rehabilitation, the biomechanics of dreams. A dream of knowledge and the body, wellness and balance. A dream of rhetoric and relation, fundraising and access. Exhibitions of beauty. A well-driven nail. Dreams of whimsy and functionality, landscaping and technology. A dream of the sacred. A card catalogue. Searches for truth. Dreams of progress, stability, and regeneration. A dream of excellence. Disciplinary, interdisciplinary, divisional dreams.

Take a minute and ask yourself: *How does the work you do connect to dreaming?* Share with your neighbor on the other side. I know this is hard—but again, this is a question to keep considering and keep mining for possibility.

10. Creative Visualization Dream
Imagine an iridescent bubble
   around your head.
This is your dreams happening now.
Use a pen or marker to realize them here.

11. More Than a Dream

The work we all do must needs be connected to dreaming, as the College of St. Catherine was built from dreams. In 1905, the Sisters of St. Joseph had what to some was a "wild and vain fancy" to provide higher education to women. Clearly the Sisters were dreamers. And what they dreamed then has now become our reality—or what Sisters Rosalie Ryan and John Christine Wolkerstorfer entitle their history of the college: *More Than a Dream.* An excerpt from this work is one of the first readings in the Reflective Woman course, the fundamental course of the baccalaureate St. Kate's education. And I'd like to share a little from it today [the emphasis here is mine]:

> Always to [Mother Antonia], St. Catherine's has been a great college. *Even when it was only a dream.* Never just a building on a hill, it was a growing family of buildings: Caecilian, the Health Center, the Chapel. All of these she planned, built, and peopled in her mind long before the architects were ever summoned. The pews of Our Lady of Victory Chapel were filled with girls in cap and gown when the old chapel on Fourth Derham was still adequate to college needs. It is the vision for the future, *that aspiration for excellence,* and the creative power to convert vision into reality that has distinguished Mother Antonia's work. *That vision of excellence was her legacy.*

Mother Antonia was clearly a dynamic dreamer: creative, visionary, proactive, and strong. We see her legacy reflected in our current mission: "to be the world's preeminent Catholic institution to empower women to lead and influence." Is this not a striving for excellence, a desire to go beyond what is merely "adequate to our needs"? Is this not a dream?

I do sometimes wonder, though: *What if you were a person who liked the old chapel on the fourth floor of Derham Hall?* Or if instead

of a new chapel, you wanted something else? A track field or a dance studio or better lab equipment. To reckon with dreamers is to deal with big plans, big personalities, grand desires that may not be your own. It is to face the fear of your own insignificance and to deal, in fact, with change.

12. A Dream after Running into Toné Blechert

One day, I was chatting—or more likely grumbling—with Sharon Doherty outside of the Women's Center. We were both just back from sabbaticals, and I for one was having a tough reentry. After spending a year away developing my book, *Swallow the Fish: Black Feminist Adventures in Performance Art,* making art and meeting artists, and traveling to Canada, Iceland, Mexico, Senegal, The Gambia, Morocco, England, and Spain, it was rough to be back in Minnesota. My gratitude to the College for sabbatical was very deep, but I was having a terrible semester. Unlike many of you, I have no roots here—no family, no house, no partner, no pet. All I have is this job, my students, this place. And in my year away, it felt like almost everything had changed.

There was Kateway and Banner, and I couldn't get into the system and couldn't find the PIN numbers for my advisees, and there was curriculum realignment and the insurance hike and the hiring freeze and merit pay, and I locked my keys in my office door, and I locked my keys in my car with the engine running, and I got a parking ticket for staying late in my office working, and my students were not at all as enthralled by the Haitian Revolution as they should have been, and it was cold, and I wondered, is this what's become of my dreams? And although some of those things hadn't happened yet, I imagine that was the gist of what I was chatting or grumbling about to Sharon Doherty in the hallway when, like a vision, Toné Blechert walked by.

Toné—gorgeous, calming, warm, enthusiastic—came over to say hello and she said, "I'm here for a meeting about the School of Health." Oh yes, the School of Health—that was another new thing.

"That's an amazing project," I said. "If I were a professor in the health care professions, it would be my dream. As an English professor, I'm not so sure what it means." And she said, "Oh Gabrielle, it's not just about us. We need all of you to make this dream come true. And we'll be there to support you in your dream." And I looked at Toné in all of her gorgeousness and I believed that she would be there for my dream.

And so that night, as if on cue—I had a dream. I was in the O'Shaughnessy Auditorium and it seemed like the opening ceremony, and I couldn't see Toné but I felt her spirit was there. And I heard:

*The lack of competent and compassionate access and delivery of creativity is at crisis level. Demographic realities require competent and compassionate aesthetic response, different from any we have known. Due to its substantial skill and experience in preparing artists, creators, elegant thinkers, fashionistas proficient in aesthetic discernment, creative thinking, dreaming, and artistic practice of traditional and emerging creative modes, the College of St. Catherine is pleased to announce its new* School of Art & Creativity.

[Cue the music from *Fame* . . .]
What?! What just happened?

*The School of Art & Creativity establishes a cohesive home for the College of St. Catherine's array of [visual, literary, performing, and conceptual art] programs and extends their scope and depth. Drawing from our Center of Excellence for Women and the Arts—wait, well, drawing on the idea of a Center of Excellence for Women and the Arts, we are well-poised to institute and institutionalize partnerships with the Saint Paul Chamber Orchestra and the Minnesota Museum of American Art (which has already featured many works from the St. Kate's collection). Many links have already been made, such as Francine Conley-Scott and le Théâtre de la Chandelle Verte,*

*Susan Welch and Coffee House Press, Robert Grunst and New Issues, Bill Meyers and the Center for Book Arts, Lynne Gildensoph and the Armenian Dance Ensemble, Brinsley Davis and Three Dances, Hui Wilcox and the Ananya Dance Theater, and oh so many more. By the time the school is done, this is what this place will look like: the famous scene from* Fame—*you know, when everybody has taken over the lunchroom and are dancing all over the tables.*

Wow—that's pretty good, I thought.

*There will be continued recognition of our already existent programs— Music, Studio Art, Art History, the Catherine G. Murphy Gallery, Creative Writing, Theater—and an expansion of facilities: a dance studio, an expanded archive of the college's art collection, a special collection in the library. Our yearly artist-in-residence will always put the aesthetic in conversation with other core college values like social justice, community work and learning, and Catholic social teaching. The school will also be grounded in explicitly feminist values and informed by critical race theory. Far from being streamlined, the TRW aesthetic unit will be expanded, and every student will read the latest issue of* XCP: Cross Cultural Poetics, *edited by Mark Nowak. And, of course, all students—Urban Library Paraprofessionals, Associate, Baccalaureate, Masters, and PhD-level students—will have to write haiku.*

[*Fame* music suddenly stops.]

With this last declaration, you could feel the electricity in the air, the buzz through the crowd, "Haiku—how will the market forces handle haiku?" You could hear the anatomy professors whispering, "Am I just here to train a more well-rounded sculptor?" The folks in business put their heads together: "Maybe we need to emphasize to parents the usefulness of business skills for filmmakers." And all of a sudden, art and creativity were at the center

of the discourse, and everyone was talking about it and thinking about it and complaining about it. "Those poets—do they really deserve *all that money?!*"

And with that—I knew it was a dream and I woke up—
*And you were there and you were there and you were there . . .*

13. Interpretation of Dreams
My dream after running into Toné Blechert is not in any way to disparage the School of Health, which remains an exciting project, but is meant to shed light on some key issues about dreams. I am here imploring you all to dream—to tap into your own visions, creativity, imagination—and to hold fast to those dreams and bring them into our community and make them a part of our climate and conversation. But what happens when we all have a zillion different dreams about the same institution? As visionary as the College of St. Catherine is, we are an institution of limited resources, and priorities have to be set, and decisions have to be made, and not every dream will be realized.

So what happens when your dream seems to run in a different direction than what's going on? When the things you love and value don't seem to be on the tip of everyone's tongue? What happens when you feel your dream is relegated to the "wild and vain fancy" category as opposed to the "goal, aim, or aspiration"—the vision of excellence?

In that instance, it would be easy to shut it all down. Play the game. Face the music. Put dreams aside. Go with the flow. Or operate solely with an instinct of self-preservation. Distrust any new idea for fear that it will lead to your own demise. *Hey, I had a dream about . . . No. That'll never happen here. We don't have the money. Give it up. Don't even go there. Where would that leave me? What was wrong with the chapel on the fourth floor of Derham Hall anyway? Let's not rock the boat. Let's focus on what's realistic.* Do your dreaming on your time, kid.

\*This is not how I want others to respond to my dreams.\*
\*This is not how I want to respond to the dreams of others.\*
\*This is not what I want for the work environment of the
College of St. Catherine.\*

The hard task of dreamers is to allow ourselves full range, full imagination even when we know that what we imagine may not seem practical or workable or may not correspond to the overall consensus at first. The hard task of dreamers is to welcome all dreams with *yes*—our own dreams and the dreams of other people. *Yes* to the School of Health. *Yes* to the School of Art and Creativity. *Yes*, if only for five minutes. *Yes* to move out of the box, to speak with imagination, and to listen with an open mind and heart. *Yes*, who knows if it will happen, but let's kick it around for a minute. *Yes* to being creative thinkers. *Yes* to culling viable ideas from dreams that might not otherwise come to light: a new sprung dance floor, a yearly artist residency, a reclaimed aesthetic unit in TRW. *Yes*. If I feel shut down to dreaming, that my dreams are sheepish and ridiculous, or that you will find them so, why even mention these things? But without their mention, new possibilities are lost to the institution. New possibilities are lost to myself. *Yes*, hold fast to dreams and the possibility of possibility . . .

We must work to claim and maintain a space for dreaming, a space of possibility, a different kind of thinking and feeling and being. From that space, from that negotiation of vision and reality, self and world, emerges the potential for excellence.

14. Joseph's Dreams

And now I'm on my way to another meeting for the second thrust of the Strategic Initiative for Academic Excellence (SIFAX 2). It's cold outside and so I walk from my office in Whitby into Derham Hall to wind my way through the Chapel to this building, the Coeur de Catherine. I love the corridor en route with all the St. Joseph's Day posters from over the years. The 1996 poster says: "Joseph had

dreams: they weren't always clear nor easy, but they were his. Eventually they changed his mind and heart." I want to sit in the chapel and just think about this message and Joseph's dreams, but I'm just too busy. I'm always in a rush. If I tried to sit now, I'd be late for the meeting where we're scheduled to dream together new ways to recognize and offer opportunities for academic excellence at the college. It seems like there's some connection between Joseph's dreams and my own dreams and SIFAX dreams but I'm too tired and in a hurry to figure it out.

Did you all know that at Google, a percentage of an employee's time is meant to be spent dreaming? Doodling, meditating, zoning out and in . . . What would it be like if we had a similar rule here? At the College of St. Catherine, we need to claim more time and space for dreaming. We need fewer meetings. We need to assess our breakneck pace. By midterm, I see my colleagues depleted, faculty and staff. By the end of the term, we are all worn down and exhausted. What dreams can come from this? What open-mindedness or creativity for new initiatives? What solutions to long-standing challenges?

## THE DREAM OF EXCELLENCE

15. The Dream of Excellence
But now let's return to SIFAX 2. In the meeting, we chase academic excellence by its tail. Are we just talking grades or other things? What about the single mother of three who is never late for class or assignments? The student athlete or church volunteer? How much do we measure GPA in relation to other factors like curiosity or ingenuity? What is the bar, and where do we set it? When we dream of academic excellence for our students, what do we dream?

Many things run together in my mind: My own biases as a college student and professor . . . How I was an excellent college student, graduating summa cum laude, a member of Phi Beta Kappa. The privileges I had going to college—an eight-semester tuition

scholarship, parents and a sister who had preceded me there. The rabid racial atmosphere of the University of Michigan. How a student in one of my classes said when he saw someone black on campus he thought immediately: athletics or affirmative action. How in my senior year, the head of Honors confessed that they never expected me to do so well because of my "test scores." (I'm sure the fact that I was black and from Detroit had nothing to do with it . . .) How, if it weren't for affirmative action, they probably wouldn't have let me into the Honors College. How much I loved the Honors College because in Honors, they expected that you could and would strive and do well—which was different from the attitude of my optional "minority advisor," who said that my schedule looked "hard." *Let's not rock the boat. Let's focus on what's realistic.* How my Honors advisor didn't bat an eye when I said I wanted to triple major in comparative literature, French, and creative writing—poetry. She even wanted me to take more science and math, which I though was nuts but she said would make me more well-rounded. How I wasn't interested in being well-rounded. How much I loved comparative literature, French, creative writing, poetry. How much I connected these things and my dreams. How much I want to make these connections, share these connections with my own students now.

I love my students. And I dream that they will achieve academic excellence. I expect this from them, and at times I'm disappointed. In Fall 2005, my Literature of Black Education course was extraordinary. The texts, the teaching, the timing of our conversations all seemed in sync, and the class was full of dynamic, critical, and creative thinkers. In particular, five black women emerged as class leaders, setting a serious, passionate tone about the course's key question: Is education something that brings you closer to your community or pushes you further away? They shared their experiences and dreams and opened the door for all the students in the class to do the same. It was a powerful exchange. Not one of my black women students earned an A in that course.

The semester before, Jane Carroll and I cotaught an amazing course called Literature and History of Slavery of the West Indies. We worked like dogs, designing new lectures, bringing in special materials. This time, our students were resoundingly disengaged, unmotivated, unprepared. I tried to inspire them with the ideal of academic excellence, but to no avail. There were five black women in that class as well. None of them got an A. In fact, no one got an A. This broke my heart.

*I dream big dreams for my students and expect them to dream big dreams for themselves.* I am dismayed when their own expectations fall short or their aspirations are different than mine. I want students to share my dream of academic excellence and then I have to remember their dreams may be different from mine. Our colleague Ellen Richter-Norgel told me how one of the students in my Literature of Black Education class had run into her office with her grade, proud and delighted to have received a B+ in the class. "That student was so smart—she could have gotten an A," I said. "And maybe next time, she will," Ellen said. Here again we see a negotiation, an overlap, an intersection of dreams; we see challenges, possibility, emergence, excellence.

*When we dream of academic excellence for our students, what do we dream?* I dream the traditional and the nontraditional: high grades, community leadership, civic engagement, critical and creative thinking, intellectual confidence and curiosity, effort and engagement. I refuse to fall into the trap of presuming some students can't achieve excellence because of a particular background. Or thinking that just because a student comes from a particular background, excellence is automatic and therefore not that big of a deal. No. *All students must have the opportunity and the support to excel academically, and academic excellence of all kinds must be celebrated.* In SIFAX, this is what we are working toward and how we need your help. This is our dream and our work.

## DREAM INVENTORY—A FINAL CHARGE

## 16. Dream Inventory—A Final Charge

It is my firm belief that in order for us to remain vibrant, engaged, active thinkers, citizens, and agents of change, we must dream. And in the negotiation of our dreams with those of others comes the opportunity for excellence. There can be no excellence, academic or otherwise, without dreaming. There can be no excellence without the space and time to generate new visions and possibilities. At the College of St. Catherine, if we are to fulfill the ever-evolving dream of our mission, we must claim more space and time for dreaming. We must recall our childhood wonder, allowing for the multiplicity of our dreams, the specificity of our consciousness. We must listen to dreams with good humor, keen ears, and open hearts. We must respect and foster the dreams of others, keeping in mind the different power differentials. In order for dreams to be exchanged in good faith, there must be trust and transparency in all our operations. There must be a shift in climate away from chronic overwork and depletion—which shuts us down and makes up grumpy—into replenishment and rejuvenation. Dreams tell us that rest is not passive. We must harness the radical power of dreams—to allow for new energy, to open more into the associative and the aesthetic. We must pay closer and deeper attention to art and the aesthetic in our lives and at this institution. We must do this not just as something embedded in something else, but as a body of discourse and a way of knowing that is valuable in and of itself. This is key, because in art we find the inspiration of dreams and the manifestation of dreams.

Finally, we must offer to ourselves and each other deep appreciation—for from this sense of well-being can come the security and comfort necessary for dreams. And so in this moment, I want to thank all of you and all involved with the College of St. Catherine, the trustees and the president, the vice presidents and the cabinet, the deans and associate deans, those in academic affairs and student affairs, in facilities and housekeeping and technology and the switchboard, those in the library and the cafeteria, in the

professions and the liberal arts, all of the faculty, staff, and students at all levels and in all places in the college: I offer you thanks and wish you sweet dreams.

I give the last word to Langston Hughes whose life and work has been such an inspiration for these remarks.

> [Audio Clip of Langston Hughes]
> *Bring me all of your dreams, you dreamers.*
> *Bring me all of your heart melodies*
> *that I may wrap them in a blue cloud-cloth away*
> *from the too-rough fingers of the world.*
> *And that is what poetry may do: wrap up your dreams*
> *Protect and preserve and hold them until maybe they come*
> > *true . . .*

# Ostinato Vamps

I have dreamed of being a writer for as long as I can remember. For many years, I scribbled and schemed in obscurity. Going to high school at the all-girls school in the chilly suburbs, and teaching at a women's college in the Upper Midwest, I felt like the heroine of a nineteenth-century novel, a shy governess, somewhat Gothic, secretly romantic, with a wild side desperate to break loose. A good girl, yes. But inside, a vamp with blood-wine lips. There was maybe a little Langston Hughes in there too ("I am the darker brother. / They send me to eat in the kitchen / When company comes, / But I laugh, / And eat well, / And grow strong"), and a sense of generating and growing wise where nobody can see, but waiting for the right moment to emerge. (A burst of light.) I didn't exactly want to be a mother actively, but just figured it would happen, like love affairs and wild nights and sexual exploits. Somehow the train of my life would jump from a cheerful grind to a parallel track of glamour. I would purse my lips, flicker my eyes, and my secret pages of writing would fly free.

Recently, I was digging through my digital crates and found this review of Wanda Coleman's *Ostinato Vamps* that I wrote for *Black Renaissance/Renaissance Noire* back in 2003. They must have

solicited it, maybe had the book on a list for possible reviews, and I jumped at the chance because Wanda Coleman was thick-hipped and dark-skinned, strong and wild, and so were her poems. What happened then? For some reason, the review was never run, so it exists as an outtake or a deep cut. I'd actually forgotten I wrote it until I saw it again, making me wonder about the pieces of myself captured, forgotten, and ready to resurface. It makes me think again of Mama Wanda, who has since died and joined the ancestors, and remains thick and dark and strong and wild . . .

<center>*</center>

Wanda Coleman writes heavy books. Heavy like the "heavy hipped women with / pressed hair & aprons" in her poem "Wichita Down West Home." Down-home, heavy, and black woman true. Her signature offerings from the now-defunct Black Sparrow Press—*Heavy Daughter Blues* (1987), *African Sleeping Sickness* (1990), *Hand Dance* (1993), *Bathwater Wine* (1998), and *Mercurochrome* (2001)—were also physically heavy. Thick tomes, they were easily two to three times the length of the average contemporary poetry collection. At 128 pages, though, Coleman's fourteenth book, *Ostinato Vamps* (2003), is slender and fighting trim. More than quantity, this book demonstrates how the matter and quality of Coleman's poetry give her work its weight. Full of blood and ghosts, jazz and rage, fractured song and silver screens, *Ostinato Vamps* is beautifully heavy indeed.

It is most heavy with child. Dedicated to the poet's son "Baby Boy, Ian Wayne Grant," the book is preoccupied with black mother love. In the black feminist vein of Georgia Douglas Johnson, Gwendolyn Books, Lucille Clifton, and others, Coleman shows how this love turns too often tragic. In "Requiem for a Nest," "the winged thang [. . .] created a hatchery for her spawn / not knowing all were doomed." In the powerful elegy "Olio Intaglia," she writes, "I worried that they would kill my children / and then not come for me [. . .] / one down." Raging against her son's death, she writes, "I have wailed loud enough / to bring down heaven / but my hurt is ever / . . . unheralded."

Along with the grief of a lost child, the poet ruminates with some humor on children "almost" or never born at all. After the "dumb girl's horror at the absence of my / bloodjet caught!" the poem "Almost Pregnant" moves to "innermost urgency . . . / of hands spreading flesh, . . . heavy cotton. the history of our future." This fused tense becomes the race's call for generation. The would-be father interrogates here not merely pregnancy but the black woman's entire existence: "if you are, please have it." The speaker's ultimate decision is ambivalent: "i stumble into the infinite embrace / . . . —a tangle / of blood-pressure cuffs, tongs and stirrups." The birth of the child connects to a birth of the self, and both are a "stumble." In the context of American society, a black woman's decision both to have or not have a child are equally fraught: "we have never made a child / and now we are infertile [. . .] / no one will notice / the tremors ("About Our Unborn").

While motherhood infuses other subjects of her poems—the childhood nostalgia of "The Woman in the Mirror" and even the social protest of "Fragments of an Essay" in which Danny Holley, "a 13-year-old boy hung himself because Mom / worked and slaved but could not provide enough"—Coleman also takes up the pleasures and problems of procreation. *Ostinato Vamps* is heavy with sex. In "Meanwhile in San Francisco," the lover is "already naked / with a nice hang / as thick as my fist." In "White Wall Syndrome—A Study," the walls of an interracial couple's bedroom solidify erotic determination: "from the bedroom's whiteness / watch me moan under his attentions [. . .] / he spills his happiness / into my willful devotion." Here, the speaker reclaims personal pleasure from the historical shame of black female sexualization. This is a large project of the book: to engage the bondage of history and the body.

This brings us to the ghosts. The black female body of *Ostinato Vamps* is haunted by both personal and historical tragedy. In "The History of My Body," "dayblooming pickaninnies [are] forever haunted / tenderly fiercely fleshed." In "Dream Fever," the poet declares, "recant a heritage of spooks if you must. [. . .] / those horror-house refugees, blazing bebop and don'tchewknow-daddio [. . .] / the themes and motivations of our common despair." But to no avail, "horns thrusting, taloned appendages

flying [. . .] / tonight they'll come." Ultimately, the poet becomes the living ghost: "slavery's been dead nigh a century / or more but i carry my chain everywhere" ("Art & Embellishment"). As such, Coleman sends a rallying cry to "the butchered, / the diseased, the lynched and the starved," all those who suffered on these shores: Martin Luther King, Jr. and the more recent martyrs of the Civil Rights Movement. She says, *whosoever put their blood in this soil, raise thy standard*" ("Revisiting Fear and Memphis").

Coleman raises her own standards, jazz singers and songs. Billie Holiday returns in "Lady Sings the Blues 1969" and Billy Strayhorn in "Plum Hunger." "78 rpms on a Piper's Dream" and "Cool Cats Snap Spats" also revive and relive black musicality. The book's title actually incorporates two musical terms: *ostinato,* "a repeated melodic phrase," and *vamp,* "a simple, improvised interlude." In this way, *Ostinato Vamps* reclaims the changing same, the melody of African American history, culture, and sexuality. It does so in a language that is earthy, rich, distinctive, and sublime. Coleman has said, "In this book, I'm taking back the rhythms that were stolen from my people." She also synthesizes them and creates new ones. She is sounding the voice of the "ostinato vamp," that strange black woman flirt, powerful sex goddess never allowed on the screen. As she writes in "Jazz Theory 101," in *Ostinato Vamps,* she is "finding inspiration in the inspired / miles of minor chords and major truths / history emanates from art . . . aesthetics is the science of vulnerability / bruises transformed, wounds immortalized."

# Unheld breath

He was the one who said it first. That first day after waking incredulous, alone in intensive care. It wasn't a dream. I hadn't been dreaming, heart racing, acute shortness of breath. My collapse in Jazzmine's after two glasses of Shiraz, an elegant salad, and some down-home chicken wings wasn't a fantasy either. I had been lying on the floor, my body straddled across the threshold of the club's bathroom and the back hallway. I had been lying to myself: jet lag, iron deficiency, exhaustion, overwork—these were all true. But a niggling something else: *something is really wrong with me.*

So an emergency room, an ambulance ride. So I called him, my erstwhile knight, and said, "I'm in trouble. I'm in the ICU. You have to bring me a puppet show." And when he came to me lying in intensive care, a few minutes before having a tiny trap threaded through my jugular, he said it laughingly, seriously, "Gabrielle, you have such a glamorous medical history."

And so I do. *Twenty-eight-year-old black woman traveling back from France suffers massive bilateral pulmonary embolism.* I can't breathe. I can't move. But I do look amazing. *I Was the Most Glamorous Patient*

*in the ICU*. The title of my memoir—if I live to tell it. One of my terrific nurses says, "It's such a treat having a patient who can speak." What could I say? I wanted my mother and my childhood teddy bear. I wanted poetry and to keep my appointments.

Desire blown to nothingness. Dr. Bad News comes and says, "Your situation is life-threatening. The clots are massive, and we couldn't dissolve them. With your history of bleeding and anemia, you might bleed out. If you get one more clot and it goes into your lungs, your system most likely will fail. We can't thin your blood too much or we'll lose you. In the meantime, your hemoglobin is so low, we have to transfuse you. You might never be able to breathe normally again. You may not survive."

So this was glamour. Four weeks in France. Pure chocolate and butter. Eating a crêpe à cannelle (like a French snickerdoodle) fresh off the street. Finding the perfect tiny tin of forest-green eye glitter. Hearing Emmanuel Ax live at Radio France. Dancing to soul music with new French friends on New Year's Eve. Speaking French every day with confident quasi-fluency. Drinking champagne. Buying Josephine Baker monographs by the side of the Seine. Dipping a page of my notebook in Hippolytus' stage blood at the end of *Phèdre*. Now it was almost equally tainted or smeared or separated away as something that had happened to someone else, someone who may never be back around. Desire blown to nothingness.

Dr. Lung Doctor walks in. "They've blown up the shuttle," he says, reaching to turn on the television. "I don't want to see it." I turn away into someone else. "I can't help them. And they certainly can't help me." True glamour: the thrall of self-absorption. The patient's romance.

I had wanted to be there so badly. Paris, the perfect solution for my late-twenties angst, my fear of stasis, my black girl attitude. Now we were discussing other solutions.

Greenfield, a cardiac surgeon at the University of Michigan, my first alma mater, originally hailed from Texas. His oil buddies—slick, mustachioed, and jocular, or perhaps W. trim—told him about the long, tall moonwalkers dropped into the works to catch the hard knobs of concretized oil. The description of this sparked Greenfield's own love. If it can be done with oil, why not with blood?

And yet how could blood concretize that way?

At the Centre Pompidou in Paris, two installations stood side by side. James Lee Byars had arranged, like bloodwork, elaborate labyrinths of heavy red glass balls all across the floor. Next door, Louise Bourgeois had recreated a strange room of memory. Dim feeling, piercing spotlights. An old-fashioned costume hanging from the ceiling, the central apparition of a bed, and iron trees bearing oblong glass globes as bulbous fruit. Now I was back there, living in that bed, in that room. Those glass bulbs were holding my unheld breath. I was trying to be re-membered.

When I went down in full patient evening glamour to have the spindly Greenfield filter fall through my superior vena cava, I had never been more terrified in my life. Especially when Dr. Tall Dark and Handsome with an Accent showed me the consent form rife with nightmares. He said, "I've done many of these procedures without a hitch. But all the literature does mention possible complications. So don't be extraordinary, Gabrielle."

But that is how I survive. Having been from Detroit. Having lived in New York City and outside Boston and north of Taos. Having taken off my black slip in public as part of my own show. Having exposed the insides of my desire, turned inside out as saline and heparin, coming back as sedation. During that procedure, I was alone and no one was with me. Two separate things but both true. And I

confronted the overwhelming sense that I had lived an extraordinary life, but here perhaps on the real outward cusp I felt real regret. I had not been rightly loved. He had not brought my puppet show. My mother was in the air but hadn't yet arrived. I was young, black, and beautifully unacknowledged.

And I took the blood clots, the blood thinner, the filter as a form of love or reassurance, or at least relief that this cataclysm was real. That my source of malaise had been concretized and could now add to my legend. (My coworkers and students were reported to say: *Have you heard? Gabrielle's had an aneurysm. Gabrielle has diabetes. Gabrielle has sickle cell anemia like T-Boz in TLC.*)

Later I sat in a room full of fragrant flowers: hyacinth, stargazer lilies, almost a dozen bunches of tulips, and to me the most stunning, the most heartbreaking long-stemmed irises, whose indigo, pen-like tips bloomed to unfurling over the course of my stay.

I became an elegant hostess, a cheerleader, a needy child.
My hospital room became a salon, a summer camp, a class reunion.
*Please come visit, don't leave me alone. Bring sympathy, cards,
and promises of Southern biscuits, time off work, bad mystery books.
Call and come see me with slick magazines,
gourmet English toffee, licorice bits.*
I ate better than I ever had as a bachelorette, five to seven fruits
and vegetables, three iron pills a day.

*Uterine fibroid complication.* Here's where it gets tricky. Here's where it hurts. Here's where, as my friend Greg says, I get lousy with blood. Here's where the clots that come out are so large that Marquista, the nurse's aide, can't get my Depends on straight. She's so unnerved she grabs the off-duty nurse and makes her come to see my monstrosity. She declares, "I won't never be no nurse."

Many times in Paris, I gasped and held my breath. I remain lonely with doctors and nurses and friends all around. Still, I do love my life. I left the hospital with bruises and perimeters of adhesive residue that don't come off. He didn't bring a puppet show.

He brought the *I Ching.*
My number: twenty-eight, the same as my age.
It says: *Critical Mass. You are stretched almost to breaking. You must proceed with character and a goal in mind.* I am learning how to rewrite the prophecy of my body, how to exchange a fortune for my life.

*. . . and so I'm kind of at a big life crossroads right now. I'm forty, although I'll be forty-one on October 12. And I feel as if right now a lot of different things are happening. I mean, I think you know, um, I lived in the Twin Cities for most of thirteen years, then I left two years ago to go teach in Ohio. And, um, I have been successful at that job, but I'm not sure I like it. So that's one big question. I feel clear that my path isn't really to stay there, but, but I have a question about whether I should come back here. So that's one big thing, work and this other thing, which I keep coming back to, where I'm supposed to live or where I'm supposed to be, because I've struggled with places for a long time. Even in the Twin Cities, I wasn't, I wasn't very happy a lot of the time, in part because it's so very difficult to be single here. I've been so alone. I've had to deal with so much loneliness. Yeah. Um, that's been very painful. And I did, of course, right before I left, I got into a serious relationship. And then the long-distance thing kind of blew it apart. In some ways we broke up a year ago. Um, almost like August, at the beginning of August, and it was fine. And I was the one who initiated that breakup. And then, I don't know, maybe three, four months ago, I just started to feel angry, I mean really angry and sad. And, and those feelings have really come up, and I think some of it is related to getting older. And I'm trying not to be someone hyper about youth, trying to always stay young, but I also don't feel like I'm a crone yet either. I'm just getting started. So like, even now, like, it's all just beginning, or it hasn't started yet. And so feeling as if, wow, this has never really happened, and this thing, this really being with someone, this having my own family, is never going to happen for me. And then, like, I, I'm so mad that my feelings got hurt, or that I just felt like I wasn't treated very well all the time, haven't been treated very well much of the time, so that's in the mix. But the real thing that happened, it has to do with my health. About twelve years ago, I had kind of a major health episode with some blood clots in my lungs. Um, and treating that, there was recognition that my fibroids played a role. Uterine fibroids are a big thing, run in my family, and iron deficiency and anemia. My mother, my sister,*

*my grandmother, the matrilineal line. Even my maternal uncle has iron-deficiency anemia. And so after the lung thing, a whole ordeal connected to breath and all these other things, I had that first myomectomy twelve years ago. And five years ago, I had a second myomectomy, which was very traumatic for me. They nicked my bladder and it was so, so painful, and the nurses were about to strike, and that on top of the whole cycle, heavy blood, so much bleeding all the time, bleeding through sheets, bleeding through chairs, bleeding through sheets, and low iron and trying to pretend like it wasn't happening and then the emergency room and transfusion and surgery, not just once but this happening over and over again, and, but this is maybe an important thing I should say because, at the end of all that, the gynecologist said to me, you know, this surgery really did not go very well for you. You have a hard time with this. And this is the second myomectomy that you've had, a doctor's not going to want to do this again for you, so if your fibroids grow back, it's unlikely that they will want to do another fibroid surgery for you. And you cannot continue having your blood levels so low like this, low enough for blood transfusions. She's like, that's not sustainable. So if you want to have a baby, you better have one soon because . . . So there was a lot of pressure on me, and it was very much connected to a lot of grief that I'd had, because I just felt like being here, you know, I have a lot of friends here, have built a really strong community here and am very successful at work, but there was always that piece missing. And whenever I left, I, it would be better. So I went to Mexico on a fellowship for a year and a half. And that was really awesome. That was, like, the most transformative, amazing experience of my life, personally, professionally. And in terms of romance and body, that was a whole other thing. Like, everybody always wants to tell you, well, if you would just do this, it would be different, or you need to be different, you did this, you do that. I didn't do anything different. I just walked into Mexico City and in all of one week met a man and started dating, and dating other people and whatever. So it just felt, I felt very validated and confirmed in the sense that a lot*

*of things are luck of the draw, and some things are not in our control. Right. And some things are, so it's not to abdicate responsibility for my life. But I just feel like there's kind of an American sensibility of, of you need to be happy, or you need to do this, or it's you, it's, it's, everything is in your control. You have to make it happen. And if it's not happening then somehow it's your fault. But in Mexico my whole life was much more pleasure and desire. But then I found myself coming back for work, or I was always running these double lives. That's been a very big problem for me. I need to find a single place. And, well, so long story short, this past Friday, this is after I made this appointment with you, I had a procedure, um, and my ex-boyfriend came with me, which was very interesting because he wanted to do that. And I was ambivalent because I felt like, you know, what if I'm still in love with this person? Or I'm still mad at this person? Or I don't know what the thought is? And maybe if I feel like this is a person who is, who can't meet all my needs, maybe this isn't a good idea for me to put all my emotional energy into that. I'm so used to being in charge of everything, like, it's just me to organize everything and figure everything out. And that's connected to loneliness, cause it's like, well, no one is walking in my life with me. And I'm like that baby, I want to be sweetly and indulgently loved. So deprivation has set out to make it difficult for me to actually accept support. And I just have not had enough of anyone kind of holding it with me, and because of that, even when my ex is sort of like, I want to come with you to do this thing, I want to push that away. Cause I don't want to get used to you showing up in this when I already know we're not really together. But at the same time, I was so freaked out because this procedure would say whether or not the fibroid they discovered in the emergency room, which wasn't very big, was basically blocking my fallopian tubes. And if ultimately, I, I was no longer, at the end, like, I would no longer be able to carry a baby. And it's kind of invasive, you know, they put a catheter in my cervix. It's sort of like, really, it's kind of an intense thing. And then you're looking at the screen, and then she just showed it to me. You know, she was like, okay, we've*

*just done that now, let me tell you what I see, you know, what I, what I understand from this. And I said, let me just stop you right there. Can I be with my friend? Can he come in and just help me, like, process whatever it is you're going to say, because I did learn, I've finally learned something from these health interventions: sometimes it's good to have another person with you. And he's a registered nurse. He actually arrived with a notebook and took notes, which was really helpful. Absolutely. And that's what the diagnosis was: absolutely I would not be able to carry a baby. And I felt sorrow and grief and loss and sadness and guilt because that first doctor told me. And how many years old and hormone levels, and still, I mean, there was no reason to believe automatically no baby at forty, because I know people who have, and even later, you're one of them. Right. But now I think I always believed I didn't need to be so stressed out and over-the-top about finding love, because it was an organic process. And that, that would just happen. And I would find someone who wanted to make a family with me. Right. So it's even less about a specific baby, because the one thing I always knew was that I wasn't interested in starting as a single mother. I mean people can die or break up and you end up doing it on your own, but I had this idea that I didn't want to start that way, and anyway it was just going to happen magically, or first things first, first comes love, then comes . . . really, I didn't want to think about, it was like, what the fuck was I thinking? And my mother is an excellent mother and really amazing. And I saw how much backbreaking work she had to do, and I love my father very much and he was there for me, but she did the housework . . . the heavy lifting with us, you know, and, and I feel like just growing up, especially as a feminist or whatever, especially as a person walking through the world as an artist, I was mad, but really, I was holding, trying to hold out for something else. And so, I mean, there was this other thing, this, I don't regret any of those things. I mean, I see other people who made different choices and prioritize different things. And now they have partners and families. And what I really see is*

*everyone around me coupling up and having their own families. Straight people and queer people just the same, weddings and babies. And I feel very, like, locked out of that. And I felt like that before and now I really feel like that. Yeah. So long story short, I have to schedule a hysterectomy, which is so emotionally intense because exactly the thing I didn't want to happen has happened. And maybe my fear of that hastened some of this in part, because my interaction with that last gynecologist made me not want to go to the doctor because I was afraid the doctor would say to me, this fibroid, it's grown back, it's happening again, and so you can't have children. And that's exactly what happened. And sometimes it's hard for me to talk honestly about what's happening for me because everybody wants to give me a solution. I shouldn't say everybody. I have many friends who are just great listeners or this or the other. It's like, they want me to be better or they want, they want me to be okay. So it turns into go do XYZ, XYZ, XYZ. But what if I don't want to only eat a hamburger every day? Well, bad example, I could eat a cheeseburger every day with fries, no, more like mixed greens and tinctures. I, I know I sound like an asshole, these people love me. So then I feel judged, and that can be very exhausting, you know? And it's sad, because I think if I had met a different person, or if I had been a different person, or if I had looked different or looked at the world differently, maybe I would have a family. And it doesn't mean I can't still have a family, but I have to acknowledge that there's another kind of family I wanted to have in another kind of way that isn't happening now. And I think about my body, feeling failed by my body in other ways. And this is just another example of my body not being in sync. So at the time when my body could've done it, I didn't have it together to do it. Or I didn't want to do it at that time, or I wanted to do it with someone else, someone who really wanted to do it with me. So I had all these conditions. And if those things weren't there, that's just, alright, that's the whole thing that brought me here. And oh yes, that totally works for me, because I make performance art. And often when I'm thinking*

*about making a new performance, there's an image or a vision of myself doing things that both is and isn't me. It's like the vision, my own vision, of myself within myself, that I'm trying to figure out or capture or bear or deliver or put back into the world, again and again. So yes, okay, before we see what the tarot says, I'm ready for a meditation . . .*

# Blue Flag

*for Mama Wanda*

*the black poets are dancing again, stomping, getting down, I mean throwing DOWN, Reginald Shepherd doing the gay boy skip, and Natasha Trethewey poured into dark blue jeans so tight and boots so high-heeled, she never lifts her feet from the ground, doesn't have to, just snaps her fingertips, moves her hips. who else was there? a throng of who's who, future heavyweight poetry prizewinners, maybe even you, now memory BLUR. in a small town in Ohio, this mecca, a dance floor. the white man who organized it wearing a tuxedo like a butler, dancing along to old-school funk and rhythm & blues, and Rosa and I were in the groove, I mean we've always been good girls, VERY good girls, both skipped a grade, top of the honor roll, spit-polished scholarships, and all the rest, but we still like to DANCE, and Rosa was doing one of her patented moves, body roll, shift turn, and twist, when she wrenched her knee the wrong way OWWW, maybe you better ice that, I say, it'll be okay she says back and ends up doing physical therapy for months. DOES ALL ART START FROM INJURY? one of my colleagues likes to ask, and Mama Wanda, I guess enough people believe that's true, because when they talk about you, they*

*start with your pain, your poverty, your Big Black Personality, how you could be wrong, maybe just didn't give a fuck, but I decided to start with something else*

About a year ago, I was invited to write an introduction for the reissue of Wanda Coleman's first poetry chapbook from 1977. Recently, I heard a wild story that she had two different contract offers in one week: one for this tiny book with the chance for a larger book later, the other from a music company for five million dollars to own everything she would ever write. She chose the former because she wanted more freedom in her future and didn't have any regrets, she said, until her oldest son, Tony, passed away from HIV/AIDS twenty years later, and she thought how maybe five million dollars could have come in handy while he was sick. They weren't offering me much money to write this introduction, but I still took it as an honor to be asked.

Dear Gabrielle,

... Would you be interested in writing a brief introduction to Wanda Coleman's chapbook *Art in the Court of the Blue Fag*. It runs 13 pages and was her first published volume of poetry. Black Sparrow Press published it in 1977 and has given us permission to reprint it ...

The PDF is attached below for your convenience. The word count for the essay would be approximately 600 to 900 words. Our budget is modest but we can offer you $250 as a token of appreciation. ... Unfortunately, our timeline is tight. I would need the copy in two weeks (October 15). Please forgive the rush.

At your earliest convenience,
could you let me know if you're interested?
Best wishes and thanks,

M.

It seemed like a no-brainer.
I love Wanda Coleman.
I love her poems and her persona.
She was a big black woman poet,
larger than life, equally erudite and profane.
She wrote *Heavy Daughter Blues,*
*Bathwater Wine,* and *The Riot Inside Me.*
Her apocalyptic visions of Los Angeles
were starshot with gleam and Vaseline,
and replete with trickster dirty angels
"sipping rhythm and blues bubble bath
crying fresh hungry grinding brown and tan
mind empty cavern and eagle overhead flying
there is a corpse down there to be eaten."
Wanda was surreal and keeping it real.
Like Jayne Cortez, she jazzed it.
Like Ntozake Shange, she bluesed it.
Like Sonia Sanchez, she reconstrued it.
Even when her work was misconstrued
or simply missing from the archive.
Raw and mysterious, musical and blunt,
Wanda has never really gotten her due.
Now they were asking me to pay homage.
But in two weeks' time, for an obscure,
early, out-of-print text I had never read
with a tricky word in the title, I wasn't
completely sure this was a good idea.

Have you ever wanted something so badly and then gotten it? And then found it hard to hold, hard to feel good deep inside it? That was me with L.A. I hustled hard to get my SoCal dream job but never wanted to live in L.A. (the earthquakes, the expense, the endless driving). L.A. was the thing that came along with the other thing. Still, I had wanted to come here, I still want to be here. What can it mean to open into something different, the possibility of being someone different somewhere else, in something else, especially if it's hard? What new California girl could emerge? Could I come to navigate mountains and plunge headlong into the ocean? Could I rumble around in a Jeep like Lori Petty in *Point Break* after she teaches Keanu to surf—I'm not a strong swimmer, but maybe in California I could surf! So what if the waist of my miniskirt would roll down under my brown belly muffin top, and my bikini top would have to be plus-sized? Even if it's true that we bring ourselves wherever we go, maybe in Southern California, I could be messy and wild. Mama Wanda certainly was. In her poems, she could cuss you out and kiss you at once.

Shivering in bed in the desert night, in my pretty apartment without central heat or insulation, I didn't feel that cool: I felt bone-deep, cold, pernicious loneliness. I had left my own landscapes, my time zones, my blood and chosen people and needed now to make myself at home. To spend time with Wanda Coleman's poems could be a way to stake my own small claim in a different legacy of place. If I couldn't quite shine yet in L.A. on my own, I could bask in Wanda's glow. Or was it heat?

Looking back now, I should have known there would be trouble. Actually, I did know then. At Eightfold in Echo Park, I sat having an overpriced, delicious, hot beverage with my rad writer friend Jess. Jess loved L.A., really loved Echo Park, although soon would leave them both. (I guess Jess would leave them to me.) Jess is white, queer, genderqueer/trans, and while warm and soft-bodied, always seems sharp, fierce, and unphased by the messiness of writing life down. Jess even texted me about "always wanting to get closer to

the edge whatever that is" in writing, a sentiment I deeply admire but, unlike Wanda Coleman, can find hard to enact. The PDF printout of Wanda's chapbook sat on the table before us as I weighed whether or not to write about it.

"I don't know, Jess. Wanda is amazing. But this work is no joke, and they want me to write something superfast."

"Let me see it." Jess thumbed through the printout with large animal fingers. "This looks badass. I think you should do it."

"I want to do it. Still it's pretty high degree of difficulty. I mean the title alone . . ."

The word *fag* was one thing in 1977 but seemed like spoiling for trouble today. Actually, that's not true. Then and now, *fag* is an inside/outside word. It can be a provocation, an insult, a tease, a joke, a whisper in bed, a word screamed before a beatdown, an echo of something overheard. Whether it lands as offensive or affectionate depends on who you are, who is saying it, who is hearing it, when, where, and how. Today, the social stakes are high, the patience for nuance is low, and the outcry can be loud if you get it wrong.

"You can figure it out," Jess said. "Go for it."

As we kept chatting and caffeinating, I felt the California sun beam through the windows. I saw Angelenos strolling into the vegan bakery next door. I heard a baby gurgling in the corner of the café. Lori and Keanu flitted into my mind. It became clear that I had already decided to accept the assignment. How could I resist the chance to lift Mama Wanda up and be linked to her badassery? I took a Lyft home because I'd been too scared to drive myself there.

**art** (n.) early 13c., "skill as a result of learning or practice," from Old French *art* (10c.), from Latin *artem* (nominative *ars*) "work of art; practical skill; a business, craft;" Greek *artizein* "to prepare," suffixed form of root *ar- "to fit together." Etymologically akin to Latin *arma* "weapons." **in** (prep.) a Middle English merger of Old English

*in* (prep.) "in, into, upon, on, at, among; about, during;" and Old English *inne* (adv.) "within, inside." **the** (determiner) definite article. INFORMAL•ARCHAIC denoting a disease or affliction. **court** (n.) late 12c., "formal assembly held by a sovereign," from Old French *cort* "king's court; princely residence," from Latin *cortem*, accusative of *cors* (earlier *cohors*) "enclosed yard," and by extension "those assembled in the yard; company, cohort," from assimilated form of *com* "with, together," also in the sporting sense "smooth, level plot of ground on which a ball game is played."

*Damn, Mama Wanda! I've been reading your book. No shocker, it's good as hell. And I've bartered with the people for a little more time. It's super hectic for me right now with work, and your poems are demanding. Your language is jam-packed with images, your tones can shift, and a poem can change on a dime. My favorite poems are "Sweet Mama Wanda Tells Fortunes for a Price" and "Landing Place" with "ancient marks / from past burnings." And I want to know more about what inspired "The Emotional Con Meets a Virginal Ideal," but you already warn "don't ask for explanations . . . / you wouldn't want to pay the price." Damn, okay. Maybe some hints about the title poems? There's so much anger there and brio and sarcasm, and maybe some insecurity and hurt. It's been hard to parse it all out. Still, it's been a pleasure. I actually first typed* pressure, *a Freudian slip. You can tell all this happened last year before the 'rona hit, because now I'd never agree to submit such complicated, condensed thinking and writing like this under such a strict deadline, especially one set by a predominantly white press—from faraway. If pandemic and uprising have taught me anything, it's about the reconfiguration of time. Your poems create and operate in black time, dense, explosive, and full of singularities. How do you wrap a supernova in a bow and press send? But, excuse my French, Mama Wanda, why the fuck did you name this book* ART IN THE COURT OF THE BLUE

*FAG??? Are you actually shading gay people? Are you trying to get me in a mess?*

*I should've asked you when we met that time back in Ohio. You shared a shuttle ride with us from the airport to the conference hotel, me and Rosa, Jeffery Renard Allen, and that photographer L, who promised to send Rosa the pictures she took of us but never did. In the shuttle, I recall the vibrant pattern of your clothes and your big owl glasses like Minerva, another wise-cracking goddess. You were funny, saying there's no such thing as random after 9/11, every time you fly, you know to add extra time for the search. As it turns out, you'll still require extra time. (Does black time always require extra time for research? But now I'm talking about now.) What did they think they had on you then? What did you carry in plain sight that they couldn't see? Towering hair, dark brown skin, stunning mouth.*

*I'd already read your poems—your American sonnets are AMAZING! I read my first one in that* Best American Poetry *that Adrienne Rich edited, the one Harold Bloom talked trash about but I deeply loved, the one with that amazing poem by Jacqueline Dash, the first contemporary poem I ever read by an incarcerated poet, and the book was full of women and people of color and YOU, and I was so surprised to learn later that you thought black people didn't read you. I read you, and read you a lot more after witnessing your reading in Ohio. You brought your poems into your body, and you turned those poems out! Ragged breath and astounding song. Your voice contained so much control and freedom. I don't recall any red flags or blue words but maybe I wasn't as watchful or attuned as I've had to become. Maybe I just got carried away.*

*Today, could you read what my intro's editor calls your "blue F poems" in public without uproar? Without getting blackballed not just by a brick-and-mortar store but the whole worldwide web? Neither you nor your sexuality were vanilla, but you weren't Larry Kramer either. How could you use language that didn't seem like it belonged to you today? Maybe with a disclaimer, an explanation, or a warning, you could somehow get away with it? Or maybe you*

*wouldn't care? In this time of ultraprecise, ultracontested speech, I CARE. Who should say the last word of the title of your very first book? Who is allowed to read it aloud? I'm sorry, PLEASE stop looking at me like that. Like the mother at the end of Jamaica Kincaid's "Girl"* ("you mean to say that after all you really are going to be the kind of woman who the baker won't let near the bread?"). *How brave am I really? How wild and cool? How queer? I'm reading your work in Southern California on a tight deadline and trying to write critically, honestly. But how much is possible in this moment? How much messiness can I abide? I'm thinking about freedom and exile, solidarity and suffocation, and of course my own quiet, tragic sexuality. I marvel at your brazenness and feel the limits of my own. Who were you to write this? Who do you need to be? (Do I get to be THAT BITCH? Am I trying to be that bitch?) What am I afraid of? Right or wrong? To really read your work, what threshold do you want me to cross?*

*Art in the Court of the Blue Fag* by Wanda Coleman
An Introduction by Gabrielle Civil

The very title of Wanda Coleman's chapbook, *Art in the Court of the Blue Fag,* raises a red flag. On some websites, the title actually appears as *Art in the Court of the Blue Flag,* as if to sidestep her problematic language. This is impossible. Problematic language is part and parcel of Coleman's poetic project. Her work forces us to confront the offensive and consider how art can and does exist within this realm. (Spoiler: it isn't always pretty.)

Born in 1946, Coleman was known in her heyday as the unofficial poet laureate of Los Angeles. A bold, brilliant, black woman writer, she combined visceral surrealist images with searing social observation and critique. She was also a proud, literary troublemaker. Even after her critique of Maya Angelou got her shunned in some Afro-literary circles, she remained stubbornly outspoken.

Appearing in 1977, this chapbook was Coleman's first poetry manuscript and marked the start of her long publishing relationship with Black Sparrow Press. Most famous for championing Charles Bukowski, Black Sparrow publisher John Martin also published Diane Wakoski, John Yau, Larry Eigner, and many other exciting, avant-garde writers. Coleman was the sole black woman on the Black Sparrow roster. She published ten more books with the press, both poetry and prose, before her death in 2013.

*Art in the Court of the Blue Fag* signaled her concerns from the start. It arrived the year after Coleman earned an Emmy screenwriting for the soap opera *Days of Our Lives*. While she had many jobs as a black working mother and writer—waitress, typist, medical secretary, journalist, magazine editor, teacher for "at-risk youth," and college instructor—the soap opera connection especially resounds. This chapbook vibrates with love affairs, sexual dalliances, and passionate confrontations. Yet, the ambience is often more gritty than romantic. Sex is often transactional, and sexual desire is fluid. The perspective is unapologetically black, female, and working class.

In the opening poem, "Sweet Mama Wanda Tells Fortunes for a Price," she writes:

> i am here to fuck
> then go back
> to the streets
>
> . . .
>
> i am hungry
> i smile
>
> i know what tomorrow
> is all about

Here a sex worker narrates her experience with a client. At the same time, I can't help but take "I am here to fuck" as an opening salvo from Coleman herself: *i am here to fuck with you: your mind, your language and pre-conceptions. Mama Wanda is here to fuck you up!* Hunger arrives as physical pang and poetic ambition. The smile comes from turning both a sexual and a poetic trick. The sex worker exists also as poet, fortune-teller, and sage ("i know what tomorrow / is all about").

But at what price? Throughout this chapbook, knowledge has its costs. In "Landing Place," a woman suffers during lovemaking knowing her lover still desires his ex. In "They Came Knocking on My Door at 7 AM," aware-ness of police intrusion changes the dynamic between lovers ("we started fucking again / but things had changed"). In "The Woman and Her Thang," an attempt at vulnerability swallows a woman's lover whole. Coleman's poems offer an unflinching look at the messiness of human relationships. This becomes the cost of living.

In light of the chapbook's title, Coleman's depiction of same-sex desire and gender deserves a special look. "Beyond Sisters" begins with a woman seemingly rebuffing another woman's desire ("she loves me she spoke words i forbade with / my sexology and lust for man-flesh") but then shifts to the speaker grappling with her own desire ("if i would say her name . . . if only i could say her name"). In the face of her own refusal ("mirror reflects determined set of my jaw"), the speaker admits to being "both male / female." At the very end, the aspiring lover proclaims: "you be mine—you be my bitch." Once again, profanity has the last word.

This returns us to "Art in the Court of the Blue Fag," the title of the three poems that end the chapbook. These poems offer urban phantasmago-rias. The first poem shows "playpoets" gnawing on the bodies of those around them ("another / tasty life appropriately spiced with / liquor drugs and a pinch of sex"). The second poem zooms in on distorted land-scapes and stark images of addiction ("reds. a pin three holes. hot water / down. thigh. moon vomiting blood").

The final poem presents a bleak scene of urban poverty and black female maternity ("black eye laced in pancake, she sips seven-up / pregnant with the eighth or ninth"). Here black mamas swear to teach future generations how to fight back, slander, and survive ("when / baby comes i will name him pretty poison / and teach him street"). Coleman makes these same moves with the creation of "the blue fag," the titular figure who shows up at the end of all three poems.

> Who or what is the blue fag?
> the slurred homosexual?
> the smoldering cigarette?
> the unspeakable? the colored?
> the aloof? the effete?
> the sovereign? the specter?
> all the stuff Mama Wanda shouldn't have said
> all the stuff she says

With this figure, Coleman conjures and demeans the realm of boho high art. This character evokes and perpetuates stereotypes of melancholy ("blue"), elegant detachment, hunger for abjection, and artistic gate-keeping. She writes, "the blue fag yawns / and requests that someone piss quick before he / dies of thirst." Here he becomes Coleman's foil, a figure she both lifts up ("he is the ruler of the realm") and defames with homophobic language. The tension between these positions is a key element of the work.

Coleman would continue to write more "Art in the Court of the Blue Fag" poems for decades to come. Outrageous and outraged, visceral and wry, this chapbook marks the debut of her distinguished literary career. This is the art she brings to court.

*HEYYYYYYY Mama Wanda, I did it! I wrote the intro to your first chapbook and got up at the crack of dawn to get it turned in on time. The press is on the East Coast and they wanted it to arrive at NOON,*

149

*which is 9 a.m. for me, but I was determined to keep my word, and so I did it and wasn't the trifling late NEGRO and felt proud of what I turned in. Or at least I did the best I could to honor your work and also hold you accountable and maybe myself. It was tricky and hard and took a bunch of revisions. After getting in that first draft, my editor came back with some serious crits. I really like this editor. We've never met in person, but I think she's white and an excellent close reader of your poems. (As a kid, I used to wonder, not often, but every once in a while, what kind of white girl I would be. Not blonde probably, maybe a brunette and thinner. Maybe smart and thoughtful, like her?) She has pushed me to be more precise, and also to try not to let you off the hook. Who is your ideal audience? Do you want queer people to read your poems and like them?*

*I'm writing this now at my friend Lewis' place in North Carolina. I've been telling him all about you and the saga that unfolded with this introduction, and he was like, "Well, as a faggot myself, I want to read her book and see what she has to say." But of course how do I sound now? "Well my self-described faggot friend says it's all good." When white people say stupid shit like that about their black friends, we all roll our eyes. (And Lewis is white too.) Anyway, it took more time to go through the various drafts for the press, but it felt like good time. Things dissolving and expanding, constellating. It's a true gift to have someone read your work and respond to you honestly. I tried to do that for you and M, the editor, tried to do that for me. She gave me good feedback, and I made changes we both thought made it better. From the start, the folks at the press seemed to like my writing (and you know they liked yours, because the whole project was about you). I heard they were so excited about reissuing your work that they actually wanted to WAIT to put it out, to maximize the impact. Uh huh. You heard that correctly—after hounding me for the text, they decided to delay.*

*The holidays were coming, and that was fine. Then more time passed and they told me they were working through some things, and we want to give it a little more time, well maybe the staff is wondering,*

*it's not your writing, Gabrielle, it's just looking at it again, well, some folks here are a little nervous, there are second thoughts on the team, like maybe forty percent of the staff (40% OF THE STAFF!), and we're negotiating some other internal situations, and we want to really do this right. I don't know, Mama Wanda, maybe the left hand didn't know what the right hand was doing, or maybe it was one of those things where one person had a grand idea and didn't really talk it through with everyone else, or maybe the reality of something coming out with lightning-rod language (thanks again for that title) started to become really real.*

*For sure I should've asked more questions from the start. But they asked ME to do this and wanted it fast fast, and then it got slow slow, and in the meantime the pandemic hit, and everything got more intense, and I got more and more nervous. I imagine you trusted John Martin a lot to do so many books with Black Sparrow, because it's an awful feeling not to know what will happen to your words and that maybe something incendiary will go out into the world with your name on it, and the folks who put it out might not have your back. I got scared and mad at myself for getting in a twist like that. (Have you seen what happens when the wrong person gets caught with the wrong word? I don't mean the President. I mean people like me and you.) And I felt selfish for worrying what might happen to me if things went wrong. Because really, the point was for you to be at the center, not me. The thing is, people could read your poems and not like them, or find you offensive or homophobic or overstepping your bounds, but the concern didn't seem to be about the poems them-selves, but the TITLE of the book. (And maybe how that title would look in an email blast or Instagram square . . .)*

*It reminds me of when I asked my old friend Eric Leigh what his relatives thought about his poems, which candidly discussed his HIV status, his gay love affairs, and his father's suicide. He said, "Gabby, this is eighty pages of contemporary American poetry. They bought this book to support me, but none of them are going to read it." Maybe sometimes what you call a thing is more important than*

*what it is, although some folks think those two things are always the same. Your title refused to smuggle anything inside. And because of it, people might not read your book. The book might never resurface. Or if it does, the world might repudiate you completely, Mama Wanda, or the press, or me. What's wrong with Gabrielle Civil? I thought she was cool, maybe a little wild, but actually she's anti-gay, or an asshole, or just stupid, getting mixed up with that white press who wanted to put out work by a black woman poet with fucked-up language like that. Ça se fait pas! Some people get to say some things all the time. Some people get to say some things sometimes. And some people should shut the fuck up. Fuck that white press and Fuck Gabrielle Civil! Gabrielle, Why Aren't You Dead? #faulty #duped #guilty #messy #rachet #overreaching #wrong #exiled #bye*

Dear M,

I hope you're staying healthy and warm!
I'm writing to check in on the rollout of the Wanda Coleman chapbook.
Has the press talked more about how and
when the chapbook might emerge?

As we've discussed, it's been a bit of an emotional roller coaster
with this project and the long process has made me nervous
(esp. because if things go sideways,
I worry that I'll end up in the jackpot.)
Can you let me know a little more about
who is making the decisions and how?
Would it even be possible for me to speak to that person?

Sending you best wishes
for health and poetry from California,
(where is William Carlos Williams when we need him?)
Gabrielle

**of** (prep.) Old English *of,* unstressed form of *æf* (prep., adv.) "away, away from" *"Of* shares with *as,* the evil glory of being accessory to more crimes against grammar than any other." [Fowler] **the** (determiner) related entries *lest nonce she that then thence there thilk ye* **blue** (adj.) "of the color of the clear sky," c. 1300, *bleu, blwe,* etc., "sky-colored," also "livid, lead-colored," from Old French *blo, bleu;* pale, pallid, wan, light-colored; blond; discolored; blue, blue-gray common from c. 1700. "lead-colored, blackish-blue, darkened as if by bruising" perhaps by way of the Old Norse. It is the meaning in *black and blue,* and *blue in the face,* "**livid** with effort" (1864, earlier *black and blue in the face,* 1829). **fag** (v.1) "to droop, decline in strength, become weary" (intransitive), 1520s, of uncertain origin; OED "common view" that it is an alteration of flag (v.) in its sense of "droop, go limp." (n.1) British slang for "cigarette" (originally, especially, the butt of a smoked cigarette), 1888 (v.2) "put to work at certain duties, compel to work for one's benefit," 1806, from British public school slang (n.) "junior student who does certain duties for a senior" (1785) (n.2) shortening of faggot, "male homosexual," by 1921.

Have you ever wanted something so badly and then gotten it? And then found it hard to hold, hard to feel good deep inside it? That was me, writing an introduction to Wanda Coleman's chapbook. Well, not the writing so much as the sending it into the world without a clear and supported plan. I'd hustled hard to live my dream, to be visible enough as a black feminist writer to be asked to offer insight about the work of another black woman writer I was coming to love more and more. But I was wary of words getting out of control (associations with problematic values and institutions). Negotiating timelines, correctness, and authority was the thing that came along with the other thing. Still, I had wanted to do this,

I still want to do this, share my words with the world and help bring more of Wanda's fullness, brilliance, and messiness to light. What can it mean to open into something different, the possibility of being someone different somewhere else, in something else, especially if it's hard? What new black feminist writing could emerge? Could I navigate mountains of exposure and plunge headlong into my fears? Could I live up to Jayne, Ntozake, Sonia, Wanda herself? Could I turn it all into a palindrome?

So what if I'm not sure how this will land, if butterflies still flutter in my brown, fleshy stomach? Go ahead, caress or squeeze. Even if it's true that we bring ourselves wherever we go, and we can be called out, ejected, or maligned (rightfully, mercilessly), I could still aspire to be messier and wilder, just like Mama Wanda. I can be honest. I've just stayed up all night in North Carolina, away from my home, feeling the spirit of Wanda Coleman all around me. Lewis went over to his sweetie's, so I had the place to myself. I burned a red hummingbird candle for love and listened to the wind brush through the trees. In a different landscape, a different time zone, with birthday love from my blood and chosen people—yes, Libras!—I'm making a new home for these words. To spend more time with Wanda Coleman's poems, to plant this blue flag, could reinforce my claim to the archive of black women's creativity. If I couldn't quite shine in the press' original project, I can still try to blaze in my own glittering darkness. Or radiate?

Looking back now, maybe this was how it was meant to be. I was on the phone with my rad theater artist friend Franklin in my SoCal apartment, where for days on end I'd been navigating the terrifying start of the COVID-19 pandemic. Franklin was planning to move to L.A., and we were discussing possible plans. (I guess Franklin was planning to share L.A. with me.)

Franklin is black, queer, uses they/them pronouns, and while warm and kind, always seems sharp, shrewd, and ready to renounce things in art that do not serve. I remember seeing a show in Minneapolis

about their (fabled) death and (imaginary) life and reveling in the scope of their imagination. I'd been struggling with the fate of the Wanda Coleman chapbook and decided to ask their opinion.

"I don't know, Franklin. Wanda is amazing. But this situation is no joke, and things are moving super slow."

"Hmmm," Franklin said, making a soft sound with their tongue from the back of their throat. "White institutions try to solve a problem and cause two more." We chuckled.

"Gabrielle, how much did they pay you for this?"

When I told them, I could see the look they gave me over the phone, really *through* the phone.

Franklin said, "You're going through all this for them for *that*?"

And in the pause before either of us spoke again, I felt the California sun beam through the windows of my kitchen. I saw the stillness of the empty street. I heard the liberated chirps of birds outside, loud as fuck during human quarantine. And it became clear to me that I'd already decided what to do. When I hung up the phone, I was driven, relieved, and unafraid.

> It's not a no-brainer.
> It's harder than it looks
> to be a badass black woman writer
> to be a badass writer or artist
> or person or reader or critic
> or thinker or publisher of any kind.
> It's especially hard to be a bad girl.
> You know, the right kind of bad girl
> a good bad girl like Cardi B
> or Megan Thee Stallion, although
> she ended up shot in the foot
> but a bad bad girl is a problem
> like Azalea Banks for 45 in 2016
> or Diamond or Silk with their schtick
> or deeper hustle like Candace Owens

I like some bad bad like Chelsey Minnis
but that's a whole different thing.
If you're a black woman poet,
what space is there really to be a mess
put your foot in your mouth
say the wrong thing for real?
Wanda wrote:
"i notch each failure with a burn. the eyes of tucson—radio's
lisp or hollywood's houndstooth jacket in nether world of
    juke and
jive, a blossom—a chocolate poppy smoked black onto a
    needle's tip."
Wanda wrote:
*"they either get too much of me or not enough"*
I want to contend with all that
but I'm not sure the world is ready
or if I am, for that matter.

Dear M,

I hope you're staying healthy and hopeful at this terrible time.

Reflecting on my art and writing practice in this moment,
I've decided to withdraw my introduction
for the Wanda Coleman chapbook.
Engaging her writing and moving through the editorial process
with you has been powerful, but the project has never felt
fully in sync in terms of timing, rollout, and organizational commitment.

For many practical reasons, including geography and timing,
I feel out of the loop of decision-making processes, and my own writing
—which is very important to me—is in an uncomfortable limbo place.
If things go sideways with public reception, which they could,
I would be squarely in the jackpot. And I probably should have

thought about that more from the very beginning. To be honest,
I was a little nervous at first but was super excited about Coleman,
and I had a lot of trust and faith in your press. Now that we are
all embroiled in a global pandemic, the stakes for art are even higher.
I don't want to feel stressed out that any day soon or in the future
the chapbook will just drop with my intro without my say
and without everyone at the press having my back
and being on the same page.

If and when the public health crisis is resolved and your press decides
to continue with the project, develops a clear plan for launching it,
writes an organizational statement about including this work,
enlists other writers to contribute essays,
and works those essays through
the same kind of editorial process
that my essay was worked through
so that the whole project is completely
thought through and fleshed out,
then I could consider resubmitting my piece—
if you all still wanted it.
But those are a lot of steps.
And one thing that really strikes me is
how rushed I initially felt with this project,
how urgent it all seemed to get it out
without perhaps everyone fully being on board.
However the project develops, hopefully that dynamic
won't happen again and everyone can take good time.

I do hope Coleman's work gets back out into the world
and that it can lead to productive conversations about messiness,
unruliness, and offensiveness in poetry and society.
I still think it could be worthwhile to have an entire series just on that.
On my end, I plan to write about those issues
as a black feminist performance artist and poet,

and I still plan to write more about Coleman in a longer essay. I have fond memories of meeting her and believe that she is a brilliant, underappreciated poet. Hopefully we can all look at this project as a learning experience and both the press and myself can grow in positive ways.

Thank you again for your thoughtful, close reading and editorial prowess. Feel free to reach out for a call if you want to talk more about this situation.

Take Care & Stay Healthy,
Gabrielle Civil

About a year ago, I was invited to write an introduction for the reissue of Wanda Coleman's first poetry chapbook from 1977. At the end of a protracted, heart-wrenching process, I had two choices: stay the course with this tiny book—either waiting out my reservations or helping the press figure out a solution—or choose the abundant security of staying out of trouble. A black woman writer's first book was trying to come back into print, and when things got hot, I split and took back my own serious consideration of her work. While I can question some of Coleman's choices, I also have to reckon with my own. Even if re-releasing her work to the public diminishes her reputation (and my own and that of the press), holding it back perpetuates her silencing. The good news is that if you want to make up your own mind, you can find Coleman's "Blue F" poems in several of her poetry collections. (Have fun trying to bend your mind around them like I did!)

In the meantime, key questions remain about vulnerability and risk, and my ability to tolerate them both. Reading Coleman's work humbled me and helped me recommit to what might seem like opposite values: I want to proceed with courage and respect for

others; I want to allow for messiness and wildness within myself and other people both inside and outside my communities. I want to be able to take a chance, to try something new, to be bad and good, to say something that could be wrong, and to be capable of taking the blowback. My dear friend Madhu once asked:

> do you want to be good?
> do you want to be liked?
> do you want to be right?
> or do you want to be free?

As this essay shows, I'm still trying to figure it out. Lewis, also a writer, says there's a difference between being vulnerable and feeling vulnerable. With her struggles with poverty, marginalization, and family tragedy, with her ambition to write startling, indelible poems reflecting both her reality and imagination, I wonder how Mama Wanda would talk about the two. Wait, I don't wonder. Her poems offer myriad answers. Everyone should read her poems, even this first chapbook, although to date its reissue remains stalled. With the right context, organizational support, and nuanced conversation, I pray a new edition will move forward.

*Well, Mama Wanda, your chapbook and my intro didn't go anywhere with those people and the process worked my very LAST nerve, and I'm rolling my eyes and clicking my tongue, but I also have to laugh because of course this was how it would go, and we can still go plenty of places on our own, and I imagine you right there in the empty seat next to me on the plane, on my BIRTHDAY trip to North Carolina, a much-needed getaway from this never-ending deluge. Mama Wanda, this virus is kicking black people's ass (as if another method was needed), but don't worry, TSA was nice to me, I have a good mask and wipes, and my earbuds have been suitably sanitized. I've been listening to this interview with your boy Terrence Hayes, who's been trying to hype you, bringing his considerable bona fides to your*

*own considerable body of work, trying to revive you, saying if people called you MEAN it was mean like Miles Davis, brilliant mean, but the interviewer was like, Wanda Coleman was POOR and BLACK and her son DIED tragically of AIDS, and I was like, that's where you want to start, lady? What kind of abjection porn is this?*

*It's like what Nikki G said: "And I really hope no white person ever has cause / To write about me / Because they never understand," but Terrence understood and tried to bring her around and explained that you read Shakespeare and Nietzsche because that's what GENIUSES do, so it's actually not that SURPRISING. Come to think of it, Terrence may have been at the black poetry dance party too, at the conference in Ohio where I met you, he showed up in the anthology that came out of it and you did to, although Rosa and I were NOT invited to submit. I guess our thing was too weird. We created a black poetry HAPPENING with writing prompts and inscribed objects, a basketball with lines of poetry by black poets, I still have it, and poems on giant Post-It notes all around the room, and cockroach candlesticks (for real, they had giant bugs soldered on to them, and they came from the dollar store). You had to declaim black poetry to get in the door, and people talked about what black poetry even was and worked together in groups to make something to show its impact in their lives, and I guess the organizers thought that was too fluffy or bizarre or didn't fit into what a proper publication should be so there's no record we were even there except on the DANCE floor because we did tear that up until the knee incident, and I was so mad at being left out of that anthology I never even opened it, although now I might peek because maybe it would remind me of the poems you read there, Mama Wanda, and the sweat and sway and waving and bearing of all those black poets, until we can see the black poets are dancing together again*

broken is a way for
filament
to pass through
any space
for riven things
to double back
and see all the pieces
—*Asiya Wadud*

gotta get a hold of me / thought i had a hold of me
... / someone's gotta hold of me / hold me
—*Okwui Okpokwasili*

*After the End*

We need new dreams.

—*Ben Okri*

bodies dream of themselves

the accumulation is undeniable

disorder the mess the non-resolutions

. . .

the shape we desire changes

—*erica lewis*

Death cannot put the brakes on a good dream.

—*Marva Collins*

# Pony, Swim, or Freeze?

*[voiceover]*

*As the lady in brown tags each of*
*the other ladies they freeze. When*
*each one has been tagged the lady*
*in brown freezes*
. . .
*All of the ladies start to dance.*
*The lady in green, the lady in blue,*
*and the lady in yellow do the pony,*
*the big boss line, the swim, and*
*the nose dive. The other ladies*
*dance in place.*

—Ntozake Shange
*for colored girls who have considered suicide/*
*when the rainbow is enuf*

## % % % %% % ? % % %% WHO OR WHAT IS HUMAN?

So, here's what happened. The door flew open and they filled the room. Juicy. Brimming. Sheer life force. Laughing. Talking. Singing. Humming together. Their energy was magnetic and radiant. They

were playful *(horsing around)*, teaching each other dance steps, making up routines *(like we used to do back in the day to our songs on the radio)*. They were blackgirls, full of themselves, feeling themselves. Loud and funny and happy and curious and so excited to be there.

It was the end of Activating / Performance \ Activism, a new class that I got to develop through a generous university fellowship. My student Cierra L. King, whom we called Ms. King at her request, had driven a college van back to her old high school to pick up these blackgirls, who had just sprung into the room. (I want to say they sprung like Athena from the head of Zeus but why keep giving the Greeks so much credit?) These blackgirls were members of #OurHeartsOurVoice, a group that Ms. King had founded as a student at that same high school. For her final project for our class, Ms. King got support from my fellowship funds to bring these blackgirls to campus, feed them a meal (at Dragon Village!), allow space for them to look around, maybe start to feel comfortable on campus, like it could be theirs, like, maybe one day, it could feel like it was theirs already. At the end of the day, the blackgirls would come to our class performance event.

Mind you, hours before said performance event, I was salty. Our dress rehearsal had not gone well, and I felt that my students had not prioritized our work, our making and being together. In class, I had experimented with offering more space in my pedagogy for students to cocreate the experience, to bring their own energy into the mix. While Ms. King and a couple others took me up on the offer, too many of my students were listless, lethargic, late to class, and lifeless too much of the time. Mind you, this was in a majority-POC, majority-female-identified, notably queer space. I looked at my black women students and was struck at how reserved, protected, and quiet they often were. To be fair, many were stressed out, sad, and exhausted. Still, I was dismayed at how dead their energy often felt, how abducted, disembodied. How often they sat doubled over, scrolling their phones.

For a black feminist professor, this was rough. It is hard to admit this because, on general principle, I love my students. And I feel special responsibility for my black women students and students of color. Yet, I have to be honest and say how much their lack of energy dispirited me and led to my own alienation. I did my best, but as the term went on, it felt harder and harder to apply my feminist sense of care. I felt harder, less present, and more disembodied myself. By the day of our final performance, I had become a downright grinch. *No Soul Train line for you at the end of this show!*

But then those blackgirls arrived, scintillating, a couple hours before the show started, and in five minutes, they gave me life. *Can we put on some music?* they asked. They started to DANCE. These black teenage girls from Columbus, Ohio, were not professional dancers. They were human beings, wonderful, embodied humans being together. How rare and precious that seemed to me, especially in contrast to my class. So many of my black women college students seemed bodysnatched, sapped, depleted, guarded, evacuated, in a kind of freeze—at least within white institutions. And I wondered, is this how it happened? The end of humanness? The end of the world? If these juicy high school blackgirls came into the predominantly white private/privatized institution, or even into my own classroom, would they too get sapped? Would they too become alien? Or should I say humane?

TROUBLING THE ANIMAL HUMAN "I" % % % %

These remarks arrive on a panel entitled "Troubling the Animal Human 'I'." To say aloud what you already know: black women have long troubled the Animal Human "I." This has been true historically, categorically, and essentially. We have been explicitly placed on the lower rungs of the great chain of being. *("Hi, Australopithecus cousin Lucy!")* We have been beasts of burden, legally exiled from human status, rights, and privileges. Scholars like Paula Giddings, Kimberlé Crenshaw, and Patricia Hill Collins have documented

this at great length; black feminists like Audre Lorde, bell hooks, and Janet Mock have reckoned with the ramifications.

At the same time, as a black feminist professor, I have to accept the ways that pedagogy, or at least traditional college teaching, has long had a troubling relationship with the humane and the construction of the human. The project of the humanities (the arts and sciences) has been to mold a particular vision of the human, as well as to humanize, i.e., socialize, i.e., civilize—not Gabrielle Civil-ize, but tranquilize—and in some instances euthanize ways of being/thinking/making/doing/writing/organizing that don't fit with the program. And I must confess, at times when my students, black women and otherwise, don't act or embody themselves and their humanness in the black feminist way that I want, I likely become a part of that dynamic as well. As the professor, I set my own pedagogical standard of the human. Even as I want to say that this standard emerges from my black feminist poetics, strategies of resistance, and thriving, I recognize within myself some old-school, wooden-ruler pedagogy invested in objectives, structure, rigor, judgment, and control.

In *for colored girls who have considered suicide / when the rainbow is enuf,* Ntozake Shange writes, "First the lady in brown is in motion, and the other ladies freeze." Then she tags them, and they start to dance, pony, and swim—although some do the big boss line and others take a nose dive. What is this freeze that stops black women in our tracks? How do we tag and activate, liberate each other? What happens when we pony and swim? What happens when we connect with other beings, other beingness, other ways of being in nature? In the world? With each other? In the classroom? How do we practice and play as human beings? Is dancing in place a good or bad thing? And what comes after that?

% % % % % % %% % ? THE END OF THE WORLD %

In response to these questions, enter Alexis Pauline Gumbs' new book *M Archive: After the End of the World.* This text synthesizes

170

black feminist theory as creative urgency. In her opening note, Gumbs declares, "This book centers Black life, Black feminist metaphysics, and the theoretical imperative of attending to Black bodies [that] calls preexisting definitions of the human into question." Written from the vantage point of the future, *M Archive* exposes how we destroyed ourselves, our earth, air, water, and sky, and how black women, long set outside of the category of the human, serve as the only alternative for survival. There is no question that we are now in a state of apocalypse. After the end of the world, all beings must confront and reject past notions of knowledge, pedagogy, and humanity. To do this, Gumbs proclaims that we must reckon and embrace black feminist metaphysics.

> the university taught them through its selective genocide. [. . .]

> to put it in tweetable terms, they believed they had to hate black women in order to be themselves.

> even many of the black women believed it sometimes. (which is also to say that some of the people on the planet believed they themselves were actually other than black women. which was a false and impossible belief about origin. [. . .]

> there is no separation from the black simultaneity of the universe also known as everything also known as the black feminist pragmatic intergenerational sphere. [. . .]

> you can have breathing and the reality of the radical black porousness of love (aka black feminist metaphysics aka us all of us, *us*) or you cannot. there is only both or neither. there is no either or. there is no this or that. there is only all. (7)

Dense, cosmic, and stunningly beautiful, this passage breaks down the university as site and mechanism of a certain kind of death of and for black women ("the university taught them through its selective genocide"). Here I think back to the annihilated affect of some of my black women students ("even many of the black women believed it sometimes"), as well as the destructive impact of academic life on many of my black women academic forebears and peers.

For too long, educational institutions have perpetuated false knowledge about the category of the human, defaulting it to the educated white male ("[they] believed they themselves were actually other than black women," indeed "they believed they had to hate black women in order to be themselves"). Gumbs' "tweetable terms" speak to how this false idea of black women circulates beyond the academy in social media and popular culture. She repudiates all this ("there is no either or. there is no this or that," "there is no separation from the black simultaneity of the universe"). The only recourse is to return to the original source: "the black feminist pragmatic intergenerational sphere."

Black women shift here from subhuman to ur-human, maybe even über-human and posthuman at the same time. Black women are centered and become central to the project of recovering—or transcending—humanity, the human animal "I." This theoretical move recalls the actual moves of those blackgirls dancing before the show, how they regenerated me and my pedagogical spirit. Gumbs' work also reminds me of teaching Audre Lorde's "Poetry Is Not a Luxury" for a group of multigendered people. When Lorde talks about black women, I asked, what would happen if you imagine she's talking about you too? What will happen to essentialism after the end of the world? And aren't we already there?

Gumbs models something wry and cellular, specific, porous, and simultaneous. In contrast to the "selective genocide" of university teaching, the hateful tweets, and self-loathing, black women (*blackgirls!*) can give way to emanation, collectivity ("aka us all of us, *us*"), and life force ("breathing"). I claim this aspiration in my

own black feminist poetics and hope to embody it in my pedagogy, my critical and creative work. Breathing deep, I return again and again to these questions:

> Who or what is a human being in a college classroom?
> How can we be humans together in a black feminist way?
> As Brenda Iijima asks:
> "How can we readapt our relational perspective
> to forge an open-source intrarelational exchange . . . ?"
> Or how can my black female-identified
> bodysnatched students keep breathing / get their life force back?
> How can I walk the walk—dance the dance—
> of my poetics in my pedagogy?
> In the classroom, in my writing, after the end of the world,
>> will I dance in place?
>> Will I pony, swim, or freeze?

# Public Mysteries

*Perhaps you've seen us . . . on the side of a road, on top of a bridge or under one, on a rooftop, by a light post, in front of a museum, at the polls, at a protest, remembered, inside your dreams . . . or perhaps it's been you . . . grooving, swaying, twisting, stretching, provoking, befuddling, insisting, dancing in the streets. Either way, this evidence: this body in space, yours or mine, has mattered for some time, and, with good luck, will matter for a long time to come.*

*How long? An Icelandic friend told me that our age doesn't span from our own birth through death, but from our grandfather's birth to our grandson's death. Or perhaps it's even more expansive. How can we capture the time of our lives, our movements through generations, into the future, at or beyond the edge of our imagining?*

*This was the task set to me: to contribute to the creation of a thousand-year plan for a public dance practice called Don't You Feel It Too? You heard that right: a thousand years. The number was staggering, comprising forty to fifty generations. Who could say what the world will be like by then? Or if it will even exist . . . Will we have grandsons or granddaughters or grandpeople or a whole new rich conception? Will there be cities and cyborgs and music piping into*

*our ears? And how will the entire quagmire of contemporary politics be resolved? (Did we win?)*

*The invitation to imagine this far daunted, enticed, stymied, and exhilarated me at turns. After a year of considering, discussing, working, sharing, and dancing, this is the plan: a time capsule, a living document, and a choreography of public mysteries. A love letter to a flourishing public art community, this is also a score for future dancers. How dare we dance for a thousand more years? What does it mean to feel it too?*

## ZONE

In simplest terms, Don't You Feel It Too? is the act of dancing inner lives in public spaces. It is a participatory art project and civic intervention. At times, it can feel like a religion, a movement, a dance team, and a consciousness-raising group all rolled into one. Here in this thousand-year plan, I capitalize the name but don't italicize the title: this shows a proper noun slipping into and against the flow. This is because Don't You Feel It Too? is both an artwork and a way of being in the world, subversive and plain. But I'm getting ahead of myself (a fair hazard when dreaming about the future).

In a way, I'm a strange person to be chronicling this practice. That's what devotees call it—not an activity or even an artwork, but a *practice*. Long an admirer of Don't You Feel It Too?, I can recall conversations and events from as early as 2009 or 2010, when I was returning to Minneapolis from abroad . . . But I am certainly not the founder, Marcus Young, the local artist who has made the practice his life's work. I wasn't there from the very beginning. Not like Aki or Theresa. I'm not a main organizer like Shira or Oliver or Diane. I'm not a mainstay like Elizabeth or Matt, who show up eager each week, smiling, ready to dance. I'm not a member of the 2017 A-H-A cohort either—the brave band of Artists-Healers-Activists who have been doing amazing things with Don't You Feel It Too? for almost a year. Kendrick. Xiaolu. Demetrius. Miré.

175

Wendy. Heather. Caspian. Alejandra. Julia. They have been exploring connections between the practice and somatic healing, ethnography, filmmaking, writing, community building, and more. I am none of these people.

Still, I am a practitioner and a dancer, a witness who has marveled at the growth and impact of the practice, a professor who has incorporated it into my classes, a writer interested in live art documentation, and a black feminist performance artist invested in the body in space and time, passionate about the intersections of art, activism, and healing, and curious about the future.

(At the very edge of our imagining, what does
Don't You Feel It Too? look like in the future?
What does it look like now?)

BODY

In 2017, Don't You Feel It Too? looks like a diverse group of people in Minneapolis meeting up each week with pocket music and magic to dance in the streets.

(In the future, do code words like *diversity* even exist?
Will racial harmony have neutralized
the need for such distinctions?
Will multiplicity and intersectionality be so deeply recognized and understood that they
become simply par for the course?)

In our time, Don't You Feel It Too? dancers are brown, black, and white; Chinese, Dakota, Indian, and Chilean; African and diasporic; queer and straight; immigrant and native; female, male, gender-fluid, and nonconforming; able-bodied and disabled; recovering, grieving, and surviving; trained and untrained in dance, in therapy, in meditation; young and old; much else and everything in-between. In this way, the practice truly embodies a multicultural community. This is important because in 2017, in the United States of America, people are extremely divided. Races and classes and communities are deeply stratified, and people from different backgrounds

don't socialize too much. Don't You Feel It Too? becomes a precious convergence.

Of course, not everyone from every demographic is always there. Sometimes, the dancers are predominantly young, white, and queer. Sometimes, as when Ananya brought members of her Ananya Dance Theatre to dance, the practice becomes a woman-of-color convening. This kind of fluctuation is key. Just as you don't know how you'll feel when you wake up in the morning, or how your feelings will change as you move through the day, you don't know how or what the exact experience of Don't You Feel It Too? will be.

You have to show up to see who is there.

You have to show up to be a part of it.

You have to show up and let it happen.

(In the future, this will be the same.)

## TIME

In 2017, we have been having a glorious season of dancing with seventy-five sessions from April through October, not including extra sessions or pop-ups. Practice is free and open to the public. Details appear on a Facebook calendar, posted since spring. A website exists devoted to the practice along with an emailed newsletter. News of Don't You Feel It Too? also spreads through workshops, class visits, press articles, and word of mouth. Newcomers arrive, hearts beating, wondering . . .

(In the future, what new media circulates?

What new modes of transmission?

What new strategies of inclusion?)

## SPACE

It's a beautiful summer afternoon, or maybe it's gloomy and gray. Rain or shine, we meet outside for Don't You Feel It Too? In our time, in 2017, *outside* is synonymous with *public* or *external* as opposed to *inside, private,* or *internal.*

(In the future, do you laugh at these dichotomies?

Don't You Feel It Too? exists to disrupt and blur these dichotomies.)

We meet at Peavey Plaza, an unassuming square near Nicollet Mall in downtown Minneapolis, or in front of the glimmering Weisman Art Museum on the campus of the University of Minnesota, or sometimes at Macalester College in Saint Paul. Practice happens in lively, populated places with multiple kinds of traffic—pedestrians, cars, buses, and bicycles. This way we are sure to be seen and are forced to negotiate the potential awkwardness or delight of this visibility. Hooray! Look! A dog walker, your neighbor, a coworker, your child's friend's mother, a potential employer, a security guard, your doctor, someone on the light-rail from afar, someone stuck in traffic, a bicycle messenger zooming by . . . They could all see and be looking at you.

(In the future, someone could ask:

"Haven't I seen you somewhere before?"

and Don't You Feel It Too?

could be the answer.)

## TIME

Practice unfolds in a clear ritual flow. The leader, sometimes Marcus, sometimes Diane or Theresa or Oliver or someone else learning to lead, welcomes us, acknowledges newbies, secures belongings, and checks in. (Does everyone have their earbuds? Does anyone need to store any valuables in a car?) From the start, we are meant to feel cared for . . . Then, the leader reminds us of the basic instructions. This language has morphed over time, as it surely will keep morphing, but for now, it's been whittled down to just these three rules:

1. Love your music.
2. Move honestly, fearlessly.
3. Feel what you feel.

178

With these words hanging in the air, we put on our headphones, press play, and dance first in a practice round, to get the juices flowing, and then for a longer stint, ideally about forty to forty-five minutes.

Dancing Don't You Feel It Too?, you can play an entire album (Alice Coltrane!), a playlist or mix of songs, or even a single song on repeat (Simply Red's "Lives and Loves," Tricky's "Over Me"). It's your choice: it just has to be music you love. Or as we used to say, "music you love that loves you back." Michael Jackson, Sigur Rós, Loretta Lynn, the Supremes, the Carpenters, Black Flag, Tchaikovsky, whatever moves you that day and helps you move. That's what you play. If you stop feeling it, if you don't love it right then, you don't have to suffer. Stop and change it. That's part of the art. Music in the practice is less a crutch than a divining stick to tap into our inner selves.

(In the future, do we even need music?
What and how will we play?
Will the rules be just "Love, Move & Feel"?
Or even just "Feel"?)

SPACE

Dancing Don't You Feel It Too?, we can stay near each other, shimmying to our own music while remaining loosely in a group; or we can venture off, dance full out on our own in and across public space. Who gets to take up space in this world? In the practice, our bodies become public space. This changes the plan, the physical and psychic landscape of the city.

(In the future, does public space exist?
Will all space be public? Or privatized?)

An older white woman pumps her fists to the rhythm of her feet while a group of Asian college students passes by. A white man with a rainbow unicorn T-shirt dances into the intersection when the traffic light changes. A chubby black woman in glasses gyrates and

shakes while a white businessman walks by with a briefcase. The chubby black woman is me.

(In the future, how often
do you see a body moving,
liberated in public space?
How often do you get to be that body?)

## ACTIVISM

In 2017, to take up public space is a radical act. To dance in public as a chubby black woman, not for money or approbation, is a reclamation. To do this for myself. To do this, undaunted by the gaze of others. Dancing Don't You Feel It Too?, I reverse marginalization. I am insisting on my presence. I am forging belonging. This is activism. For myself, for other people from marginalized groups, in marginalized bodies, Don't You Feel It Too? becomes protest and resistance.

(In the future, what is protest
and proclamation?
How is activism infused with joy?)

## BODY

I stay close to others for a while, watch their bodies peel away, then find myself dancing alone. My body heats up and I can feel my hips sway, the tips of my fingers pressing together and snapping, the bend of my knees, my heart rate rising, the flat soles of my feet, the ground beneath the sidewalk, and sometimes, when I'm lucky, my ancestors beneath that ground, strength and connection. Sometimes, silliness bubbles up as I wag my finger, skip and twirl like a little girl or hop onto a bench, shaking my shoulders. Suddenly, in the middle of an afternoon, the entire city becomes my playground, a straight-edge club without darkness or booze or someone nudging forward with an offer of pharmaceuticals. In front of everybody, I get to have this body and space and time. It's exhilarating and scary too, even though I've done it many times

before. Even though I don't embarrass easily. At the center of my action radiates wonder and awe at my own audacity, along with some trepidation. Am I ridiculous? What does it mean to have this body? What am I feeling? Sometimes joy but also grief, unleashing. The singularity of being inside this particular body. This collective singularity.

(In the future, do you still delight
in this collective body?
Do your inner and outer landscapes
still move toward solidarity?)

ZONE
*don't you feel . . .*

heavy
clumsy
rhythmic
thick
black
light
airy
solid
bold
alone
scared
evident
obvious
juicy
ignored
hot
tired
dogged
scared
noticed

sheepish
overlooked
avoided
undeniable
activated
female
unfeminine
ungendered
cracked open
spectacular
chugging
graceful
transparent
surprising
public
together
mysterious
unknown
known

*. . . too?*

## HEALING

Through the exploration of bodies in space and feelings in practice,
Don't You Feel It Too? marks a crossroads of personal and social
healing. In 2017, we dance to reckon with our inner lives, our feel-
ings about and within ourselves, about and within our society, as
well as our presence in the landscape of the city. People around us
become witnesses to this process. They are an audience, in a sense,
but the practice is never meant as entertainment. We are danc-
ing, but not performing for them. Although we acknowledge that at
times we are. We move in and out of exhibitionism and introspec-
tion, aiming to straddle external and internal awareness. We don't

deflect the gazes of spectators, but we don't invite them either. We negotiate their watching.

A dancer might smile, but a "smile for the audience" is not a set performance pose. A smile might even bubble into a laugh, but it is the joyful, ridiculous humor of playing a joke on yourself, playing yourself with others in the world. This evokes the actions of Improv Everywhere, famous for its "No Pants Subway Ride" and other collective pranks, except that in Don't You Feel It Too? we are the joke teller and the joke, and we don't get the joke at all, and it is full of the wondrous humor of life, and we tell the joke over and over.

On the flip side of laughter, Aki says the practice gives her space to cry. Practicing public dancing through a painful divorce, she would weep, allow herself to feel sorrow and grief, and allow those feelings to move in and through her body on full display. She still cries sometimes . . .

(In the future, will we be encouraged to cry?

Can public tears be accepted as personal and social cleansing?)

## BODY

Sometimes in Don't You Feel It Too? I cry too. Sometimes, I laugh and feel ecstatic. Sometimes, I'm bored. Sometimes, I fall so deeply into a favorite song, Beyoncé's "Sorry" or anything by Prince, that I can't help but mouth the words, or sing a phrase out loud. The message is gentle but clear: the practice does not encourage singing along. Mouths are meant most for deep breathing and later discussion. Just watching, you can't tell what music people are dancing to—or even necessarily what kind of music. A dancer leaps into a pirouette, then switches to a boogie, then grinds down to a slow interpretative glide. This could all happen over a couple of beats. Don't You Feel It Too? is not choreographed or synchronized. It is an individual within collective purpose. We can move with or against the rhythm of a song. Theresa has said that the practice has given her courage, as a downtown dancer, to actually dance *to* the

183

music. For me, at times, the music falls away and becomes a kind of psychic hum, a way to sound into my own body. Because only the dancer can hear it, only the dancer knows.

(In the future, does mystery remain?)

## MYSTERY

During a practice, if anyone asks us what we're doing, the official response is the question "Don't you feel it too?" (or Don't You Feel It Too?) This is honest: giving the name of the practice. This is also turning the question back on its head, or rather away from the head into the body of the spectator.

(In the future, what does a dancer feel like then?

What does it feel like to watch this display?

How will feelings change?)

When the time for dancing draws down, we signal each other with a series of deep bows. The sight of another dancer bowing ignites your own bow. This becomes deep breathing, psychic and physiological cooling down. Finally, *savasana*. Bliss. We end in corpse pose. After a few moments there, splayed out on the sidewalk, we revive and assemble to discuss what just occurred: How did we feel when we arrived? How do we feel now? What was the arc of this particular practice? What did we notice or see? What encounters did we have? Do we feel more connected to the city, to each other, to ourselves? How can we go even deeper, take the practice further? How can the practice itself evolve?

(In the future, how far has it gone?

How far can it still go?

How much of the original spirit remains?)

## ACTIVISM

Don't You Feel It Too? began as a creative protest against the 2008 Republican National Convention in Saint Paul, Minnesota. The wars in Iraq and Afghanistan, the Great Recession, and the housing collapse all still waged. At new lows of unpopularity, George W. Bush

was winding down while McCain/Palin tried to seize the crown. When news hit that right-wing politicians associated with this mess would be landing en masse in the land of ten thousand lakes, Twin Cities artists and activists got busy. Marcus Young was especially concerned about the militarization of the city. He dreamed of creating something deep to embody protest without giving in to fear or escalating the tone of political polarization. Marcus was not opposed to confrontation; rather, he craved opportunities for authentic encounter with difference, something Republican organizers had gone to great lengths to avoid.

To appease GOP jitters, the city of Saint Paul issued a proclamation that protestors had to remain in a designated "protest area." Miles away, politicians, delegates, lobbyists, and the media could then enter and depart the convention without directly encountering—or perhaps even seeing—political opposition. The convention and the city aimed to marshal public space and control the movement of citizens. Don't You Feel It Too? arose to fill the borderland between a set "protest area" and the fixed halls of power. Moreover, the practice became a way to process and repudiate the atmosphere of fear. In the face of police in riot gear, tear gas, and barricades, the practice was a way to take the city back, to move through it foolishly, fearlessly . . .

(In the future, how do we
mobilize against militarization?
Do we still dance our way through fear?)

BODY

For four days, during the Republican National Convention, up to ten people could arrive to the convention center with MP3 players and start breaking out into dance. Marcus told me that they could be out there for a couple of hours or longer. Sometimes they met up or saw each other and sometimes they didn't. They had practiced in his loft in Saint Paul, discussed their intentions and possible strategies. But during the actual dance at the RNC, they had to figure

it out in real space and time, mark each moment in their bodies, sometimes on their own.

Don't You Feel It Too? was mobile, flexible, individual, collective, and a little wacky, too. Just being there, dancing in protest defied the city ordinance and broke social codes. Some police officers didn't see or sometimes overlooked or ignored the dancers. Many took photos, a large number of them, perhaps anticipating court appearances. One officer lifted a sign that said "8.5" as if scoring the performance. And maybe after three or four days, some police even laughingly shook their heads. If true, it would have been the tone of the protest that disarmed them. As well, I believe, the fact that it happened in the body. If an officer did become alarmed and start to approach, the dancer could stand down, go slack, or turn back into a regular citizen walking away.

Of course, any form of confrontation was still a risk. In a highly charged, highly policed space, any unregulated action could be seen as a threat. I imagine how the adrenaline must have spiked, how the heart must have palpated, how the legs must have shaken . . . I imagine the fear of those first dancers, how any general anxiety about dancing in public would be ratcheted up a thousand-fold with the possibility of arrest. And what kind of protest was this anyway? No shouting, no slogans, no posters, no designated negative gestures . . . Just bodies opting to dance.

(In the future, do people still make posters or banners?

Do bodies register or process themselves as protest?

Do people beam critiques into embedded chips in each other's brains?)

## SPACE

At the 2008 Republican National Convention, Don't You Feel It Too? highlighted how a series of people, moving in coordination across space, could transgress city plans and reclaim agency of the personal and public body. The practice tuned out partisan messages, police alerts, and even traditional protest chants in favor of

listening to one's own melody, moving differently, and modeling another way of being in the world. In solidarity with other groups in the "protest area," Don't You Feel It Too? opened new space to explore outrage, fear, anxiety, pleasure, joy, and other emotional states in and through the body. The practice demanded, and continues to demand, the courage to reveal, manifest, or discover a personal body in public space, asserting that movement as a political act. Nonviolent and nonoppositional, this burgeoning practice offered protestors a means not just to march, but also to groove.

(In the future, remember this
start as vital embodied action.
Remember participation and the body
dancing to disrupt social and civic codes.
Remember transgression and humor,
stealth and surprise.
Remember self and community,
self with community;
Remember the desire to reclaim
and take up personal and public space.
Remember politics and protest, people and art.)

## ART

In 2017, Don't You Feel It Too? aligns itself with art, activism, and healing. A recent postcard for the practice declares that it is "participatory public dance for social healing and inner-life liberation." And in discussions of the practice, we often talk about personal transformation and social change. I relish these discussions, but I sometimes worry about the art part falling away. When I ask Marcus Young why or how the practice is art, he says, "Because it started as an art project and still is one."

(In the future, is it still an art project?)

Dance, of course, is an art form, but the claims of the practice go beyond just that. As in the large-scale public artworks of Christo and Jeanne-Claude, the administrative work of Don't You Feel It

Too? is as much a part of the art as the specific sessions of dancing. In planning and organizing meetings, Marcus strikes a meditation bell and invites stillness. He incorporates guided visualization and poetry. As the practice has expanded, he has played with the language of marketing, the possibilities of corporate sponsorship and collaboration, while still striving to maintain the core of creative vision and action.

(In the future, is the practice traded on the Nasdaq?

In any art world, what does it mean to buy in or sell out?

How can and should Don't You Feel It Too? expand?

How does it reach more people and still remain itself?)

## BODY

Marcus Young, the founder of the practice, is responsible for much of the leadership. While he is not the only steward of Don't You Feel It Too?, his nature and background deeply inform the practice.

Things to know about Marcus Young:

Marcus Young is 楊墨.

He is tall and slender and has been single for many years.

He is Chinese and American.

He is gay.

He is lovely, humble, and ambitious.

He works extremely hard.

He values slowness.

He is very busy.

He loves tea.

He was born in Hong Kong in 1970.

He has lived in the Midwest for most of his life.

He has struggled with belonging.

His family ran a Chinese restaurant in Iowa.

His father died when he was still in his teens.

He is close to his mother and sister and her family.

He has struggled with loneliness.

He has worked in multiple ways to build community.
He practices meditation.
He is very patient.
He cultivates mindfulness.
He is the founder of Don't You Feel It Too?
He is a multidisciplinary artist.

(In the future, what do you say about Marcus Young?
Will you have a picture of him hanging as they have
guru photos in every Bikram yoga studio or
pastor portraits in Baptist pulpits?)

## ART

Marcus Young earned his undergraduate degree at Carleton College in Minnesota, where he majored in music with an emphasis on conducting. Later, he earned an MFA in theater at the University of Minnesota with a concentration on directing. He also was mentored by the legendary Chinese dancer Shen Pei for many years and continues to work in dance as a collaborating director with the Ananya Dance Theatre, Ananya Chatterjea's justice-oriented ensemble grounded in South Asian dance techniques.

Marcus has also worked in visual art realms, including installation, live art, and social practice. He has premiered work at the Minneapolis Institute of Art, curated evenings at the Walker Art Center, and received prestigious fellowships from the Bush, Jerome, and McKnight foundations. He has used institutional support to develop work outside the gallery. Like many artists of the twenty-first century, he is interested in art in life, art as life, and the operation and disruption of the everyday. His key influences are Yoko Ono, Mierle Laderman Ukeles, and Tehching Hsieh (who has shared dumplings with Marcus on more than one occasion). He shares their thoughtfulness, tenacity, and conceptual boldness.

(In the future, do we eat dumplings with our gurus?)

I can't remember my first time meeting Marcus Young, but it might have been in 2004, when I visited "The Big Idea Store." Selected for the Jerome Foundation's Inside/Out series, this project re-created an old-fashioned general store within the walls of Intermedia Art's gallery. Wearing a long-sleeved shirt and pants, a vest and bow tie, Marcus presided over two long tables with four seats and four Rolodexes. These were his wares. When you arrived, he would call "Hi, neighbor," and serve you tea with a coaster. You would then sit in a dimly lit room, sip your tea, and flip through a Rolodex searching for an idea. The Rolodex whirred low in a pleasant, meditative hum. The warm tea bloomed through your body. It felt like breathing, thinking, entering another world. Once you picked out your idea, you gave Marcus a nickel and he wrapped it in a transparent sleeve for you to take it on your way. This experience was lovely.

Later, I saw some of his other artworks. In "Pacific Avenue," Marcus wore a long robe with a high mandarin collar and walked at a glacial pace through the business district at rush hour, carrying an umbrella and continuously smiling. In "From Here to There and Beyond," he drew a line from the gallery of the Minneapolis College of Art & Design, starting with a crack in the wall, then crossing through the tile on the floor, smashed up through the window on the door, and then outside through neighborhoods for two miles all the way to the Mississippi River. Your first time following the line, you wouldn't know where it would lead or how long it would take. All this work was about trust, observation, and transformation, as well as defamiliarization and reclamation of public space.

Marcus calls himself a "behavioral" artist, a term that highlights his interest in making and using art to engage and transform the behavior of individuals and groups in society. He has long been interested in the social and aesthetic experience of the city. From 2006–2015, he worked as a city artist for the city of Saint Paul. Observing city planners and engineers, he argued that the

city needed a person whose job was to consider and create opportunities for art within civic and municipal processes. Upon hearing that the city had a program and budget to replace the concrete of broken sidewalks, he developed a city publishing poetry program called "Everyday Poems for City Sidewalk," in which poems by Saint Paul residents would be stenciled into the newly poured concrete squares. On Earth Day 2012, he created "Wishes for the Sky" to foster a space for community to gather and send their hopes aloft on eco-friendly kites.

To understand Don't You Feel It Too? in the future, it will be crucial to consider the past and recognize these artistic antecedents. Marcus' training in music, dance, conducting, and directing, his work in public and city art, his exposure to city planners, his background in performance and conceptual art, his move out of the gallery into the streets, his interest in community, his positivity and playfulness, his commitment to the enigmatic, all have shaped the values of Don't You Feel It Too? and should endure in its legacy.

(In the future, who are the stewards of the practice?

How are they appointed?

What will happen to the practice

with the passing of the founder?

How much is Don't You Feel It Too?

his, yours, ours, everyone's?)

## ACTIVISM

Marcus wasn't at our practice on June 25, 2016. We met to dance Don't You Feel It Too? at a pretty corner of Loring Park in Minneapolis. It was a gorgeous day, and a festive one with the annual Twin Cities Pride festival in full swing. My friend Amy came to try the practice for the first time. Not far from us, a cloud of long, multicolored streamers hung over a resting area of lawn, falling in all hues of the rainbow.

It had been a while since my last practice, so I was concentrating on, well, concentrating. I wanted to be present in the populated

festival, allow my dancing body to be in the mix, but I also wanted to explore my inner self. I danced alone for a while, moved alongside stalls of community activists handing out literature. I spent time by a tree not far from another dancer. Then a contingent of folks arrived, unpacking hatred from suitcases, signs on sticks: "Repent! Jesus hates sinners." They looked drab, white, mainly adults with a couple children in tow. I pitied those children. The group with signs numbered fewer than a dozen, and yet their impact was exponential. A white man in a baseball cap pressed a bullhorn to his mouth. Blissfully, I couldn't hear what he said. But I knew, I knew . . .

Then I watched Oliver move closer in harem pants. Theresa slid over, almost skipping. Then Shira. One by one the dancers created a new zone between the shouters and the rest of the festival. I sashayed down the hill to join them and spy up close the bullhorn man's harsh jaw. I wasn't fazed. Prince was crooning "Life Can Be So Nice" in my ear. Without planning it, we had shifted the energy of the demonstration, or at least contained it. Without violence or vocal confrontation, we became a buffer, dissipating the negative energy.

What started off tense became humorous for some spectators. A gay couple walked by and smiled. A person with multicolored hair gave a thumbs-up. Two teenage girls paused and started dancing a little with me. No one tried to stop us. No one asked what was going on. The hate-mongers were mongering and we were dancing. The hardest part of this practice at Pride for me was staying true to my own breath, my own movement, and not making it about these other hateful people. They were already taking up so much space. The question became how big, how open, how alive could I be? Could we all be? Moved against their hateful presence, our bodies became counterprotests. Our bodies dancing still insisted on mystery.

(In the future, are we moving
toward and against those who hold hate
in the name of love?
Are we dancing love?)

## SPACE

In 2017, the College Republicans at the University of Minnesota scrawled "Build a Wall" on their free campus space. Echoing the divisive rhetoric of a certain U.S. president, this action sparked immediate outcry. At a roundtable on the practice with Marcus, Aki, Theresa, and Julia, the incident came up and we talked about having Don't You Feel It Too? be a part of the protest. This led to this question: Does Don't You Feel It Too? have a particular political position? We speak often of social justice and activism, but is there space for the politically conservative? Could we imagine College Republicans dancing Don't You Feel It Too? Or inviting College Republicans to dance with us?

(In the future, do College Republicans exist?

Does the Republican party?

Or colleges the way we know and understand them?)

The question is complicated and urgent. Because Don't You Feel It Too? can offer a sense of empowerment for marginalized people, what impact can it have for those already empowered? Or in power? Is Don't You Feel It Too? just for people who think and feel as we do? Or could the very nature of encountering one's "honest, ridiculous self," as we say, bring tension to any political certainty? Including the certainty of those on the left?

Marcus often speaks of the potential of Don't You Feel It Too? to spark dialogue and bridge ideological divides. In practice, it has been embraced mainly by progressive people and social justice organizations. The Healing Place Collaborative, the Kulture Klub Collaborative, and the Million Artist Movement have all collaborated with the practice and engaged it in their communities. How can we build on these positive connections and grow? In 2017, we have moved in new directions.

(In the future, which bodies

do we want to move with us?

Which bodies do move with us?

Which bodies do we want the practice to move?)

# ZONE

Explaining her groundbreaking term *intersectionality*, legal scholar Kimberlé Williams Crenshaw says, "Discrimination, like traffic through an intersection, may flow in one direction, and it may flow in another. If an accident happens in an intersection, it can be caused by cars traveling from any number of directions and, sometimes, from all of them. Similarly, if a Black woman is harmed because she is in the intersection, her injury could result from sex discrimination or race discrimination." What if we replace "discrimination," "an accident," and "injury" with liberation? "Cars" with feeling? And "sex discrimination or race discrimination" with dancing? Try it.

The identity of "a Black woman" cannot simply be swapped for woman of color, person of color, queer person, transgender person, disabled person, especially because this identity can overlap with any or all of these other identities. This is part of Crenshaw's point. But what if we could imagine a new intersection? What if people of different political beliefs could dance together?

So many sessions of Don't You Feel It Too? have occurred in so many places, this must have already happened. We might just assume that we know and agree with the beliefs of those dancing near us, the way we might assume this about our neighbors right before an election. As in an election, we might be wrong.

(In the future, will we dance away our differences
like warring factions in movies from the eighties?
Seriously, can we put aside for just a song or two
the torn language on both sides and move before,
alongside, and with each other?)

# ACTIVISM

Marcus Young has called the activism of Don't You Feel It Too? the second swell of revolution, what can buoy and shore up the front line. It's a kind of backup built from self-care and breathing and dancing through it all. It's the groundedness of conviction

and personal, public awareness. It is the fearless dancing at the Republican National Convention, the joyful buffering of our dance at Pride. Harking back to the origin of the practice, the experience at Pride marked a milestone and planted the seed for a new event called "Welcome to the Fire."

In 2017, Don't You Feel It Too? organized a special practice on Good Friday, a day when antichoice protestors and Planned Parenthood supporters would be demonstrating against one another at a local clinic in Saint Paul. This year, in "Welcome to the Fire," dancers danced Don't You Feel It Too? in the spaces around and within the spaces of the opposing protestors. They arranged for people to be on hand to teach the practice to anyone who wanted to learn it. They were determined to hold an embodied space outside traditional polarities. More than replicating traditional modes of protest and counterprotest, Don't You Feel It Too? offered a third path. This again was a radical act.

More than a buffer zone, the space of "Welcome to the Fire" beckons as a threshold. In *Transformation Now!* feminist theorist AnaLouise Keating writes "*thresholds* represent complex interconnections among a variety of sometimes contradictory worlds—points crossed by multiple intersecting possibilities, opportunities, and challenges. . . . [T]hreshold theories facilitate and enact movements 'betwixt and between' divergent worlds, enabling us to establish fresh connections among distinct (and sometimes contradictory) perspectives, realities, peoples, theories, texts and/or worldviews."

Replace "theories" with actions then dancing then Don't You Feel It Too? Try it. It's not easy. But it's quite worthwhile. The dancers who danced in "Welcome to the Fire" have talked about the difficulty, intensity, and power of the experience. The project marks deep growth in the practice and signals new directions for the development of Don't You Feel It Too?

(In the future, what new thresholds exist
between worlds, perspectives, realities?
Are you used to dancing in thresholds?)

# HEALING

Tasked to consider Don't You Feel It Too? in a thousand years, language entices and slips. Will this planet exist in a thousand years? Well, fossils and canyons and ravines and oceans are even older. But will we humans allow this planet to remain? Will our appetite for destruction chew it up and spit out the bones? At the rate we're going, will we still exist? The practice encourages us to face the current jeopardy and exercise our most hopeful imagination.

Kendrick has modeled for me how to do this. A member of the Artist-Healer-Activist cohort, she has long struggled with chronic pain and is currently in the throes of grave illness. She is also one of the most joyful, gracious, curious, wise, and wondrous people I have ever met. This year, in 2017, she has taught me a lot about the power of the practice. Kendrick finds Don't You Feel It Too? so stimulating that she doesn't need external music. In her wheelchair, with her hands and sometimes with a push from a friend, she dances to the sound of the wind, the trees, the footsteps of people walking by, the vision of our own dancing. Marcus told me at this point, she can only be out of bed about an hour a day. He believes that she sometimes does the practice however she can during that hour. This already seems like the future.

As inspiration for the thousand-year plan, Kendrick sent Marcus quotes from Alexis Pauline Gumbs' short story "Evidence" not too long ago. In the story, included in the rad anthology *Octavia's Brood: Science Fiction Stories for Social Justice,* a twelve-year-old girl sends back evidence from the future. Reflecting on her lineage and describing her society, she says:

> Now in the 5th generation since the time of the silence breaking we are called hope holders and healers. There are still people doing a lot of healing, but it seems like generation after generation, people got less and less afraid. People took those writings and started to recite them

and then another generation hummed their melodies and then another generation clicked their rhythms and then another generation just walked them with their feet and now we just breathe it, what you were saying before about how love is the most powerful thing. About how everything and everyone is sacred.

These words, from the twelve-year-old girl, from Alexis, from Kendrick, become a powerful reminder of the future. These words beckon us from the other side of healing.

(In the future, do you recite,
hum, click, walk, and breathe
this sacred love?)

These words are the aspiration of Don't You Feel It Too?, its purpose and body and breath. They are the spirit of this thousand-year plan.

(In the future, do you know
our hope for you?)

### SPACE

My laptop screen fills with the image of Julie Mehretu's painting *Looking Back at a Beautiful Future*. At the top of the frame, red lines streak across the sky. At the bottom, blue-black curves, like wild pen strokes or long blowing strands of hair. Underneath these marks, multicolored shapes look like refracted land formations—like a globe pulled apart with its continents reformed, flattened and stretched, pulled into new dimensions. On the lowest level, faintly discernable to the eye, are the remains of a map or a blueprint, now palimpsested, activated, and transformed. When I think of Don't You Feel It Too? in a thousand years, when I think of the city or wherever we will be, at the edge of my imagination, I see this. The plan of the city explodes into color and imagination, visible action of life. Merce Cunningham once said, "Dancing is a visible action of life." We can't see the dancers, but we know we are there. We can't

see the future, but we believe in its power. We believe we can make it there.

(In the future, isn't it beautiful?

Are you living it up?

How do you remember us?)

## MYSTERY

*That first time you danced in public, do you remember it? Were you scared? Awkward? Sheepish? Embarrassed? Alive? How did your body feel? How did the ground feel beneath you? How did the city, the space feel around you? Now move to the edge of your imagination. Move out into the public. Move deeper into your inner life. Fast forward a hundred years, a thousand years, as far as you can reach. To get there, we know, a whole lot needs to be worked out, but for now jump ahead. Through cyborgs and geodesic domes and tiny machines in the valves of our hearts. On city blueprints, between the berm and the curb, in the designated dance lane, the LED leaves on the trees. Jump beyond even all these, their possibilities and perhaps salvation. Realize new problems and resolutions . . .*

*(In the future, don't you feel it too . . . ?)*

```
*       *       *       *       *       *       *       *       *

+       + +.  +       + +.  ++      + +.  +.+      + +.  +

*       *       *       *       *       *       *       *       *

+       + +.  +       + +.  ++      + +.  +.+      + +.  +

*       *       *       *       *       *       *       *       *

+       + +.  +       + +.  ++      + +.  +.+      + +.  +

*       *       *       *       *       *       *       *       *

+       + +.  +       + +.  ++      + +.  +.+      + +.  +

*       *       *       *       *       *       *       *       *

+       + +.  +       + +.  ++      + +.  +.+      + +.  +

*       *       *       *       *       *       *       *       *

+       + +.  +       + +.  ++      + +.  +.+      + +.  +

*       *       *       *       *       *       *       *       *

+       + +.  +       + +.  ++      + +.  +.+      + +.  +

*       *       *       *       *       *       *       *       *

+       + +.  +       + +.  ++      + +.  +.+      + +.  +

*       *       *       *       *       *       *       *       *

+       + +.  +       + +.  ++      + +.  +.+      + +.  +
```

# after the end

*

a performance dossier
Gabrielle Civil & Moe Lionel

*

What can I say to you that you cannot allow for yourself alone?

Hemorrhage, surgery (and then again and then again)

Ambiguous loss: literal near death, the death of another, the presence
of another

What happens when loss is imprecise?

How do we return to ourselves?

*

Sun, Mar 3, 5:03 PM

How are you doing?

> Ah Moey. So lovely to have you
> pop up here!
> I'm good. Busy but almost
> caught up. Still reveling in the
> new book and trying to move it forward

A few things:
(1) when you are here this
summer, we can go to Tracy's
all the time.

(2) any more word from
Markele and jo re trip? I was
unclear when I talked to them.
I'm definitely in for the road trip.

(3) I have this idea (and it's just
that, an idea—no obligation)
that you and I could do
a performance piece for
queertopia called something
along the lines of my hysterectomy
or our hysterectomy.

<center>*</center>

Desire. Love. (Dis)connection. Blood pooled and batched, screened
and scanned. UV light, maroon, a deep cold in the hospital basement,
waiting time out, or is time waiting you out? The medicalization of
body, the sanitization of blood, the washing of desire. We are capable

of turning stain to beauty, loss to existence, pain to desire. This is not what we dreamed we would become.

How are we still so possible?
How can we find hope in the aftermath of profound loss?

<div align="center">*</div>

Sun, Mar 3, 5:06 PM

    1) yes!
    2) yes!!
    3) yes!!!!
when is queertopia again . . . ?

<div align="center">*</div>

QUEERTOPIA / June 19–22, 2019 / Heart of the Beast, Lake Street
Queertopia is in our fourteenth year of ungovernable queer art-making during Pride week. This year, we are responding to urgency with care and adaptability. This year, we are in sustained conversation with crisis.

What happens when an emergency doesn't conveniently end? How do we adapt to continue to respond effectively? How do we grow right responses? How do we sustain ourselves during continuous emergency? (The first) Pride was an emergency.
This is an emergency.

THEME NIGHTS
Wednesday: Sliding scale $5 and up
Thursday: ASL interpretation & Audio Description
Friday: Sober night
Saturday: Visual art extravaganza @ 6:30 p.m.

ARTISTS
Performing Artists: Gabriela Santiago, Gabrielle Civil and Moe
Lionel, Kol Lisinski, Niara Williams, Sci-Fi, Teighlor McGee, and
Venus DeMars
Visual Artists: Alice Ferox, Ellis Pérez, Juliette Myers, and Tori Hong

*

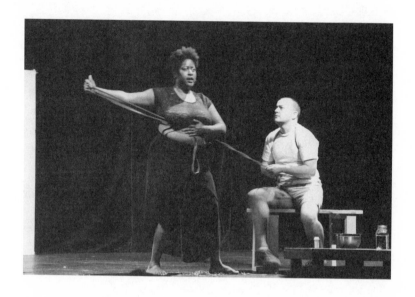

*after the end*
Gabrielle Civil & Moe Lionel
(Queertopia Script 6.18.19)

*Lights up. On stage left, a set of stairs with a silver bowl, a jar of water, and a bottle of pills. On stage right, a white pillowcase. Upstage center, a white screen.*

SLIDE CUE:
"It's an incremental death . . .
Both here and gone.
I don't know if it's so important to bury our dead,
but I think it's important for us to know where the body is."
        "Right. To have a body."
—Pauline Boss with Krista Tippett
*On Being, on ambiguous loss* (2018)
*Slide holds for a beat.*

MUSIC CUE: *Prince's "Solo" plays for one full minute, then fades out. As Prince plays, Moe and Gabrielle arrive from opposite sides of the stage.*

LIGHT CUE: *Bright white light shining light*

*Gabrielle and Moe move upstage with speed. Moe unfurls the red rope and creates a harness around his body. Gabrielle gestures infinity with her arm on the screen. She moves to the pillowcase, turns it over, and begins to shake a fall of grass from inside. She gathers a nest from this grass, gets down inside it, and curls into a fetal position. Moe walks to the stairs.*

Moe: Gabrielle lies curled in a fetal position.

Gab: Moe stands next to a jar of water and a bottle of pills.

Moe: Gabrielle is in the bathtub.

Gab: Moe is in Paris.

*Moe shakes the pill bottle. This shaking lasts for a while. At the sound of shaking, Gabrielle curls her body, makes the shape of legs in a V as in gynecological stirrups, then turns completely over. She returns to a fetal position, now with her knees toward the audience. She hears the pills shaking.*

Gab: Stop, Moe! You're doing it again.

Moe: I could tell you how it started.

Gab: Tell me, how did it start?

Moe: I'm in the bathtub. I can't stop bleeding.
　　Got things switched around.

Gab: I let that melt.
　　Let myself move closer to a person.

Moe: I should have known things weren't going well
　　when the stitch slipped.

*Moe throws the rope to Gabrielle, who catches it. Moe pulls her in. They sit down together on the steps. Gabrielle grabs the bowl and begins to "wash" the rope.*

Gab: I could tell you how it started.

Moe: How did you almost die again?
   Wasn't there something about Phaedra's blood?

Gab: Yeah, I was in Paris. Glamorous me, at a production of *Phaedra* where they were strangely playing this song by Prince from the *Come* album that he did with David Henry Hwang—

*Moe starts to sing:* Solooooo
*Gab joins in:* Solooooo (*Their upper bodies gyrate. She continues singing the rest of the verse alone.*) I can hear the blood rushing through my veins . . .

Moe: Yeah, that one.

Gab: And they were doing this modern version
where you sat in the middle of the action
and at the end of the play,
I was right next to the spot where Phaedra died,
and as I was leaving, I couldn't help it,
I dipped my little notebook in Phaedra's blood.

*Gab dips hands into the pool / lifts up the red rope.*
Moe (*teasingly*): . . . Oooh, Gabrielle, you shouldn't have done that.

Gab: Boy, don't I know!
            Because the next thing I know . . .
      a coat full of blood
            And then the next thing I know . . .
      an ambulance ride
            And then the next thing I know . . .
      singular time
            And then the next thing I know . . .
      never bleeding again
            And then the next thing I know . . .

nobody to touch
      And then the next thing I know . . .
Solo. I can hear the blood
      rushing through—
seal it off. Say good-bye.

*Moe approaches to hold her close. Gabrielle balls up the rope and throws it at his heart. They break apart. She circles the stairs while he walks over and stands in the nest of grass.*

Gab: So Moe, how'd your life turn out?

Moe: You're looking at it.

LIGHT CUE: *Bright white light shining light.*

Gabrielle: Tell me about hemorrhage.

Moe: Holding pressure. There is a ball of blood thick inside me, closest sensation I can tell you of is being fisted. Bright red arterial flash. Gauze to follow. I lost my breath.

    I should have known then.

*Moe starts repetitive body motion in the grass, something strenuous like knee drops or push-ups.*

    I should have known then.
    I should have known then.
    I should have known then.

Gab: Stop it, Moe! You're doing it again.

*Moe stops motion.*

Moe: What's being worked out is beyond my body.

Gab: Do you mean love? *(She picks up the jar of water in one hand.)*
Or heartbreak? *(She picks up the pills in the other.)*

Moe: Yes. Ambiguous loss. A literal tearing, then blood with
      nowhere to go but away.
      How do you mourn the body?
      My grandmother, then me hemorrhaging,
      then my boyfriend died suddenly. He lost his breath.
      The rage heat of loss.
      And then no body to touch.

*Moe curls himself into the fetal position in the nest of grass.*

LIGHT CUE: *Bright white light shining light.*

Moe: Tell me about hysterectomy.

*Gabrielle picks up the bowl and places it in front of her stomach,
first with the roundness protruding, then later showcasing emptiness.
Throughout her speech, she slowly manipulates the bowl.*

Gab: Ambiguous loss.

Deeply cared for / deeply alone.

You know how I used to talk . . .

now I can be quiet for hours.

I can be very still. I can still love the world

and turn into myself. I can still get offers.

I can turn things down.

A cut. A line. / The other side.

*Gabrielle picks up the bowl and uses her fist to knock on its round-ness and rouse Moe from his nest. She moves toward him, knocking on the bowl. She keeps knocking her way to the nest of grass. Moe gets up and moves over to the stairs. He picks up the jar of water and bottle of pills and shakes them both back to the nest, where Gabrielle stands. When he arrives, Gabrielle sets the bowl down in the center of the nest. Moe sets the unopened bottle of pills inside the bowl.*

Gab: A participation in a survival pact.

*Moe opens the jar of water. He takes a long drink and holds the water in his mouth. He passes the jar to Gabrielle, who does the same. Together they pour the water back, spit into the jar.*

Moe: Was it a work-around?

Gab: An antidote.

*Moe and Gabrielle circle the rope and move around what they've made. A ritual. (Make a bed with the grass. Make a grave. Make something beautiful.)*

Moe: How do you end something that never stops?

Gab: How do you move after the end?

Moe: You asked what happens when the organ comes out.

Gab: Does everything fill in?

Moe: Yes, and what fills in is you. More you.

LIGHT CUE: *Lights fade while Moe makes an infinity symbol around the nest of grass and across the stage. Gabrielle picks up the grass and creates infinity symbols on the stage, in the air.*

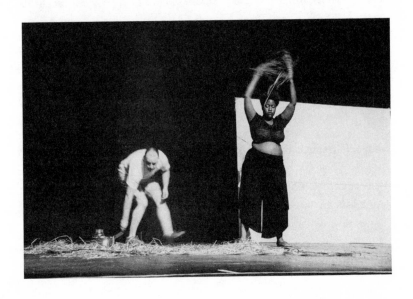

*

*refractions*
aegor ray & bobbi vaughn

aegor: Should we start with the string?? I know we were both struck by the string, the redness and physicality of it.

bobbi: It felt like how they were negotiating being attached to the past. Or maybe it was their only physical relationship to memory. But the string is so tenuous in itself, and you have to work your way through the tangle.

a: Yeah, the part where Gabrielle is kind of pulling herself with the string, recalling something embodied, and things started to click and she started to stress her *And thens* like she was following a lead.

Hmm, I don't know why the string as shared blood totally freaked me out? I'm not freaked out by blood generally.

b: Yeah, you're really not, and you mentioned that you were fixated by it. What about the string as blood struck you?

a: Hmm . . . I guess the feeling of the string felt like it could be ripped out and was so singular or contained? When blood pools on the floor or if you're donating blood, I tend to think that there is still so much more left in the body/the container. The string was a reminder that there could be a finite quantity of blood, which freaks me out. It spelled out this anxiety that I have about loss, that you can be emptied out by loss. The string and the bowl are such contrary images that way.

b: Yeah, I'm never going to forget that last sentence that went like, "What happens when you lose something or a part of yourself? More of you fills the space." I can't decide if it's comforting or not. Like we were talking about . . . there isn't a core authentic self that remains unaffected by what happens to us. We are constantly losing or filling up spaces and shifting/transforming in reaction to what happens to us.

a: I couldn't stop thinking about binding with that last line. Like, binding is a physical negation that makes room for me to be . . . who I am right now. And, like, it also makes me less legible in a way? So much of this piece was in a kind of flat affect that was a bit alienating but felt like those small, personal moments of internal dialogue. But then they were also together.

b: Because ambiguous loss is so hard to talk about and think about, it seems necessary to have another person to help you make sense of it or see what's really there. It's funny that for you and me—we were both so freaked out by trans bodies when we were kids. There was definitely a kind of body horror element in it for me, not a loss/change of body parts but a fear of seeing myself in those bodies and losing legibility and who I was at the time.

a: It's been a weird kind of loss for me recently on HRT having to reorient myself to my body. I feel so unsure about what actually feels good and it feels lonely to have to figure it out, you know? Isn't it just supposed to feel good immediately? I loved that Gabrielle and Moe were both in their bathrooms—in the tub and the medicine cabinet. Like, that is such a scene of those private, internal monologues and mundane negotiations.

b: Yeah, so much of this kind of grief is really mundane. Getting through it and kind of narrating every minute to coach yourself through it. Her hay, too, was just such a mess, and was her bed? That feels relatable for sure.

a: I really love what you said about not knowing if that final statement was comforting or not. It's almost like an if/then statement.

b: That you have to live with yourself or be there for yourself when shit hits the fan.

a: And that friendships can help us learn how to be alone, together.

b: Looking back, the whole piece kind of mirrored the experience of living through/with trauma. Even the narrating and then how spare it is while they're trying to make sense of themselves. I was drawn in and then displaced, which felt a lot like surviving really hard experiences and then reflecting on them.

a: Yeah, like having to live on with or grapple with the change or what you have learned about yourself from trauma or loss. All the internal moments that lead to you being who you are. All the little losses and big ones. The geographical and physical isolation. I can't stop thinking about it.

\*

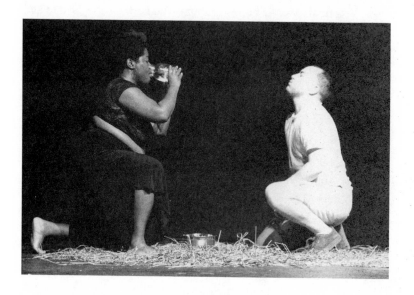

### Gabrielle
**What have these experiences allowed you
to appreciate about me?**
At Target last night, we watched two black girls standing together inside a sculpture of a big red hole. They climbed in a way that their outside feet were perched against the inner ring of the circle. And they had their opposite hands up to each other creating the shape of a heart. A black man, who looked like their father, snapped a picture on his phone of this escapade. They hugged each other, their hair beads bobbing in the sun. How lovely to witness this heart.

Moe, I've always witnessed the depth of your heart. When we met, you seemed so omnivorous, so sexually various, so able to open into desire for so many different people, so many different kinds of people, so much at the same time. And then how open you could be to Douglas, who seemed to me like the complete opposite of me. And then in and through his death, I saw the true, great muscle of your heart flex as you stood in the rose garden under the deafening roar of the jets overhead and spoke of your love for Douglas, but also spoke honestly about who he was, how he had lied to you and hurt you, how he had lied to and hurt other people, and also how you would cherish and mourn him. This was the quality of your heart, the capacity to see it all and to hold it all and to love. And this is what is at risk . . .

### What have these experiences allowed you to appreciate about yourself?

I can be quiet for hours, not speak to anyone, sometimes with cellos or music—but is that really quiet? Sometimes with nothing at all. Is that quiet either? I hear birds outside. I hear the growl of the leaf blower. I like that I can turn things down. I can love the world and turn down offers to be in it. I can be my own world. Desolate or resolute. I can be still. I don't have to say anything and don't feel silenced. I am beyond the wall. I am still. I am still here. Well, moving. A greater internal movement. Am I holding a glass of water? Is it stirring? Is it blowing? Is there something rippling inside the still glass? There's a line—it's a cut, but it's also a trajectory on a map. It's visible and I am not on it but on the side of it. Maybe the other side of it. I stand still there. I'm still there. But what is that stillness? There's movement in it. Simultaneous time.

### What do you feel hopeful about now for me?

As wildly, unrelentingly painful as it's been, there's been an incredible loosening in chaos. This likely started happening before the hemorrhaging, before Doug's death, but what was extremely tight

about timing and scheduling and opening into time or even falling in, deep diving with someone, coupling, felt cracked open in a way that was amazing to witness. You have seemed more grounded and aware of the gift of life, possibilities, more fearless. You also seem more enmeshed in family, more willing to morph the narratives around family that were difficult before—not that you've forgotten what happened in your life, but you're able to see yourself as a person who is loved, who has many different people around you who can and will show up for you. Your body, the grief and woundedness of your body, became a site of connection as opposed to isolation. A silver lining? A participation in a survival pact. I feel hopeful that you will feel yourself in family, find yourself in family, and form new family of your own.

### What do you feel hopeful about now for yourself?

Here's what could happen: something rash and wild and wonderful. Years ago, right before the first near-death experience, I was sitting in a café in Paris and saw a handsome, dark-haired person smoking a cigarette and drinking dark coffee at another table. I felt attraction there but couldn't imagine ever being found attractive or ever being able to exist in that world. Years later, I can imagine being back in that café and having another kind of interaction, a possible display of desire. That could happen because whatever storybook ending I tried to beat back to the edge of my mind has disappeared, and so I can be something else. I don't have to live in the United States. I can be in a long coat, maybe black or brick red, drink my own coffee or cognac, flirt, smoke, why not? Who cares about death? Walk into art spaces. Teach classes. Have hardcore sex. Go to play parties. All the things I wanted then, maybe I can have them—because I don't care as much about them. Maybe when a whole world, another life, another person, whole other people aren't riding on you living right, making your life happen a certain way, maybe you can drop out and do what you want. Maybe I could want something. Maybe I could understand how to live. I'm not

sure this is hope exactly but an articulation of some kind of possibility, which feels as close as I can honestly get.

<u>Moe</u>

### What have these experiences allowed you to appreciate about me?

You are a very strong person. You are capable of shifting, you are capable of movement. You are able to say that something is painful. I want to say that's the only way to get through pain, but that's not actually true. But I do think it allows you to do a certain kind of work that is inaccessible otherwise. Your life may not have turned out the way you imagined or dreamed. Some dreams may be inaccessible in this time and space, but that does not mean there's anything wrong with your dreams or with you. *You can't always get what you want, but if you try real hard, you get what you need.* I think you're closer to getting what you need.

An image—a red plume in water, not blood but flowers. Pleasure. A return to body.

Gabrielle, I am able to appreciate that on the other side, you may find a certain kind of ease. You may know a certain kind of wholeness that only comes from loss. A completion in absence, a presence in absence. You asked what happens when the organ comes out. Does everything fill in? Yes, and what fills in is you. More you. You cannot be cut into parts. When a piece is taken out, what fills in is you, still whole.

### What have these experiences allowed you to appreciate about yourself?

I appreciate that I am a strong person, that I will persist. Mostly I can think about how hard I am on myself. I feel sad that this question is so hard. What could I do for myself that would allow me to be kinder? Fall in love again.

Standing on a diving board—the girl on the horse who went blind from the jump but she kept on jumping. She jumped until she

died. People said her love took her passion, but it was continuance of action that was her passion.

When I think about hemorrhage, I think about this thing, I think about the aftermath. I do not feel afraid of dying, but if I am honest, I would prefer to live. I appreciate that about myself, because that information wasn't accessible to me before hemorrhaging. I appreciate that things can go terribly wrong, that this is *not* the result of my precise actions, and so my precise actions cannot prevent them. If I am really going to embrace that this spans beyond my own lifetime, then I have to embrace that I have to be softer to myself about my own choices—they're not the only thing at play.

### What do you feel hopeful about now for me?

I feel hopeful that you can release into more dreams. Children from your body, that grief—I don't wish that you set it aside, but rather I've seen it run through you. And yes, always the wake, the ebb and flow. But dreams, we know, are not infinite. I see you, bright white light shining light. Something falling from the sky—water, rain. Becoming soaked, lying down in the bathtub, covering yourself in flowers. Me walking out onstage with my mouth full of red flowers, pulling them out. Drinking the pool water, spitting it out.

When you come out of a storm, there will be another, but the shock, the pain of that loss cannot repeat. Some things hurt more with repetition. But a scar, however painful, is not as shocking as the cut.

I am hopeful that you will let yourself nurture yourself as much as you would a baby from your own body. I am hopeful you will appreciate the art you have birthed into the world, and what else you want to create—whether that be family, love, relationship, physical objects, more books, learning to cook, trusting your gut, not being so hard on yourself.

### What do you feel hopeful about now for yourself?

I am holding an umbrella, but I'm in the bathtub. I am prepared for the situation, but I got things switched around.

I am hopeful that I will continue to center love in my life, if only because it is a source of conflict, ambivalence. But I hope I let that melt. Accept and allow myself to be loved, let myself move closer to a person. Accept that I am already loved, that I already love so much, and this is not my downfall, it is perhaps less a strength than fundamental. Why try to fight a feeling? The way with my own body, when I stand still, when I know this is what will and won't happen right now, the multiverse spins madly on. I can relax into what is. I can stop thinking how it is painful that in Narnia there are Turkish delights. It is snowing. My umbrella would be even less useful. There is a lion with meat hanging onto his teeth because he is not afraid of what he had to do to eat.

I don't want to pity myself for what I did or do for love. Desperation is passion without end. Deliberation, a toss of the dice and walking away from the table. Instead of spinning a wheel that isn't working, what if I walked in, put all the chips on red, spun once? It's either there or it's not. Assess and then walk away.

Why do we use time when it is so subjective? I am hopeful that my life will feel different in time. That I will put the umbrella down and sink into the tub—I was already there.

*Black Time*

If there are flowers flowers

—*Gwendolyn Brooks*

You start out with one thing, end
up with another, and nothing's
like it used to be, not even the future.

—*Rita Dove*

# SPHERICITY

*

begin with flatness

make a line

now turn the line into a square

now turn the square into a circle

now turn the circle into a sphere

now turn the sphere into a globe

now turn the globe into a world

now turn the world into a spiral

now turn the spiral into a shell

WELCOME TO BLACK TIME

*

reacting to an earthquake in haiti

rolling into a mound of dirt

holding a shovel over my face

tangling myself up in paper

from cash register rolls

walking back into black atlantic

releasing myself in waves

submerging trying to dissolve

holding a mirror over my face

confronting history and reflecting sky

then years later or maybe centuries now

returning to a mound of dirt

encircled by a hundred-foot

extension cord

THIS IS A POWER LINE

coiling around my feet

walking and tracing the line

*charging into past and future*

*holding a shell in my hands*

holding this shell I hold a spiral of BLACK TIME

within a spiral of BLACK TIME

repeating and changing

reckoning and grieving

resurfacing and harnessing

re/generating power

*

BLACK TIME is not flat

is multidirectional

is multimodal

is global

is diasporic

is dispersed

is jam-packed

is overextended

is can i call you back

is i'm not always there when you call

is i'm always on time

is early is on time

is on time is late

is right and write and rite on time

is day after day

is the changing same

is taking a long time

is at the same time

is taking twice as much time

is being twice as good to get half as much time

is double consciousness and double time

is aftermath and aftershocks

is aspiration

is hurry up and wait

is one step forward two steps back

is back to life back to reality

is go back and fetch it

is flop and drop

is off the clock

is flavor flav's clocks

is maybe flavor flav's teeth

is how long it takes for afro sheen to come out the nozzle

is how long it takes for the hot comb to heat

is how long it took you to grow that hair

is how long it takes for the hair to grow back

is how long it takes to bargain at the market

is how long it would take to forgive the debt

is how long it would take for lotion to fix my ash

is never-ending

is this pandemic

is taking a long time

is what we make not what we have

is what happens if we take our time

is what happens when time takes us back

is flashbacks and flashforwards

is time and time again

is curtailed and controlled

is cutbacks and numbers

is cut back and devalued

is cut down and controlled

is feared and restrained

is gone too soon

is resting in power

is rising in power

is resurgent

is cyclical

is divination

is divine

is sphericity

is all the time

is seeping and oozing

is the déjà vu

is what happened before

is what's happening now

is on and off the page

is embodied performance

is mobilized through body and breath

*

THIS IS A SCORE

close your eyes and take a deep breath

you have arrived into blackness

of inner and outer space

you are not settling here mind you

* that would require permission *

you are simply inhaling

and exhaling where you are

*

extend your limbs

allow your neck to roll in all directions

allow

vibration                              landscape

scale

feel

those things                    m o v i n g

in your body

through

specific                    parts

of your body

it could

be your hands                    your tongue

your head,

your foot, your fingertips

*

THIS COULD CHANGE AS YOU GO

allow your moving to revolve thought

allow your thought to span time

consider what has happened here for you

consider what is happening now

consider your body and your work

what is flat? what is spherical?

what spirals? what shells?

what has crystallized or emerged?

what has subsided or closed?

how have you marked

your own time or your people?

*

THIS IS A PORTAL

*

as a black feminist performance artist

my practice has to be about

claiming and wallowing in

BLACK TIME

stretching my body across

time lines

blood lines

power lines

*holding the shell*

*un/earthing and re/grounding*

*channeling generations*

# *Wild Beauty*

\*

Within the celebration of the erotic in all our endeavors,
my work becomes a conscious decision—a longed-for bed
which I enter gratefully and from which I rise up empowered.

—*Audre Lorde*

\*

I have a dream . . .

—*Dr. Martin Luther King, Jr.*

\*

\*

\*

\*

*

enter into a space
where you feel safe.
describe it.
find a portal.
designate a guide.
move through the portal
with your guide.
take your time.
sense and apprehend.
if you need assistance
draw a tarot card.
discover what's yours.
don't do this alone.
have someone outside
your skin to hold
your energy pull
cards from the deck
and remind you
of the other world.
when you're ready
retrace your steps.
make sure to close
the portal before you
return. if not you
may remain gaping.

*

TUES 1/7 preparation
for ritual is ritual
on the last day
of their movement
research winter
melt workshop
"honing bodily intuition"
iele paloumpis guides us
through a visualization
*enter a space where*
*you feel safe / describe it*
*find a portal /* they tell us
they learn this spell
from Eva Yaa Asantewaa
a powerful black dancer
+ curator + creative
spiritual force
this transmission
of magic + energy
feeds and fortifies me
cracks me open
+ propels me to explore
black time
+ black dreams
it comes with me
to wild beauty
the next week
which starts here
before it starts

# WILD BEAUTY

*What happens if we take our time?*
*A Dr. Martin Luther King, Jr. Ritual /*
*Black Movement Intensive*

with Gabrielle Civil, Randy Ford,
Neve Kamilah Mazique-Bianco, and Fox Whitney

JAN 12–20, 2020
**VELOCITY DANCE CENTER**

EVENT CALENDAR
Gabrielle Civil reading at Elliott Bay — Thursday Jan. 16, 7pm
Free movement workshop — Monday Jan. 20, 2–3pm
Community celebration — Monday Jan. 20, 3–4pm
Free performance — Monday Jan. 20, 4-6pm

CORE ARTISTS

**GABRIELLE CIVIL** (she/her) is a black feminist performance artist, poet, and writer, originally from Detroit, Michigan. She has premiered fifty original performance art works around the world, most recently with Moe Lionel at Queertopia in Minneapolis (2019) and at the Eclipsing Festival at Links Hall in Chicago (2018).

**RANDY FORD** (she/her or they/them) is a Seattle-born dancer, choreographer, actor, and activist. After some time at the University of Washington, she became a member of Seattle's Au Collective, a collective of artists committed to bringing womxn, queer people, and people of color to the forefront of everything it does.

**NEVE KAMIILAH MAZIQUE-BIANCO** (they/them or she/shis/shers), or NEVE, is a Black (specifically Sudanese, even more specifically Nubian) punk disabled queer fairy beast. A certified personal trainer and integrated dance teacher trained by NASM and Axis Dance Company respectively, NEVE cares about the welfare and equitable access to joy, sensuality, community, self-expression, and liberation of all bodies.

**FOX WHITNEY** (he/him) is a dancer and interdisciplinary performance maker working at the intersection of dance, film, theater, and visual art. Fox's transgender, Black multiracial, and queer point of view is at the heart of their performance project, Gender Tender, for which he creates experiences that investigate the nature of trans and queer relationships and histories as well as the surreal nature of transformation.

# *what happens if*

SUN 1/12 arrive to seattle
land of the Duwamish people
shirley picks me up and
drops me at angie & dan's
everyone is wonderful
feel NERVOUS and EXCITED

MON 1/13 first day in velocity!
* * * * * * S N O W * * * * *
wake up to frosted windows
and weather reports
start to learn bus lines
run late to pick up flowers
and salami and bread and cheese
and fruit and wine
arrive late but on time
fox and randy are already there
this is my first time meeting randy
and she is so lovely
and fox is lovely too
we wait for neve
who i already know is lovely
they led an amazing workshop
at SFDI last summer where
you had to come up
with a phrase
with a partner
a shared gesture +
a shared sound

# we take our time?

then you close your eyes
and spin around a few times
and disperse and crawl
reaching out trying
to find your partner again
you feel surrounding bodies
or surrounding desire
and snap your fingers
and move to tap elbows
or whatever the gesture
only to realize
you aren't the one
looking for so much
loneliness in search
of connection
terrifying and thrilling
+ how good it felt
when you finally came together
we can't start without neve
i'm chomping at the bit
and this is the starting already
we have already started already
in our own time
and this is the time
black circular colored people's time
like june jordan says we are the ones
we've been waiting for time
we are always all the time

*setting intentions*

<u>Randy</u> →
move and feel good about the process

### *randy says: we're not going to do a minstrel show*

<u>Fox</u> →
prioritize intuition to welcome the emotional spectrum
tap into it for people

<div align="right">

<u>Gabby</u> *(sic)* → (notated in my notebook by Fox)
wallow in the possibility of black collaborative
space movement + rest, emotional, intuitive
what can people do together that
they can't do by themselves?
the 4 of us can learn more about these questions
ART + LIFE? Be open to self, others to move
[an asterisk of arrows erupting between open and move]

</div>

Neve → intention emerges as / through movement / synesthesia
→ lean into the richness of the experience
rather than trying to analyze or glean a conclusion
before it's ready → lean into the complexity
of people moving together, our bodies moving together

*

AUGMENT + SUSPEND
AUGMENT + EXPOSE

*

TUES 1/14 listen to emahoy tsegué-
maryam guèbrou on the way
to the no. 8 bus on mlk avenue . . .
heather told me to try maryam and so i do
already starting to groove
woo hoo! find out about longlist for the believer prize
boo hoo! find out elliot bay forgot to order
my books for the reading on thursday!!!!!!!!!!!
excited and angry and excited and tired and
feeling behind on the making of wild beauty
and also trying to lean into things taking time
arrive early to find randy already moving
fox and neve on the way
fox arrives and randy starts teaching us
her brand-new choreo for whoopi i am awful
at following steps but it sure is fun to try
something that feels like belonging
the friends i thought i'd maybe see in seattle
don't have time to track what's happening
for me here right now or to come to the show
my feelings are hurt but i know i can't complain—
these 3 very busy, very beautiful black dancers
have taken their precious time to do this with me
+ catherine the director of velocity
has shown up in polka dots and octagon earrings
because she saw me wearing those yesterday
what does it mean to show up
in wild beauty myself? finish the diversity
powerpoint and send it to my job
hooray! neve arrives in splendor

245

*Velocity Dance
Production Meeting*

WE ARE
trying to conjure
colored peoples time
resistance
resilience
↓

self-care                                    PORTALS ←
community care
　　a world where black people take their time ←

DURATIONAL ←
a world where black people use the space
as needed

BLOOMING IN WINTER

→ <u>how do we keep time?</u>

*neve says: I like to call him
Rev. Dr. Martin Luther King, Jr.*

*

I want to take advantage of
time / I want to claim
time / I want to activate myself in
time / I want to allow /
// S O M A T I C   C O N N E C T I O N //
time / what is beautiful and to allow for
time / to cultivate the wild within myself /
time / and the space as a form of
time / deep, velvety blackness /
the texture of the most black red rose petals

*

presentation + invitation
a night garden
> dreams — MLK — dark light
> dream state — pop-up performances

audience politeness
can be both polite + stagnating
> err on the side of shy

### *foxy says: we are the art same blueprint same score different versions*

time: conforming

a changeling: exposed and augmented

beauty as camouflage

\*

\*

MAGICAL SPACE < = > GROUNDING
WALLOWING
WALLFLOWER
SECRET GARDEN
   WALLFLOWER DANCE
WILDFLOWER    WEED

———————————

NIGHT GARDEN
SECRET GARDEN
WALLFLOWER WILDFLOWER
WALLOWING IN
   SADNESS DANCE
MLK — NOCTURAL DREAM

\*

\*

## gabrielle says: things tumbling from dreams

↓↓↓↓

I want to make a bed in the space
I want to rest and dream in real time
I want footage of MLK unfurling
I have a dream behind this bed
I want this to turn into a dance
I want to slow dance to Dinah Washington
// W H A T  A  D I F F E R E N C E  A  D A Y  M A K E S //
I want everyone to want to slow dance with me
I want everyone to want to slow dance with each other
I want everyone to slow dance with everyone in the world
I want to dance slow in the world and be held in slow bodies
I want people to cut in cut up and cut out to dance

ALLOW REST

BRING FLOWERS

*

WED 1/15 *happy birthday mlk!*
born 01/15/1929 martin luther king, jr.
is ninety-one today radiating in power
like crispus attucks + harriet tubman
+ marsha p. johnson + erzulie dantor
black heroes / sheroes / eros
how does uprising begin?
trying to get everything together
for the reading on thursday +
picking up the vegan chocolate cake
get to the studio late—
birthday party for martin in the big studio!
neve, fox & me celebrate with loren & saira
randy can't make it but is there
in spirit we chat and sing and eat
the cake (who knew a vegan cake
could be so moist and delicious?
but of course it is chocolate)
devour blackness and dance
meet adwoa down the street
for happy hour at momiji in the summer
mayfield loved the lychee cocktails
there across from what used to be
the police station but is now
the empowerment zone!
take the bus to see fox dance in *an augur*
at on the boards his dance swelling
with cartomancy other divination
that night via colored dye poured
and swirling in water and whispers
in stairwells and peering through holes

THURS 1/16 all together
in the same space at the same time
        is SO MUCH FUN!
rehearse randy's choreo for whoopi
learn neve's translated ballet
pull from the ghetto tarot
and the slutist deck where neve
shows up as the prince of coins
        we keep getting
the moon              2 of pentacles
9 of pentacles        4 of pentacles
            the world
opening and trying to make sure
to close portals + bibliomancy
*the tradition* by jericho brown
*the changeling* by victor lavalle
it goes in a blur then velocity
volunteer happy hour
(deep    red    wine)
my x in j reading at elliott bay
despite them forgetting
to order my books still sell 12—
through the genius of janice lee
(my art goddess angel!) + my former
student stephanie j who bought 5!
yayyyyy! dance party after party
at velocity with fox, will, neve
and a friend of theirs with
really good energy who wallows
in our bed at the heart of our making
6 big cushions in red velvet
and metallic swirl set space
for dreaming and rest
kind of downstage left

covered with angie's blanket
from my bed in seattle and
next to a vase of dark roses
(pronounce it *vahzz* dreamy
so it rhymes with *ahhhs*)
where we improvise bed solos
draw cards and collect spirits
now fox pours gin with club soda
neve works the stanky leg
will shows off moves from the pole
dance class while feminist me
chuckling and shaking her head
dances VERY HARD to silentó and
backseat freestyle by kendrick lamar

FRI 1/17 still trying not to do
a show show still learning
still making wild beauty
tech meeting with jessica
whose voice is thoughtful
and soft and whose pencil
is sharp materializing dreaming
miss the bus with fox and will
so grab a burger and fries
at some homespun seattle spot
then will drives through gnarly
traffic in one of the last city cars
to see neve & randy dance in
dani tirrell's *showing out* and
randy sparkles bustier fire and
neve glitters tiny animal bones
in a bowl deep memory and
so much life it makes me so happy
to know this extravaganza of

blackness dancing is happening
at the langston hughes center
in the black poet's space like
a family reunion watch dancers
feel like cousins or at least
claim them so markeith
and saira and michael and david
guess we're family now then
run into a young black poet
i met a few months ago
in bothell of all places
and now here we meet
again with pleasure

SAT 1/18 cusp time show
make slides of images show
mark the order show
run through gestures show
—but wait what was that
creeping feeling muscle
memory returning registering
at rest somehow queer desire
is in here too lost time
somewhere in this feel
twinge + wonder deepening
blush oh this is deep
attraction to fox how nice
to dance with a dreamboat—
stare at dream pictures show
dream into bed solo show
try to put this in my body show
practice show flow show

SUN 1/19 *SLEEP IN*
listen to the rain fall hard outside
watch 3 episodes of *power*
talk to madhu on the phone
for almost 4 hours
6:30 p.m. tech with jessica
solo with text assist from fox
wild beauties rest apart time
good for preshow dreaming
splurge and squeeze in time
at the spa a few blocks down
from velocity right before closing
time down time my muscles
so stiff pray the masseuse's
knuckles won't break
catch the bus just in time
to ride it back to mlk then
get off the bus and dance
on empty sidewalks solo
dance to beyoncé and sudan
archives on headphones
dance all the way home
to your borrowed bed
at angie & dan's dance
to deep sleep before tomorrow
rest to rise and dream
as the moles say enjoy yourself
it's later than you think

MON 1/20 arrive early
to the studio feels so good
fox leads a warm-up
after nancy stark smith
one minute of movement
one minute of stillness
one minute of sounding
          repeat
we do this together
in the little side studio
show energy starts to surge
randy arrives and moves too
then looks at the flowers
picks up her car keys
and heads out the door
to buy a whole lot more
we crave and demand
          *wild beauty*
open the accessible door
and welcome everyone inside
a massive altar with lit candles
gorgeous flowers books images
tarot cards and markers +
special signs neve made
one says *make something*
*for an ancestor or a descendent*
anyone can put something down
convening and grounding
neve reads the velocity
land acknowledgment then
our free workshops begin
gab embodying justice
randy sharing whoopi choreo
for the flash mob later

neve teaching a dance
telephone one person
dances and another tells
the story of the dance
for another person to dance it
all at the same time
in the back studio windows
and pillows and books
for conversation and rest and
tables of food and drink
(more vegan chocolate cake!)
+ a slideshow of projected images
/ ntozake shange with plants
/ eartha kitt in trees / the mlk
peace garden / mlk & malcolm x
/ mlk & rosa parks/ rosa parks
doing yoga (for real in 1971,
rosa parks is doing the boat pose!)
/ stormé delarverie / stonewall
kids on the stoop/ freedom dreams
/ the world in the ghetto tarot
fox + gabrielle + neve + randy
making dreams and body shapes

# Wild Beauty

*what happens if we take our time?*

*Always keep light on the altar*
Collective actions appear all in caps
An asterisk (*) might suggest a pause for rest,
for eating, drinking, talking, pulling a tarot card,
lying down on pillows in the room next door . . .

EMERGE INTO DREAMING
Start loop projection of MLK's "I Have a Dream"
on the curtain ten minutes before we arrive
// then Gabrielle slow travels to the bed
a bouquet of roses and other flowers near her head
Fox, Randy, and Neve emerge one at a time
slow traveling from behind the curtain
of MLK dreaming . . . *I have a dream today* . . .
black-and-white footage no sound but captions
Fox and Neve join Gabrielle dreaming on the bed
*light: MLK projection and bed spotlight*
*music: "How I Got Over (Live)," Mahalia Jackson*

Fox Score:
SLOW TRAVELING
*exposure to dreaming*
*slow but not slow motion*
*high to low to enter dream state*

FLOWER MAZE LABYRINTH CRAWL
Gabrielle, Neve, and Fox roll off the bed
and begin crawl choreography
Randy makes a pathway with flowers
we keep moving // the rest of this section in silence
*light: fill light (similar / extending bed spot)*
*music: Mahalia plays out to the end*

Neve Score:
3 TYPES OF CRAWLING
Mermaid on land 3 times
Dreamboat crawl 3 times
Pattern with booty bourrée
We slide drag luxuriate our bodies across the floor
Repeat until we get to where we want to go

Whoopi Randy Solo
*light: stark fill*
*music: "Whoopi," Rapsody*

Randy Score:
WHOOPI
(for *solo and flash mob*)
RESIST          FORM
BREAK          OUT
Unpoint your toe

Find your yummy
Find the steps
Make it your own

Randy Bed Solo
Randy goes to the bed and makes a dance
*light: bed spot only*
*music: "Goat Head," Brittany Howard*

Gabrielle Score:
BED SOLO
Go to the bed and make a dance
This can be movement or rest
or whatever you need
Bring the dream back into the body
BED as a site for dreaming + rest
BED as a territory of sexuality desire loveliness
BED as a place of MLK'S DREAM linked
to YOUR OWN MOVEMENT/DREAMING
PUBLIC politics history and justice linked
to PRIVATE personal interior dreaming
BED SOLO as a practice of public dreaming drifting
dozing
writhing waking resting recovering meditating
visualizing
moving for public witness and/or action

Fox Dream Aloud                    *rosa parks with martin luther king, jr.*
Fox stands at mic and starts speaking    *in profile in the background*
which cues light and mic
*light: blue mic spot*

Fox Score:
DREAM ALOUD SOUND STATION
Describe an image by heart
the material qualities of a painting
or photo or tarot card
start with the quality of light
(eyes closed might be needed)
then take account of all the things
in the background the color
the shapes the architecture
of the space what figures
in the foreground // you can
SPEAK WHISPER SCREAM SING
as though you were a peaceful detective
inspired by forensic investigations
of missing persons // the image
appears only in another room
// your description reverberating
will be the only record

ENCHANTED SCULPTURE GARDEN
Fox raises his hand above his head
and makes the portal-opening gesture
Gabrielle, Neve, and Randy arrive to dance
*light: blue fill*
*music: "Water Me Down," Vagabon*

Neve Score:
ENCHANTED SCULPTURE GARDEN
you can dance if some part of your body
is connected to some part of another person's body
if you disconnect you have to freeze
another person's touch and sustained
bodily connection brings you back to life

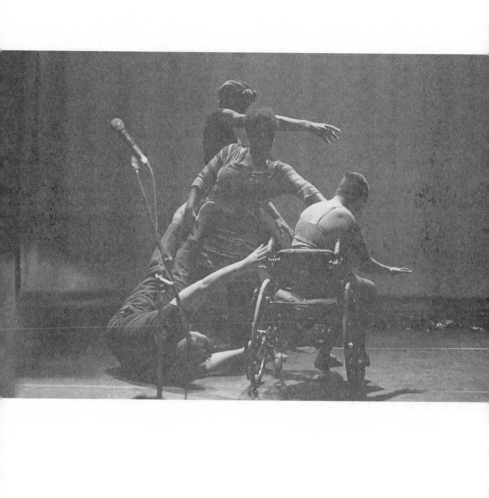

Neve Bed Solo
Neve goes to the bed and makes a dance
*light: warm fill*
*music: "Hallelujah," Leonard Cohen*
Neve sings this a cappella

\*

Gabrielle Dream Aloud                                     *rosa parks doing yoga*
Gabrielle stands at the mic and starts speaking     *ntozake shange with plants*
She makes the portal-opening gesture
This cues the bed light on Fox whose
movement starts at Gabrielle's shift
from Rosa to Ntozake // this moment
of overlap is a duet // Fox's sound starts
after Gabrielle's speaking ends
*light: blue mic spot & bed spot*

Fox Bed Solo
Fox goes to the bed and makes a dance
After the track ends we go immediately
into the flash mob—Fox will still be
on the bed that's cool // so much the better
*light: bed spot*
*music: "Confessions," Sudan Archives*

WHOOPI FLASH MOB
Those who learned this dance
will come join us onstage
cue light and sound after Fox track ends
*light: warm fill*
*music: "Whoopi," Rapsody*

SLOW DANCE
Gabrielle asks someone to slow dance with her
and then wild beauties + audience slow dance
Neve sounds into mic at the end of the dance
This is the cue to change the light
*light: blue fill*
*music: "What a Difference a Day Makes" 2x*
*Dinah Washington then karaoke version*
*the two tracks play one right after the other*

> Gabrielle Score:
> SLOW DANCE
> everyone slow dances in couples
> or throuples or more or alone
> and everyone can cut in or switch at any time
> or the whole time remain a wallflower

*eartha kitt perched in trees*

Neve Dream Aloud
Neve sits at the mic and starts speaking
*light: blue mic spot*

*

An Interruption of Joy
Gabrielle reads from "The Call for Experiments in Joy"

> *"What is the urgency of our invention?*
> *How can we engage in collective imagining?*
> *How does our work change when we create*
> *from a place of freedom?*
> *How can we claim joy?"*

*light: warm fill*

POP-UP DANCE PARTY
Everybody DANCES
Neve gave us this idea
because we all came there to DANCE
*light: "party" multicolor fill*
*music: "Church," Samm Henshaw*

Randy Dream Aloud                                    *ghetto tarot card*
Randy stands at the mic and starts speaking                    *the world*
Randy makes the portal-opening gesture
as cue for Gabrielle bed solo light to start
*light: blue mic spot*

Gabrielle Bed Solo
Gabrielle goes to the bed and makes a dance
*light: bed spotlight*
*music: "Dreams," Kelsey Yu*
*track plays out to the end*

BLACKOUT

I want to throw roses.
I want to break open
and eat a watermelon.      [ONSTAGE]
I want to break into red
sweet fruit meat fruit flesh

It's already sticky
I want it to be sweet
I have mixed feelings
about messiness.
I need to make a mess.
I need to not be afraid
of making a mess.

And I don't want to waste it.
Our time is precious.
My time is material.
My time is a portal.
My time is this watermelon.

What happens when you
take this watermelon?
What if this is the time
for new fruit and flowers?

what happens if
we take our time?

*

*

*Dreams tell us*

*that rest is*

*not passive.*

*

*

*

Text Message Thread
Tue, Jan 21, 11:04 AM

[To Fox from Gabrielle]

I'm at the airport about to
board. Will write about Wild
Beauty on the plane. And
maybe will do ritual at home to
close the portal. Before I do, I
want to ask you about my bed
solo. Before I went to bed I felt
so broken open and gaping and
kind of failed—exposed
(augmented?) very 5 of
stones. What did you see?
What happened? Sending you
so much love, admiration and
thanks [emoji of black hands in prayer]

[To Gabrielle from Fox]

It was a beautiful solo. It
started with love with a friend
on the bed, unison arm and leg
movements and closeness and
then they left you, it seemed an
unexpected departure. But still,
you grew, into luxurious arm
movements and lines of leg
extensions that eventually
connected you, little by little you

tested the waters and then
disappeared for a moment
caught up in a tangle of bed
sheets and blankets. Then
precariously, even though you
were encumbered and caught
up, you rose up to stand,
dancing through the tangle,
then you ventured out into the
sea of people, seeing the
people, turning and sensing
different sensations in your
body, echoing our own hearts
and heads with your torso and
neck movements, balancing on
one leg at times, never losing
track that you were part of
the group but also in a different
time, then suddenly you were
the ancestors in a forest,
wrapped up against the harsh
wind and then you were the
priestess card, and then you
were in-between worlds like a
ghost in angie's blanket,
melding back down to the floor
spine undulating as you
became connected to the
ground again, crawling,
traveling away from us
to another realm.

[To Fox from Gabrielle]

Thank you so much for this.
Thank you for all the care and
reassurance you offered me
in Wild Beauty.
["Fox loved this message"
an emoji of a pink heart appears
before the next words]
You are a dancing dreamboat.
Please let me know if I can offer
you anything now in the future.
[emojis of black hands vibrating /
red flower/ green fairy in flight/
black hands pressed in prayer,
fingertips and palms pressed together]

# Waves ~ ~ ~ ~ ~ ~ ~ ~ ~ ~ ~ ~ ~ ~ ~ ~ ~

I imagine the moment when the/a/each poet looking for themself/herself in a strange mirror, they/she see only a face twisted and erased, multiple images cancelling each other out, buffeted by the waves of endless events and voices, and they/she a singular body, strives to retrace their/her steps in order to identify the point at which they/she become a part of the mirrored-world, and how to preserve their true faces . . .

*—Nhã Thuyên (translated by Kaitlin Rees)*

~ ~ ~ ~ ~ ~ ~ ~ ~ ~ ~ ~ ~ ~ ~ ~

Imagine this written in yellow gold, the color of California sun
we imagine behind palm trees, hazy radiance peeking through . . .
I'm walking to the cineplex to see *Waves* again
I don't usually see movies more than once
Press rewind instead under covers in bed
at home, alone, online streaming
But there's something about this movie
this walk to the silver screen that's holding me close
That's nestling me, that's jostling something loose
Who would play me in the movies?
And what are movies, anyway?

~ ~ ~ ~ ~

WAVES: A SYNOPSIS

*Waves* is a 2019 American drama film written, directed, produced, and co-edited by Trey Edward Shults. It stars Kelvin Harrison Jr., Lucas Hedges, Taylor Russell, Alexa Demie, Renée Elise Goldsberry, and Sterling K. Brown. Set against the vibrant landscape of South Florida, it traces the emotional journey of a suburban family as they navigate love, forgiveness, and coming together in the aftermath of a loss. (Wikipedia)

~ ~ ~ ~ ~

It makes no sense for me to be seeing *Waves* again
or really seeing *Waves* at all
I've said for a while that I never want to see
another movie with teenagers again
If we're lucky enough to live to be ninety
why fetishize the time between nine and nineteen?
It's not the best time of almost anyone's life
Like Oprah, I'm living my best life right now
*(Swallow the fish, motherfucker! Experiment with joy!)*
I don't like teen movies because they lie
They pin coming of age to a particular time
when as the Black Quantum Futurists say:
TIME IS NOT ALIGN. Freudian slip.
Time is not *a line.*

~ ~ ~ ~ ~

Hollywood teen movie time is not aligned
with black quantum time black feminist time
*concentric circles and concurrent overlaps*
Where are the young souls in movies?
the ingénue eighty-year-olds?
I just know I'll be flirty and slutty in the old folks home

if I can make it that far
I'll be batting my eyelashes, unsure who to choose
girlfriends and boyfriends, maybe at the same time
(They will all see my shine)
I'll be blowing off crafts and flower arranging
the way I never could when I was
cracking the books
hard as a teenage girl

~ ~ ~ ~ ~

*Who would play me in the movies?*
Tempestt Bledsoe aka Vanessa on the besmirched *Cosby Show*
people used to say because that was the only black girl they saw;
Gabourey Sidibe doing performance art; Viola Davis, brilliant and
dignified in pain; Octavia Spencer as the sassy maid; or Lizzo after
she "checked her petty" and said sorry to the Postmates delivery
girl (cause It girls get messy too)

~ ~ ~ ~ ~

I think about *innocence*
and how to signal that
A blush usually stains pink on pale skin
A quiver in a doe-like body
What to do when your blush doesn't shine through?
When the ingénue is never you but that is what you are?
*sweeping rolling cresting flushing inside but never shining through*
Who gets to play you in the movies?
How do you get the movies to play?

~ ~ ~ ~ ~

    WAVES: A SYNOPSIS
    A black boy hogs the spotlight in the family.
    He is the prized prince, the precious son. He
    takes up a lot of space. He moves with strength
    and speed. He wrestles like his dad. He wrestles
    with his dad. He loves his girlfriend. The
    goddess. He loves to hold her and kiss her. He

wants to be the boy of her dreams. He wants to be the father of her baby someday, but maybe not today. He wants to be the one she could run to / if somebody hurt her / even if that somebody was him. No, really. He wants to be Prince in "If I Was Your Girlfriend." He struggles with the weight of his father's expectations. (Prince also struggled with the weight of his father's expectations, but that's another story, really another movie called *Purple Rain* . . .) The black boy and his daddy issues are swagger and hot air and a lot of secret pain. Then shaking. Then shouting. Then breaking. Many faces crumple. The movie starts off as one thing then turns into another.

~ ~ ~ ~ ~

Take the very beginning of *Waves*
a cocoa-with-milk colored girl is riding a bicycle by herself
*could this be a figure of freedom?*
Forget about her
Oh we do!
We see a speeding car, a brown-skinned boy and an olive-skinned girl
both with dark hair, their heads sticking out of windows
They sing words you don't know unless you watch it again
and learn it by heart *Flori, Flori, Florida, Floridada, Floridada*
If you don't watch it again, you don't even see
the black girl was there at first.
*The black girl was there*
You could say that about the whole first half of the film
If you're not paying attention you don't realize
the black girl was there SPOILER ALERT
The black girl is always there all along
even if you don't see her

~ ~ ~ ~ ~

How can we see ourselves when and where we aren't seen?
But isn't that what movies are for?

~ ~ ~ ~ ~

In *I Know Why the Caged Bird Sings,*
Maya Angelou's brother, Bailey, gets in trouble
for staying out too late
Nobody knows where he's been
It turns out that he was seeing a movie over again.
The white movie star looked exactly like their mother
who had abandoned Maya and him
Maya goes to see the movie for herself
and laughs heartily at the screen
While the white folks are laughing at the racist jokes
the black maid saying "Lawdy, missy"
and the buffoon butler polishing expensive cars
the black girl is laughing at how they couldn't tell
how they didn't know and couldn't see
except that she was white
the movie star looked like her mother

~ ~ ~ ~ ~

Recognition becomes a second sight, a second skin
I walk to the movies to see *Waves* again
No one knows I'm going
No one knows I'm here
Look harder and I'm already there

~ ~ ~ ~ ~

I see *Waves* at the Americana
in an outdoor mall in Southern California
where I also saw *BlaKKKlansman, Harriet, Queen & Slim,*
and *If Beale Street Could Talk,* a film I deeply loved
At another Americana right outside Detroit
I saw *The Last Dragon, Trading Places, Jumpin' Jack Flash,*
*I'm Gonna Git You Sucka, Hollywood Shuffle,*

and Prince in *Under the Cherry Moon*
I didn't walk to that Americana and I didn't go alone
We came in cars and had to go through metal detectors
after a bunch of teenagers got shot
Do I need to clarify that the teenagers
in this Americana were mostly black
or is that implicit in the shooting?

~ ~ ~ ~ ~

Prince shot *Under the Cherry Moon* in black and white
in the south of France, where later I would study
literature and politics and movies SPOILER ALERT
Prince himself gets shot in *Under the Cherry Moon*
and he directs his own death scene at the end
The critics were less than impressed
(We did not study this movie in my French film class)
but of course it still makes me gush
If you can catch her, get Tisa Bryant to share
her Neo-Benshi on *Under the Cherry Moon*
She recut the movie and voiced over it, pointing out
all the black women flitting in the corners

~ ~ ~ ~ ~

How can you spy black women where we're least expected?
What do you have to pass through to find us?

~ ~ ~ ~ ~

WAVES: A SYNOPSIS

In *Waves*, a white man writes and directs a movie
based on his own life. He casts black actors to
play himself and his family. He splits himself
in two. It didn't start that way. (Flashback:
a black girl on a bicycle.) In an earlier movie,
the filmmaker had worked with a young black
actor, a rising star, and wanted to work with
him again. He saw two parts to his own story.
There was Tyler, the brash son wrestling with

injury, struggling with having and maybe being
a father. Then there was Luke, the soft-hearted
romantic who ends up the boyfriend of Tyler's
sister Emily. The filmmaker asked the actor to
choose: Which part did he want to play? So much
to move through. Dyed blond, black and not-
black people in and under water, electric-pink
fingernails, body swaps, a road trip, switched
point of view. And yes, it is fucked up that
in *Waves* the black boy is savage and the white
boy is sweet, but you can bet that the internet
clapped back and let everybody know. I think
about *innocence* and how to signal that. I think
about *experience*. A cinematic sleight of hand
meets a cinematic shorthand. The black boy is
the white boy too. TIME IS NOT ALIGN. In *Waves*,
Kanye chants I AM A GOD while Cudi wonders,
*When did I become a ghost?*

~ ~ ~ ~ ~

What if you could restage the key moments of your life?
What do you look like on the inside?

~ ~ ~ ~ ~

*Who would I pick to play me in the movies?*
CAConrad for the rituals; Divya Victor for the line breaks;
David Hammons for the readymades; Dev Patel for the earnest-
ness; Keanu Reeves for obvious reasons; Megan Thee Stallion for
obvious reasons; the daughter I never had

~ ~ ~ ~ ~

How can we reckon with race and resemblance?
Who checks our identification?

~ ~ ~ ~ ~

Blackface soils the foundation of every feature
ever since old boy first smeared his face

with burnt cork and invented Jim Crow
*vaudeville radio movies television memes GIFS cable news*
We feel the sensational undertow
Have you seen Al Jolson in *The Jazz Singer?*
It's a real scream! Or Steve Martin in *The Jerk?*
A trickier case is Angelina Jolie in *A Mighty Heart*
They say Mariane Pearl, a woman of color
chose Jolie, a white movie star, to play her
This likely sprang from personal connection
The two had worked together on human rights
after the murder of Pearl's husband
So Pearl knew Jolie's heart as well as her own skin
Tongues wagged and Jolie's bronzer was laid on pretty thick
but I am actually more interested in Pearl
Can we disregard cinematic history and make our own?
Who decides who can play you in the movies?

~ ~ ~ ~ ~

*Who would you want to play you in a movie?*
They ask OutKast in *People* or some other celebrity magazine.
Their brown heads float on the corner of a page. André 3000
responds in one bubble: *Leonardo DiCaprio.* In another bubble,
Big Boi says: *a white-shoe playa like Jude Law.* (If you've never seen
Big Boi singing Kate Bush's "Running Up That Hill"
then I swear you have never lived.)

~ ~ ~ ~ ~

What happens when essence leaks beyond race?
Wouldn't you want a movie star to play you?

~ ~ ~ ~ ~

*But wait, you're telling me you can't find*
*a dark-skinned black woman to play Nina Simone?*
In *Waves,* a pretty, light-skinned Latina
plays the goddess, the son's doomed girlfriend
In *Nina,* a pretty, light-skinned Afro-Latina
plays the high priestess of soul

Well, she's not *that* light-skinned-ed-ed
My godsister Kathy in Detroit and my godmother Liz
from Mississippi are *a lot more light* than her
But still, Hollywood goddamn!
The makeup never budged
No blush spread across this face
Zoe Saldana had to darken her skin
and you know how we feel about that
To get *Nina* bankrolled the producer said
she had to get a movie star, or at least the closest thing
*suck teeth roll eyes at blatant colorism in movies*
*how we get turned against our own reflections*
~ ~ ~ ~ ~

Poor Zoe Saldana got told by her own kind
you may be black, but you're not black *enough*
As you can imagine, I've heard that refrain myself
*white-talking proper Oreo uppity think you better*
What would Nina herself have had to say?
Did she distill her blackness down to hue?
What is the heart of true resemblance?
I imagine Nina cussing out
the white lady director and producers
and eyeing Zoe Saldana from head to toe
and maybe she would say,
"Back off, little girl" or maybe
"You're not me, but let's see what you got"
In any event, the movie flopped
How could Miss Simone's majesty
and genius, her expanse
and contradictions be rendered
in any one movie?
Or in any one body?
~ ~ ~ ~ ~

*Who would Nina Simone have wanted to play her in the movies?*
Hattie McDaniel or Dorothy Dandridge? That seems unlikely.
More like Yaa Asantewaa or Johann Sebastian Bach.

~ ~ ~ ~ ~

WAVES: A SYNOPSIS
*Boy, I'm not sure you should play this,* Spencer K.
Brown says to Kelvin Washington Jr. *When I first
read the script, I didn't even know he was
white. I mean really the man's first name is
Trey. And now you've got this white boy having
you play him and you're aggressive and violent
and tragic. What are you doing?* But it's a good
part, Kelvin rejoins . . . There's depth to it.
It's not the same old stereotypical bullshit.
You see how he's trying to be all these dif-
ferent things. And I get to train and change
my body and turn myself into something else.
*But watch out, warns* Spencer K. *It's positive
images of our people, plus your reputation and
career. Damn, I'm already sounding like your
father . . .* I know, Spence, but look, what are
the chances? Parts this don't come every day.
This is us: we are our people. Sometimes we get
to be the people we see and become them.

~ ~ ~ ~ ~

What do movies show or elide?
How might the movies play you?

~ ~ ~ ~ ~

It still blows my mind that Diana Ross
a dark-skinned skinny gal from Detroit
got to play both Dorothy in *The Wiz*
and red-boned, curvy Billie Holiday
drenched in ache in *Lady Sings the Blues*

283

Talk about an ingénue dipped in tar
crushing smoky gardenias in tinfoil
It makes no sense except these movies
are now black film classics
casting an indelible spell
~ ~ ~ ~ ~
Still the split can go wrong in many ways
Where was Malcolm X's sister Ella in *Malcolm X*?
Where was Yuri Kochiyama?
Go to the archives of *Life* magazine
and you will see a Japanese American woman
cradling Malcolm's head in her hands
as he draws his dying breaths
Maybe it's divine order that Yuri was there
at Malcolm's death since they shared the same birthday
Yuri Kochiyama doesn't appear in the movie *Malcolm X*
Spike Lee stages the death scene with Angela Bassett
playing Malcolm's widow, Betty Shabazz
cradling Malcolm's head in her hands
as he draws his dying breaths
~ ~ ~ ~ ~
I love Angela and Betty
I love Malcolm
(and, despite it all, I love Spike)
but now that I know that she exists
I love Yuri Kochiyama too
I'm mad that Yuri K was cut out of the movie
I want to see a cut of *Malcolm X* where
the fiery black nationalist leader is friends
with a fiery Japanese mother
an activist and supporter of the Black Panthers
who invites him over for family meals
and maybe joint birthday parties
This needn't be the point of the movie

*(a touching tale about cross-cultural friendship)*
This would just be what happened
The exact plot of *Malcolm X* would be the same
except Yuri and Ella and any other
absent women would be there
as they actually were

~ ~ ~ ~ ~

I learned about Yuri Kochiyama
from my friend Allison Yasukawa
who has been listening generously
to my musings about *Waves*
To help me shore up my unwieldy thoughts
she sent me an essay by Kalamu ya Salaam
called "Why Do We Lie about Telling the Truth?"
In the very first paragraph, ya Salaam revives
Kochiyama's words and her place in Malcolm's life
ya Salaam repudiates the death scene in *Malcolm X*
In his spirit of rigorous honesty
I should mention that I saw *Waves* the first time
with Allison who actively disliked it

~ ~ ~ ~ ~

What do we see when we see movies?
Are we seeing the same movie at all?

~ ~ ~ ~ ~

WAVES: A SYNOPSIS
I'm keeping a list of things I like in Los
Angeles, California. So far, palm trees, the
Wi spa, Yayoi Kusama's *Infinity Room*, the 90/91
bus, and *Film Week* on KPCC. *Waves* premiered at
the Telluride Film Festival in August 2019 and
then went wider that November. Around then,
Jeff Chang on *Film Week* talked about *Waves*;
he said he was blown away. He didn't want to
give too much of the story away, but he said

there was a black family and tragedy and it
was beautifully shot. And somehow, I knew it
was for me. He also said the acting was very
strong but didn't mention the security guard,
who gave one of my favorite performances.
*These people out here are crazy, man,* the guard
says about the protesters outside the abor-
tion clinic. *They say the worst things to me.*
*I gotta take it every day, but listen—I'm here*
*for y'all . . . I just ask that you're here for*
*me, too.* Although the character doesn't get to
have a name in the credits, the actor's name
is David Anthony Payton. In a film chock-full
of complicated black masculinity, he counter-
acts aggression with care. He only appears in
one scene. Still, he should not be overlooked.
Stanislavsky declares: there are no bit parts,
just bit actors.

~ ~ ~ ~ ~

How do you see what's in a movie?
What do you notice when you see it again?

~ ~ ~ ~ ~

When my friend Andy Lim invited me to see
*Moonlight* at the Uptown in Minneapolis
It said in lights on the marquee
*A FRANK OCEAN SONG FOR THE EYES*
Andy Lim saw *Moonlight* at least fifty times or more
He wanted it to win the Oscar for Best Picture
and he believed that taking everyone he knew
to see it could maybe make the difference.
*Does the movie ever get boring?* I asked
He said, *well, I know what it is that I'm seeing*

~ ~ ~ ~ ~ ~ ~ ~ ~ ~ ~ ~ ~ ~ ~ ~ ~

And what it is to be glimpsed /And what it is to be claimed /And what it is to be held /And what it is to have always been /at the edges of /your own life story /And what it is to be always becoming and never /really seen and then seeing /something that maybe reflects / some part of you back /some parts of yourself /you never show to anyone /but that doesn't mean that you don't want to see /yourself /reflected back /like maybe it's seeing /or trying to show what it looks like /like Prince says at the end of "If I Was Your Girlfriend" /*we'll try to imagine /what it looks like* /what you look like /on the inside /and the outside /and the silver screen /showing some other world /maybe a better one /where George Floyd didn't have to die and Breonna Taylor and Ahmaud Arbery and Eric Garner and John Crawford III and Sandra Bland and Trayvon Martin /and *60 million and more* /in deep /expansive waters /at the bottom of all the ancient waters /radiating power /still all alive /so you don't need to escape /to the movies /where violence still flares /where a goddess is murdered /before a baby can be born /someone innocent dies /and at the same time /in the middle of that mess /something shifts /a revolving siren /becomes a blur of red light /dissolving the scene /and filling the screen /like the electric guitar solo /at the center of Frank Ocean's "Nights" /a red dissolve /a visual blare /a hinge and a swirl /then something /coming into focus /maybe somebody sees this thing /inside you / O K A Y /maybe it's just /a dopey white boy who makes his movie /I mean his move /but we have been trained to have /patience for such /romance and heroics /We've watched lots of movies /so we're ready /for a swain /for tenderness /to run off /we're ready /to see where it goes /I mean /I've been waiting a long time /for this /*concentric circles and concurrent overlaps* /And what it is finally to come /into your own /To allow imagination /to flow /When he asks her at first /if she wants to go / see mermaids and manatees /the black girl wonders /But how could we go? /He replies/ it's summer and I have a car /who could stop us? / She takes a leap off a crag and plunges into the waves /*Could this be a figure of freedom?* /You go back to see it again /and again

~ ~ ~ ~ ~ ~ ~ ~ ~ ~ ~ ~ ~ ~ ~

In *Le cri des oiseaux fou,* Dany Laferrière
calls Le Lido the only movie theater in the world
that shows only one film *El Caballero Blanco*
It plays in the original Spanish without subtitles
The owner says the dubbed French version
is coming soon to Port-au-Prince
but he's been saying that for ten years
The story goes that when he saw *El Caballero Blanco*
it touched him so much that he built an entire
movie theater to watch it again and again and again
At first no one came to see it
Then people started to slip in, little by little
until Le Lido filled three showings a day
Sometimes to welcome the crowd
the owner of Le Lido would stand
in the threshold dressed up like a cowboy

~ ~ ~ ~ ~

Sometimes reflection creates belonging
Sometimes meaning overflows

~ ~ ~ ~ ~

In *The Searchers,* it takes John Wayne
and his sidekick five whole years to find
the niece "abducted by Comanches"
The movie is a racist classic of its time
and by the time the cowboys are in place
to get the white girl back SPOILER ALERT
she has become somebody else *beads and bones*
*and native bound hair and again lots of bronzer*
(Poor Natalie Wood, the movie star
who played the girl grown up
herself perished tragically in waves)
Finding her is supposedly the point of the movie
but it takes a long time to get there

~ ~ ~ ~ ~

For many hours in *The Searchers*
nothing really happens
the cowboys ride and meander
in silence or shoot the breeze
When Douglas Gordon complained
as a child about this long stretch
of nothing in *The Searchers*
his father explained this nothing
was searching and waiting and living
across vivid American landscapes
This western was about filling time
and maybe how things change
off-screen while nothing
looks like it's changing

~ ~ ~ ~ ~

In college, I would pore over
grown-up Douglas Gordon's proposal
with *The Searchers* in *Unrealized Dreams*
*How can anyone sum up 5 years in only 113 minutes?*
His idea as an artist was to project *The Searchers*
for as long as the search in the movie
*1 second of cinema time = 6.46 hours in real time*
*113 minutes of cinema time = 43824 hours*
He called his project *5 Year Drive-By*

~ ~ ~ ~ ~

Do I need to clarify that Douglas Gordon
is white or is that implicit in his use of *drive-by*
as a funny play on drive-in movie?

~ ~ ~ ~ ~

What would it be like to have *The Searchers*
slowed down and blown up for five years
as a giant stop-motion billboard in your town?
Instead of seeing the movie again and again
the racist visions would just always be there

sometimes just a blur
so you might never see the movie running
or really unspooling on the horizon

~ ~ ~ ~ ~

Or maybe after months or centuries
of delusions TIME IS NOT ALIGN
something else would happen
something new PRESS PAUSE
*Giddy up, cowboy!* SELECT ANOTHER FUTURE
and the friendships that would form
and the friendships that would end
and the new alliances and broken treaties
and maybe things would really change
and people would see movies for what they are

~ ~ ~ ~ ~

In our independent study on Identity
& Representation in Animation
I am supposed to be the professor
but Benni Q teaches me a lot
They teach me animation doesn't happen in the stills
how a movie comes to life between the frames

~ ~ ~ ~ ~

A painting spills out beyond the frame
and becomes a black motion picture
My friend Amy Hamlin sends me an article
on pandemic looking with a huge close-up
of *Gulf Stream* by Kerry James Marshall
In movie terms, it's a remake
of *The Gulf Stream* by Winslow Homer
but in Homer's work, a black man is alone
in a broken boat, ragged and surrounded by sharks
Marshall's painting is a sea change and balm
The painting is gorgeous *full of rich water and blues*
*and birds in flight and surging, resplendent waves*

The black family is still floating at sea
except they're *cruising satisfied kicked back*
even with the acute tilt of the sail

~ ~ ~ ~ ~

*Who am I playing in the movies?*
Taylor Russell playing Emily in *Waves*

~ ~ ~ ~ ~

WAVES: A SYNOPSIS
After the violence, after the red dissolve,
in the heart of being shunned, in the wake of
grief, a black girl sits quiet in the radiance
of the sun. Imagine this written in yellow
gold . . . School is almost over: it's the
end of year. And maybe now she can start to
live. Emily does a lot of things in *Waves*.
She whines and witnesses and slips away. She
holds her brother close when he is falling
apart. She exchanges lip gloss with his girl-
friend, the goddess. What does it mean to take
a life or finally have one? Emily is allowed to
drift. She sits on her bed beneath a collage
of pleated fans. She strokes her asthmatic cat.
She drinks milkshakes with a boy who asks her
out. Everything becomes wet. They buy liquor
underage, gambol through sprinklers at night.
She consoles him in bed when he comes too soon.
You know they'll try again in a few hours. They
soak together in a bathtub, listening to Frank
Ocean on her phone. The phone sits in a glass
to amplify the sound. She turns it off to say,
*Come on, your father is dying. We have to go
see him before he's gone.* Her brother is not
her demon. Her boyfriend is not her savior.
Even her father, whose arm stretches across her

back on the poster of *Waves*, is not her raison d'être. She becomes herself the answer. Not selfless, it's just that she has so much self to spare. The camera loves her. She begins to gleam. Waves starts as one thing then turns into another. When you see it again, you realize it was always that all along. The black girl rides off on her bicycle into the sunset listening to Alabama Shakes' "Sound & Color." Like at the end of Gwendolyn Brooks' *Maud Martha*, her hands stretch out into the air.

~ ~ ~ ~ ~

What do movies mean to me?
What can we make of movies?

~ ~ ~ ~ ~

Trey Edward Shults says his summer
making *Waves* was the best summer of his life
*remembering living remaking*
I wanted to remake *Purple Rain* with my friends . . .
this time with no woman of color dumped in a trash can
and we would all be Prince
and we would all be stars

~ ~ ~ ~ ~

WAVES: A SYNOPSIS
When I was a kid in Detroit, Gary Coleman came to premiere his new movie *The Kid with the 200 I.Q.* We cheered him as he took the stage. He stood to welcome us in the threshold, dressed in a tuxedo. I remember the spotlight creating radiance around his small boy body and the red velvet curtains over the movie screen. What a thrill! This wasn't the movie where he lived homeless in a locker in a train station,

which was supposed to be heartwarming but I found disturbing even then. In this one, Gary was a genius and Robert Guillaume wasn't a butler but was his genius college professor. They were doing astronomy, I think. Black Quantum Futurism. Gary cleared his throat and said, "Thanks, folks, for coming out this afternoon! Let me tell you about the movie. *Waves* is black feminist stream-of-consciousness about cinematic representation and what you're doing here right now. It's got it all, folks: overflowing memories, historical ripples, rhetorical questions, police action! Really, you want it, we put it in there! Seriously, folks, there's a lot of heart and elbow grease in here. We tried to spit polish it to a shine. You know what they say: *'Black movies are black life.'* I hope you enjoy the show."

~ ~ ~ ~ ~

What would happen with me behind the camera?
What kind of movies would I make?

~ ~ ~ ~ ~

My favorite critical tomes would turn into sweeping epics
of gossip and sex and octogenarian ingénue romances
plus poetry squabbles and all my friends and political
movement and stillness and wacky style and some
attempt to reflect back my own black female interiority
*sweeping rolling cresting flushing inside now shining through*
projecting and radiating
through other people's bodies
some that maybe look like mine
some others with different resemblance

~ ~ ~ ~ ~

Coming Soon to a Cinema Near You
GABRIELLE CIVIL presents
Cheryl Clarke's *AFTER MECCA*
Nhã Thuyên's *UN\\MARTYRED*
Martha Cobb's *HARLEM, HAITI, AND HAVANA*
Sandra Cisneros' *A HOUSE OF MY OWN*
Will Alexander's *SINGING IN MAGNETIC HOOFBEAT*
Andrea Quaid's *URGENT POSSIBILITIES*
Zahra Patterson's *CHRONOLOGY*
Lila Abu-Lughod's *VEILED SENTIMENTS*

~ ~ ~ ~ ~

Okay no sex in *Veiled Sentiments*
just lots of juicy Bedouin poetry
there was no sex in the Tuareg remake
of *Purple Rain* either
*Akounak Tedalat Taha Tazoughai*
Set in Niger and cast with local actors
it was directed by Christopher Kirkley in collaboration
with his star the musician Mdou Moctar
Whose story was that again?
What did it have to pass through?
Prince never said a word
There is no word for *purple*
in Tamajeq so the movie is called
*Rain the Color of Blue with a Little Red in It*
Roll the camera of these words in your mouth again
Another name for that rain is *Waves*

~ ~ ~ ~ ~ ~ ~ ~ ~ ~ ~ ~ ~ ~ ~ ~ ~

# The Déjà Vu

black time & black dreams

Gabrielle Civil

aesthetics is the science of vulnerability
bruises transformed, wounds immortalized.

—*Wanda Coleman*

Dear Reader,

If you've made it this far, then you already know that I am an idiosyncratic writer. Sometimes a sentence breaks in the middle of an essay. Sometimes an essay comes out in bubbles. I like to think of myself as *experimental,* but sometimes I'm just stubborn. It feels like my writing has become the only place to claim authority over my own language. So I push back against overreach. As my fantastic editor Anitra Budd can attest, I reject 's after a word that ends with *s* because it makes the word look like it has buttocks. I often eschew contractions or add extra adverbs for rhythm. I'll format performance texts differently depending on the vibe.

I swear I'm not doing this just to be difficult. Sometimes it feels like I'm not doing it all. Some language just wants to come down on the page for me a certain way. When I try to change or delete it and move on to another phrase, it pulls me back and makes demands. It cajoles or snarls. It's a whole thing. And quite often, my idiosyncratic language wins. Thank you, Reader, for hanging out with it and sometimes even granting it your affection. My heart resides in these words and gestures, so it really means a lot.

This brings me to something for which I will claim complete authority: my lack of capitalization here for the word *black.* Anitra asked me to write about this stylistic choice, which perhaps strikes you as surprising. In a book by a black feminist performance artist about black dreams and black time, featuring a whole bunch of black people, you gotta know the word *black* shows up a lot. Basically this book is: *black black black black black black black black black black black black black.* Except that when Anitra first line-edited the manuscript, it became capital *Black Black Black Black Black Black Black Black Black Black Black Black Black Black Black.* This made sense not just because Anitra like myself is black/ Black/ BLACK but because she is the editor responsible for aligning manuscripts with the house style of the press and the most updated editorial approaches. I love Anitra and respect her professional opinion. So then why did I go

back and meticulously return each capital *Black* to lowercase *black* (except in direct quotes from other sources)?

Back in the ninth grade, I remember writing about Black people with a capital B in my English class, and Sister Rose Marie Petranek correcting me and telling me that *black* was not to be capitalized, even in reference to people, unless it was at the beginning of a sentence. To be fair, she said the same thing about *white*. To keep it all the way real, Sister Rose loved me and I loved her back. She was one of a string of white English teachers who both encouraged my passion for language and enforced these kinds of rules. I had my feelings about this correction. (Clearly, I still have feelings about people telling me how to describe myself.) But, I started building a writing relationship with lowercase *black* that was specific, intimate, and stealth. I didn't need for *black* to be capitalized in order to signal magnitude or impact. Sonia Sanchez, Nikki Giovanni, and Ntozake Shange showed me that. Besides, to paraphrase Bob Marley, the small ax can cut down the big tree.

Don't get me wrong. I don't have an innate beef with capital Black. If others describe me as capital Black, I'm cool. I appreciate the efforts of Black journalists who have pushed for predominantly white journalism and language organizations to adjust their style guides. I understand the context, exposure, and scale there. I recognize how racism resides in unequal language standards and how news outlets, in particular, have played a specious role. In this moment of racial reckoning, I've also seen how predominantly white organizations have shifted their house styles and capitalized Black to signal their recognition of our humanity. I do value this gesture and hope it helps expand resources and opportunities for Black people at those organizations. Finally, I have capitalized *Black* myself at times (and even went further with my idea of BLACK TIME). I've even allowed journals to capitalize my lowercase *black* to fit their individual publications without a fuss.

But *the déjà vu* is my book. It is an attempt to reflect my voice, my inner life, my intuition, and something about my time. Not just

this moment, but the time that made me the kind of writer I am. I don't want to erase out my specific, intimate, stealth blackness. My style is a time stamp and I don't want to just update myself and pretend like little b *black* never happened or that everything about it was retrograde, ignorant, or white-identified. Or that people were always on board with where little Gabrielle started out. Or that little Gabrielle was never corrected and then managed to figure out other ways inside the language.

Toni Morrison was talking somewhere about the origin of her first novel, *The Bluest Eye*, a devastating portrait of anti-blackness, colorism, and self-loathing. She said something like: "People were talking about Black Power as if it had always been happening and I wanted to remind them of the recent past." I can't recall exactly where I heard this story, and I'm certainly no Toni Morrison (writer goddess queen!), but her words made me think about how our language can hold cultural memory, even the lack of capitalization; and how cultural amnesia, erasure, or homogenization can come with narratives of progress.

I remember when Jesse Jackson announced one day that we were all African-Americans (it was hyphenated then). Even as a kid, I didn't like this term or agree to this shift. Although I was a member of the group being described, it didn't matter what I thought. (Jesse Jackson and Sister Rose somehow had this in common.) Who gets to decide which language we can and should use to describe ourselves? The message of the moment was to fall in line. In professional, academic, and formal contexts, I used the updated term *African-American* even though it never actually reflected the nuance of my diasporic black identity, the reality of my family, or my relationship to homeland or nation.

In this moment, when so many of our attempts to improve our society have come down to the use of specific language, I have tried to be respectful, especially to others not from my own racial, ethnic, or gender background. In my own book, though, I want to call the shots about describing myself and my people, recognizing

that others in my own group may not make the same choices. Moreover, I reserve the right to make different choices myself (even within the span of this text). I'm down for lowercase blackness, capital Blackness, all caps BLACKNESS, wild-style bLaCkNeSs, nourbeSe-N b l a c k N e s s, and other combinations. That is to say: On some level, the *little b* holds out the diversity of blackness, the way that not all blackness looks or has to be the same.

Kevin Quashie gets into this in *Black Aliveness, or A Poetics of Being.* It's soooo good! He invites us, really challenges us to "Imagine a black world." yes/ Yes/ YES. I just started it and feel like his descriptions of "black aliveness" and "black worldbuilding" capture the dream for my own work. Have you read it yet? Wanna do a book club? Let me know. Thanks again for reading.

See you soon,
xo Gabrielle

# Homework

a syllabus for *the déjà vu:*
*black dreams & black time*

1. *I Am a Black Woman,* Mari Evans
2. "Dreams," Langston Hughes
3. "Uses of the Erotic," Audre Lorde
4. "I Have a Dream," Martin Luther King, Jr.
5. *Wild Beauty* & *lost in language & sound,* Ntozake Shange
6. *Don't Explain,* Alexis De Veaux
7. *M Archive,* Alexis Pauline Gumbs
8. *Black Quantum Futurism: Theory & Practice,* ed. Rasheedah Phillips
9. *A Time for New Dreams,* Ben Okri
10. *The Black Condition Ft. Narcissus,* jayy dodd
11. *You Are My Joy and Pain,* Naomi Long Madgett
12. *La mémoire aux abois,* Evelyne Trouillot
13. *Build Yourself a Boat,* Camonghne Felix
14. *The Forgetting Tree,* Rae Paris
15. *Silencing the Past,* Michel-Rolph Trouillot
16. *The Hoodoo Tarot,* Tayannah Lee McQuillar
17. *Blackspace: On the Poetics of an Afrofuture,* Anaïs Duplan
18. *Mess and Mess and,* Douglas Kearney
19. *Mercurochrome,* Wanda Coleman
20. *Magdalene,* FKA twigs
21. *L'exil vaut le voyage,* Dany Laferrière
22. *Incalculable Loss,* Manuel Arturo Abreu
23. *Athena,* Sudan Archives
24. *Chronology,* Zahra Patterson
25. *Black Futures,* ed. Kimberly Drew & Jenna Wortham
26. "Young Afrikans," Gwendolyn Brooks
27. "You'll Never Find Another Love Like Mine," Lou Rawls
28. *Everything Prince Always* but especially: "Still Waiting" from *Prince, 1999, Sign o' the Times, Parade,* "Solo" from *Come,* "Time" from *Art Official Age,* "Million $ Show" from *HITNRUN Phase One,* and always, deeply *Purple Rain*

# Notes & Acknowledgments

*the déjà vu: black dreams & black time* was written in the wake of the murder of George Floyd in Minneapolis, Minnesota, and is dedicated to his memory. It is written to claim vibrating, undeniable power and to honor those resting and radiating in power.

The title essay received inspiration from Ben Okri's "Form and Content" in *A Time for New Dreams* and John Berger's "Twelve Theses on the Economy of the Dead." Anna Martine Whitehead's exploration of Berger's essay in their "Surrounding Desire" workshop at the 2018 Seattle Festival of Dance Improvisation helped me deepen my appreciation for Berger's form and ideas.

"On Commemoration" enacts Exploding the Text, a strategy learned and practiced during my time teaching in Bard College's summer Language & Thinking Program (in 2002, 2004, 2005, and 2006). I "exploded" or annotated words and phrases from a 2006 unpublished meditation on a mural in Montreal. Learn about more reading and writing strategies from the Bard Institute for Writing and Thinking at writingandthinking.org. / The sequence of dates in "We Will Always Forget" was partially inspired by the word portraits of Félix González-Torres. / 2 . 22 . 22 is the publication date of *the déjà vu.* / At the time of this writing, Tourmaline's *Happy Birthday, Marsha!* can be viewed on Amazon Prime. I learned about this film through Black Youth Project 100, which included it in its webinar on Mapping Black Trans Resistance. Learn more and donate to BYP100 at byp100.org. / At the time of this writing, Sophia Nahli Allison's *A Love Song for Latasha* can be viewed on Netflix. I learned about this film through *A Long Walk Home,* which cosponsored a screening and conversation with the director, archived on YouTube. Learn more and donate to A Long Walk Home at alongwalkhome.org. / "Words for Skin Tone," the text that

Anitra shared with me, can be found at writingwithcolor.tumblr .com. I appreciated the food for thought (yes, I took the pun) and the other resources there. / The annotations on "men and women" and "youth and age" were informed by long-running conversations with Nick Daily. The characterization of Generation X was inspired by conversations with Rachel Moritz. / Another Montreal meditation can be found in my collection of performance writing *( ghost gestures )* (Gold Line Press, 2021).

"these bodies don't touch" was published in the Black Aliveness special issue of *Interim,* edited by Ronaldo V. Wilson and launched online in December 2020.

"Tourist Art" started as a series of conference presentations with Vladimir Cybil Charlier about our poetry–fine art collaboration of the same name. It was developed as the essay "Tourist Art: A Tracery of the Visual/Virtual," included in the anthology *Writing Through the Visual and Virtual: Inscribing Language, Literature, and Culture in Francophone Africa and the Caribbean,* edited by Ousseina Alidou and Renée Larrier (Rowman & Littlefield, 2015). The text in this book combines key elements of the book, the presentation, and the essay with my memories of Haitian art. See the list of further resources below. Forever thanks to Cybil for her beautiful images.

> Further Resources on Haitian Tourist Art
> Belafonte, Harry. "Haiti Chérie." Video, 3:20, 7 March 2010. https:// www.youtube.com/watch?v=VpjZx4iCNX4
> Civil, Gabrielle and Vladimir Cybil Charlier. *Tourist Art.* Produced via Create Space, 2012.
> Corbett, Bob, ed. "Haitian Art before and after 1944 and DeWitt Peters." 2001. http://www2.webster.edu/~corbetre/haiti/art /pre-1944.htm.

Derrida, Jacques. *Of Grammatology.* Translated by Gayatri Chakravorty Spivak. Baltimore: The Johns Hopkins University Press, 1976.

Dreyfuss, Joel. "A Cage of Words." In *The Butterfly's Way.* Edited by Edwidge Danticat, 57–59. New York: Soho Books, 2001.

Fanon, Frantz. *The Wretched of the Earth.* Translated by Constance Farrington. New York: Grove, 1963.

Herz, Ansel. "How to Write about Haiti." *Mediahacker,* 23 July 2010. https://www.huffpost.com/entry/a-guide-for-american -jour_b_656689.

Lévi-Strauss, Claude. *Tristes Tropiques.* Translated by John Russell. New York: Criterion, 1961.

Livernois, Joe. "Art links Monterey and Haiti." *Monterey Herald,* 10 January 2010. https://www.montereyherald.com/2010/01/17 /art-links-monterey-and-haiti.

Philogene, Jerry. "Vladimir Cybil," *Bomb* 90 (Winter 2005): 18–24. http://bombmagazine.org/article/2692/vladimir-cybil.

Poupeye, Veerle. *Caribbean Art.* London: Thames & Hudson, 1998.

Price-Mars, Jean. *Ainsi Parla l'Oncle.* (First Published 1928). New York: Parapsychology Foundation, 1954.

Rodman, Selden. *Where Art Is Joy.* New York: Ruggles and Latour, 1988.

Taylor, Erin B. "Markets as cultural intersections I: Reflections of nationality in Haitian and Dominican paintings." *Erin B. Taylor,* 22 September 2011. http://erinbtaylor.com /entry/markets-as-cultural-intersections-i-reflections-of -nationality-in-haitian-and-dominican-paintings.

———"Why the Cocks Trade: What a Transnational Art Market Can Reveal about Cross-Border Relations." *Visual Studies* 29.2 (2014): 181-190. doi: 10.1080/1472586X.2014.887271.

"The Spring Tour" premiered at *The Promise of Green: Resilience, Resistance and the Coming Season,* curated by Ellen Marie Hinchcliffe at the Center for Independent Artists in Minneapolis in March 2006.

"Hold Fast to Dreams" was delivered January 22, 2008 as the Anne Joachim Moore lecture on Social Justice and Education at the College of St. Catherine in Saint Paul, Minnesota, which became St. Catherine University in 2009. The original title was "Hold Fast to Dreams: Excellence, Creativity, and Community." This speech is a blast from the past in many ways.

The transcript section of "*~flashback~*" came from a 2015 psychic tarot reading with Nancy Antenucci in Saint Paul, Minnesota. Learn more about her work at betweenworlds.us.

"Blue Flag" arrived in one feverish night at Country Dreams in Durham, North Carolina. Many thanks to Lewis Raven Wallace for the hospitality and to Lewis and Catherine Edgertion for feedback on that first draft from my all-nighter. The structure of the essay is a palindrome. David L. Ulin's 2014 *Los Angeles Times* article "When Maya Angelou was reviewed by Wanda Coleman" describes the drama between these two amazing black writers. Rest in Power, Mama Wanda! I truly wish she could be here to talk to me about her chapbook and everything else.

"Pony, Swim, or Freeze?" was published in *Urgent Possibilities, Writing on Feminist Poetics & Emergent Pedagogies,* edited by Andrea Quaid (2020). It was originally developed for the Feminist Poetics, Emergent Pedagogies conference organized by Andrea Quaid and Margaret Rhee in June 2018. The text references my time spent as the Laura C. Harris Scholar-in-Residence in Women's and Gender Studies at Denison University where my project was "Activating / Performance \ Activism." Many thanks to my students

and colleagues there, especially Ms. Cierra L. King and Dr. Toni King.

"Public Mysteries" was commissioned by Forecast Public Art in 2016 as part of the thousand-year plan of Don't You Feel It Too?, the public dance practice founded by Marcus Young in Minneapolis-St. Paul. Many thanks to Marcus and the whole DYFIT community. You can learn more at dyfit.org.

*after the end* was performed with Moe Lionel at Queertopia at the Heart of the Beast in Minneapolis in June 2019. Thanks to all the curators and audiences of that show. Special thanks to aegor ray and bobbi vaughn for sharing their dialogue about the work. I remain deeply grateful to Moe for the invitation to create this work and for deep soul connection.

"Sphericity" features text from the performance lecture "Sphericity (or, black time is not flat)," a performance lecture created for the *Flat Earthers* multimedia project, cocurated by John Lake and Raewyn Martyn. The lecture appears in the *Flat Earthers* e-publication, edited by Raewyn Martyn (2020). The text here also takes inspiration from Sawako Nakayasu's "Say Translation is Art." It owes much to Madhu H. Kaza who asked me to expand more upon the notion of BLACK TIME.

*Wild Beauty* was performed at the Velocity Dance Theater in Seattle in January 2020. Thanks to Catherine Nueva España, Erin Johnson, Gedney Barclay, Shirley Kim, and especially Angie Bolton and Dan Schmidt for their hospitality. Thanks to Fox Whitney, Randy Ford, and NEVE for beautiful dance stylings. Extra special thanks to Fox for opening the door to the project through his artist residency at Velocity and for everything he did to see it through. Sections of "Wild Beauty" along with other meditations on the project appear in *Wild Beauty/what happens if we take our time,*

a chaplet in the DanceNotes series, edited by Sam Creeley &
P. Sazani (2021).

An excerpt from "Waves" appeared in the *Autotheory* special issue
of *ASAP* (2021). Thanks to special editors Lauren Fournier & Alex
Brostoff for the invitation to submit.

# Image Credits

The cover photo and the center blurred photo in "~*flashback*~" were taken by Sayge Carroll. They come from my 2004 performance after *Hieroglyphics* (directed by Miré Regulus). This work is discussed at length in my first book, *Swallow the Fish*.

The photos in "On Commemoration" and "Hold Fast to Dreams" are courtesy of my own collection. Ellen Marie Hinchcliffe made the video "Yawo's Dream" with me in 2006.

The artwork in "Tourist Art" was created by Vladimir Cybil Charlier.

The photograph of the Haitian painters was taken in the 1940s in Haiti. The name of the photographer has been lost to time, but some of the painters have been identified. In the back row: #3 Rigaud Benoît; in front of him in white, #4 Antonio Joseph; #6 Lucien Price; #7 Géo Ramponeau; #9 Maurice Borno; #11 Pierre Monosiet; and #14 Max Ewald. In the front row: #2 Luce Turnier; #3 DeWitt Peters; and #4 Tamara Baussan. Thanks to the Haitian artists and cultural workers who helped me research this image.

The photos in *"after the end"* were taken by Jaffa Aharanov in 2019.

The photo in "Sphericity" was taken by Rosamond S. King during a rehearsal of *Fugue (Da, Montreal)* in 2014.

The photo in "Wild Beauty" was taken by Jim Coleman in 2020.

All images outside the public domain are used by permission.

God     the ancestors     the spirits     the Civils   Mom Dad

Kate F     André     Yolaine & Herman   Uncle David   the Smiths

my godfamily   the Jones   Kathy & Walter  Eric & kin

Madhu   Rosa     Zetta     Purvi     Eléna     Hannah Priscilla

WG     Allison Y   Andrea Q     Moe Lionel

Sayge     Anitra Budd     the Artas   Jess & Litia   Eyvind & Jessika

Alexis  Alexis  An D     Coffee House Press   CalArts   Jaamil  Wendy Cauleen

Nick Daily     Dennie E   Miré     Tisa B

McCann     Baltimore Janet & Ken     Vladimir Cybil

## THANKS

Diaspora Project   Omi Osun Joni L. Jones   Sharon Bridgforth

Toni King   Lisbeth L

Janice Lee     The Accomplices     Marcus Young     Rachel Moritz

Ellen Marie     Josina     Lisa Marie   Eleanor S.   Amy Kelly   St. Kate's

Juma     Ananya     Rafael & Dina     Allison A.   Michelle NP     J'Lyn

* Prince Rogers Nelson *     Love Drive     Laura   Mike   Don  Eric   Greg

JDP & Jorge G     Jeremy   Ira     Sharon & Therese     Raewyn M

David & Blue   *Wanda Coleman*   Sailors & Ecrivains   Lewis & Catherine

Wild Beauty     Velocity Dance Center     Erin J

Fox   Neve   Randy

Queertopia   Nastalie & Erin & Nathaniel   Jaffa  Aegor     Bobbi

Sawako   E. Franklin   Aisha SS & Hannah E   Heather C   Miguel G

Anna Martine W     Ronaldo W     Yolanda W

314

Thanks to God, ancestors and spirits, my family, friends, teachers, colleagues, and students.

Thanks to the editors of the journals and anthologies where some sections of this book first appeared.

Thanks to the curators who invited me to create the performances and lectures that ended up in this book.

Thanks to the photographers and artists who gave permission for me to use their images in this book.

Thanks to the College of St. Catherine/ St. Catherine University, Antioch College, Naropa University, Denison University, UCLA, and my current home institution, the California Institute of the Arts, for steady employment while writing the various sections of this book.

Thanks to Hannah Priscilla Craig, the secret sauce in my artistic pursuits, for helping me stay organized and ambitious. Thanks Hannah for being upbeat, for watering my plants when I'm away, and for helping me give California a chance.

Thanks to the many kind folks who read drafts and offered feedback on different sections. This includes Aisha Sabatini Sloan, Lewis Raven Wallace, Catherine Edgerton, Ellen Marie Hinchcliffe, E. Franklin Avery, Tisa Bryant, Janet Sarbanes, Anthony McCann, JD Pluecker, Paolo Javier, Dennie Eagleson, Moe Lionel, and more. I appreciate you all.

Thanks to the indefatigable members of my writing group, Allison Yasukawa and Andrea Quaid, who not only responded to key sections of this book but helped me maintain weekly sacred writing time despite the pandemic chaos. Thank you, WG. Index cards for life!

Thanks to the incredible writers who agreed to write blurbs for this book: Alexis De Veaux, Alexis Pauline Gumbs, Anaïs Duplan, Jaamil Olawale Kosoko, Cauleen Smith, Ronaldo V. Wilson, and Wendy S. Walters. You remain inspirations. I remain your fans.

Special thanks to Aisha Sabatini Sloan who first suggested that Coffee House Press might make a good home for this book. Thanks to Chris Fishbach for acquiring the manuscript. Special thanks to Erika Stevens, Carla Valadez, Lizzie Davis, Marit Swanson, Daley Farr, Lee Oglesby, Annemarie Eayrs, Rachel Holscher, and the entire CHP team for bringing this book into the world. Special thanks to Anitra Budd who held my hand, had my back, and helped me through each contraction.

Special thanks to Rachel Moritz, Jess Arndt, and Madhu H. Kaza who encouraged, challenged, and believed in me at pivotal moments. You read this book closely, thoughtfully, and generously. When things got rough, you helped me battle my doubts and forge ahead. I thank you writing wizards from the bottom of my heart.

Thanks finally to you, courageous reader of *the déjà vu*.
May you revel in black dreams and black time.

# the déjà vu

Coffee House Press began as a small letterpress operation in 1972 and has grown into an internationally renowned nonprofit publisher of literary fiction, essay, poetry, and other work that doesn't fit neatly into genre categories.

Coffee House is both a publisher and an arts organization. Through our *Books in Action* program and publications, we've become interdisciplinary collaborators and incubators for new work and audience experiences. Our vision for the future is one where a publisher is a catalyst and connector.

LITERATURE
is not the same thing as
PUBLISHING

# Funder Acknowledgments

Coffee House Press is an internationally renowned independent book publisher and arts nonprofit based in Minneapolis, MN; through its literary publications and *Books in Action* program, Coffee House acts as a catalyst and connector—between authors and readers, ideas and resources, creativity and community, inspiration and action.

Coffee House Press books are made possible through the generous support of grants and donations from corporations, state and federal grant programs, family foundations, and the many individuals who believe in the transformational power of literature. This activity is made possible by the voters of Minnesota through a Minnesota State Arts Board Operating Support grant, thanks to the legislative appropriation from the Arts and Cultural Heritage Fund. Coffee House also receives major operating support from the Amazon Literary Partnership, Jerome Foundation, McKnight Foundation, Target Foundation, and the National Endowment for the Arts (NEA). To find out more about how NEA grants impact individuals and communities, visit www.arts.gov.

Coffee House Press receives additional support from Bookmobile; Dorsey & Whitney LLP; Elmer L. & Eleanor J. Andersen Foundation; Fredrikson & Byron, P.A.; Kenneth Koch Literary Estate; the Matching Grant Program Fund of the Minneapolis Foundation; Mr. Pancks' Fund in memory of Graham Kimpton; the Schwab Charitable Fund; and the U.S. Bank Foundation.

# The Publisher's Circle of Coffee House Press

Publisher's Circle members make significant contributions to Coffee House Press's annual giving campaign. Understanding that a strong financial base is necessary for the press to meet the challenges and opportunities that arise each year, this group plays a crucial part in the success of Coffee House's mission.

Recent Publisher's Circle members include many anonymous donors, Patricia A. Beithon, Anitra Budd, Andrew Brantingham, Dave & Kelli Cloutier, Mary Ebert & Paul Stembler, Jocelyn Hale & Glenn Miller, the Rehael Fund-Roger Hale/Nor Hall of the Minneapolis Foundation, Randy Hartten & Ron Lotz, Dylan Hicks & Nina Hale, William Hardacker, Kenneth & Susan Kahn, Stephen & Isabel Keating, the Kenneth Koch Literary Estate, Cinda Kornblum, Jennifer Kwon Dobbs & Stefan Liess, the Lambert Family Foundation, the Lenfestey Family Foundation, Sarah Lutman & Rob Rudolph, the Carol & Aaron Mack Charitable Fund of the Minneapolis Foundation, Gillian McCain, Malcolm S. McDermid & Katie Windle, Mary & Malcolm McDermid, Daniel N. Smith III & Maureen Millea Smith, Peter Nelson & Jennifer Swenson, Enrique & Jennifer Olivarez, Alan Polsky, Robin Preble, Jeffrey Sugerman & Sarah Schultz, Nan G. Swid, Grant Wood, and Margaret Wurtele.

For more information about the Publisher's Circle and other ways to support Coffee House Press books, authors, and activities, please visit www.coffeehousepress.org/pages/donate or contact us at info@coffeehousepress.org.

*Gabrielle Civil* is a black feminist performance artist, poet, and writer originally from Detroit. She has premiered fifty performance artworks around the world. Her performance memoirs include *Swallow the Fish, Experiments in Joy, ( ghost gestures )*, and *in and out of place*. She teaches at the California Institute of the Arts. The aim of her work is to open up space.

*the déjà vu* was designed by Bookmobile Design & Digital Publisher Services. Text is set in Minion Pro.